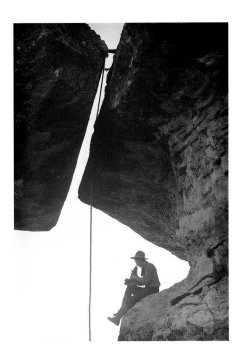

"What if photography does not stop time
but rather lets us see *through* time?"

ESTELLE JUSSIM
The Eternal Moment, 1989

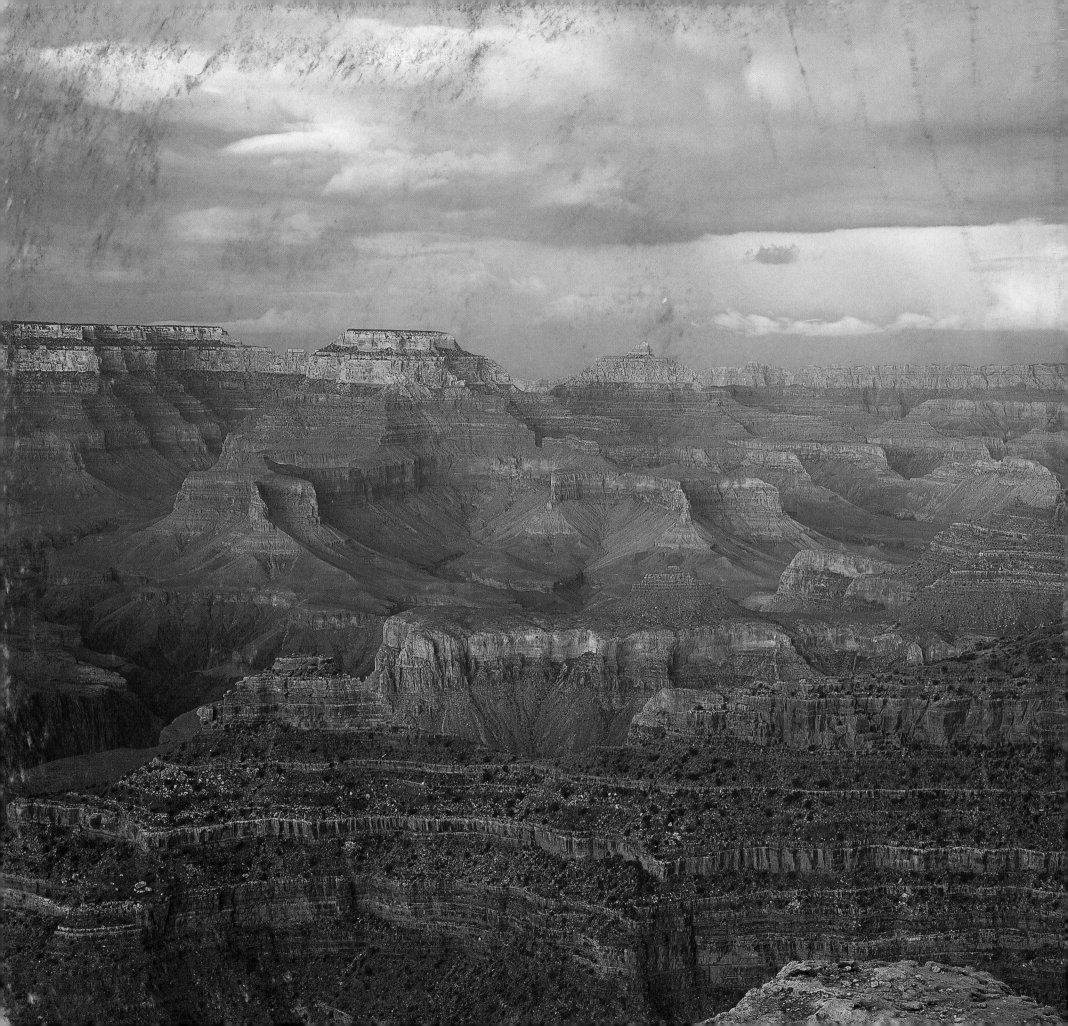

LASTING LIGHT ~ *125 Years of Grand Canyon Photography*

STEPHEN TRIMBLE

NORTHLAND PUBLISHING
in cooperation with Grand Canyon Association

To our elders:

ELIOT PORTER (1901-1990)

ERNST HAAS (1921-1986)

and PHILIP HYDE (1921-2006)

Inspiration for a generation.

COVER PHOTOGRAPH: Tom Till—*View from Lipan Point*
BACK COVER PHOTOGRAPH: Liz Hymans—*Sacred Datura*
HALF TITLE PAGE: Kolb Brothers—*Photographing from an outcropping*
 (Courtesy of the Cline Library, Northern Arizona University)
FRONTISPIECE: Liz Hymans—*Dusk at Mather Point*
OPPOSITE: Dave Edwards

www.northlandbooks.com

Composed in the United States of America
Printed in China

Acquired by Tammy Gales-Biber
Edited by Claudine J. Randazzo
Designed by David Jenney

35766558 6/07

PUBLISHER'S NOTE: This book expands upon a juried exhibition sponsored
by Grand Canyon Association. Any omissions are due to inaccessibility or
inability to gain permission for use of photographs. In some instances,
photographers or organizations controlling their work declined to participate.

We acknowledge with appreciation the contribution of camera equipment
from: Arizona Historical Society–Flagstaff, Cline Library–Northern Arizona
University Special Collections, Michael Collier, Richard Jackson, Robert
McDonald, and John Running.

FIRST IMPRESSION 2006
ISBN 10: 0-87358-894-0
ISBN 13: 978-0-87358-894-2

06 07 08 09 10 5 4 3 2 1

Library of Congress Cataloging-in-Publication data pending.

CONTENTS

I INTRODUCTION
The Psychology of Light

7 THE EARLY YEARS
Prospecting for Views [1871-1935]

27 THE MIDDLE YEARS
Icon of the Irreplaceable [1936-1975]

61 THE CONTEMPORARIES
Photographing the Mighty Stone Word [1976-2006]

205 NOTES

207 BIBLIOGRAPHY

209 INDEX

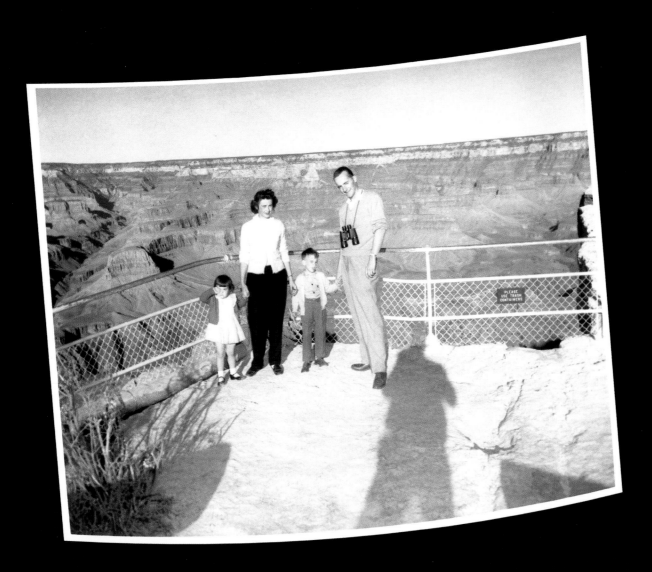

INTRODUCTION

The Psychology of Light

YEARS AGO, I watched a woman step up to the rim of the Grand Canyon for the first time. She arrived at Mather Point mid-morning on a clear summer's day. The Canyon had begun to warm and fill with haze hours before. Slowed by the blanket of heat, she walked up to the fence surrounding the overlook and took a Polaroid picture. She stood looking from the greenish snapshot with its tilted horizon back to the Canyon itself, back and forth, down to her picture, back to the real thing, bewildered.

As we all do, she carried an expectation with her, a reckoning of what this place should look like. Her "Grand Canyon" grew from twenty years of *Arizona Highways* arriving at her midwestern home, cover after glorious wraparound cover featuring rim views fired by shafts of sunrise light or richly colored stone temples framed by stunning late-afternoon clouds against an azure sky.

And now she was here. Her image, her dream of so many years, matched neither what she saw before her—this chasm of terrifying depth and austerity, its colors muted by smog and midday heat—nor the photo she had taken of the place. She turned and walked back to her car, heading toward the next "photo pullout" along the Rim Drive, earnest but perplexed.

☼

The dramatic images lodged in this woman's memory come from lifetimes of work by landscape photographers. The photographers do what this traveler could not take the time to do.

She will spend only a few minutes at each viewpoint. The photographers stake out their favorite spots on the rim, waiting for magic light, for hours. Sometimes for days.

The visitor comes and goes, as ephemeral as a flash flood. Photographers commit to the place. They hike every trail, pioneer backcountry routes, dream of going where no one has yet taken a photograph. They spend two weeks running the Colorado River through 280 miles of the Canyon, learning to row, running the river again and again, prospecting for new images.

[*OPPOSITE*]

*1956—The Purcell family standing on the rim of Grand
Canyon. Their arrival marked the one-millionth visitor
to the park since its inception in 1919.*

POLAROID LAND
CAMERA 700

While the photographers patiently lie in wait for sunset, the visitor will keep moving—*fast*—headed for Las Vegas, Disneyland, Yosemite, Yellowstone. The actual experience of the Grand Canyon will fade, but those issues of *Arizona Highways* will keep coming, and the coffee-table stack of large-format photo books about the Canyon will grow ever higher. Dreams colored by the work of Grand Canyon photographers will drift back like a Technicolor filter over the glancing reality of a single midday view of the Grand Canyon.

For more than 125 years, photographers have shaped our understanding of this place. The Canyon's remoteness and its *grandness* lend themselves to myth-making and to idealization. Its light inspires. The best photographs forge a bridge with three piers, a triangular relationship that connects the viewer to the place and the photographer. Such photographs have the power to carry the viewer into the waves in Lava Falls and to the brink of soul-stirring cliffs at Toroweap Point, in heat and stormlight, through the emotions and imaginations and craft of men and women with their cameras.

☼

The psychology of light fascinates Grand Canyon photographers. They speak of light as if it's animate. It comes to life. It dies.

They anticipate its moods. They dream of light.

Photographers are both awestruck and exhilarated by how *fleeting* the light can be. They may have only a few seconds to capture what they see. The light is flowing, surprising, fierce, evanescent, often getting away before it can be captured. It's Coyote Light, the trickster, always tempting you, always leading you on—frequently leading only to disappointment and yet sometimes delivering ecstatic moments of splendor, rewards that no one else sees—*unless...* Unless you get the timing and the technology exactly right and bring the Grand Canyon home in your pictures.

Next comes the ironic twist. When photographers succeed and capture that moment, the light that streamed through the clouds for only a few seconds then exists on film and paper for viewers to see for a long, long time. That's when it becomes "lasting light."

That's what stayed in the mind of the woman at Mather Point—these unforgettable photographs of Wallace Stegner's "lovely and terrible wilderness." For her, that's what will last.

☼

Lasting Light celebrates the stories of these photographers. This book began when three people who work with Grand Canyon photographers realized that the tales from the field were as compelling as the pictures themselves. Richard Jackson, at Hance Partners in Flagstaff, Arizona, has been making large custom prints for professional Grand Canyon photographers for years. Pamela Frazier of the Grand Canyon Association at Grand Canyon National Park and David Jenney at Northland Publishing in Flagstaff have been publishing those photographers. Moved by stories of commitment and patience, they decided to create an exhibit for the historic Kolb Studio on the South Rim and to publish this book.

In writing the text, I have had the pleasure of

interviewing twenty-one of the contemporary photographers—or the family and friends of those recently lost to us. I am a photographer, too, and so I add my own stories.

Long ago, I first ventured into the Grand Canyon one Thanksgiving as a college student from Colorado. My climbing buddies and I had fantasized about basking in warm sunshine at the bottom of Bright Angel Trail. Instead, the November Canyon was frigid, and after photographing sunset from the river, we decided to hike right back out that same day. We reached the rim at Bright Angel Lodge by moonlight—our quadriceps having turned to jelly. In the years since, as every other photographer who comes to the Grand Canyon, I've been humbled by the place and its checklist of challenges: vastness, remoteness, ruggedness—and on the river, the constant danger of water damage to equipment and the sickening sound of sandy grit in lenses and camera bodies.

In *Lasting Light,* I am revisiting people and places I hold dear. In the late 1970s and early '80s, I spent five years in Flagstaff, working for the Museum of Northern Arizona, editing *Plateau Magazine* and participating in research trips on the river in Grand Canyon. In my most profound Canyon experience, I journeyed downriver with musician Paul Winter when he recorded *Canyon*, his landmark album of "earth music." I listened and photographed while he played his soprano sax with the ravens and canyon wrens. I've talked with and photographed many Havasupai and Hualapai people for my books on Southwest Indians. And I've interviewed some of the Grand Canyon photographers in *Lasting Light* before,

in a 1980 portfolio issue of *Plateau* and in my 1986 book, *Blessed By Light: Visions of the Colorado Plateau.*

Landscape photographers come to the Grand Canyon daunted by its fame, knowing that they unfold their tripod legs where dozens of others before them have looked into the abyss of their viewfinders to search for a new perspective, a unique vision. They discover a multilayered place, with endless variations on light and composition and gesture. No two photographs of Granite Falls will be quite the same. No two afternoons at Lipan Point will be identical. And so the photographers tune themselves to nuance.

Photographers Alfredo Conde and Sherri Curtis try to capture their love for the Grand Canyon in their pictures, "that feeling," as Conde puts it, "that emotion, that spirit of the magnificent and instantaneous." The mood of the photographers changes. The Canyon's mood changes. The light changes. Constant movement tells a story—a story unreeling in light and time. Tom Till believes that his "most successful pictures have a narrative—a simple story that could be related in a short poem."

Lasting Light gathers these stories—the pictures themselves, with narratives for each viewer to imagine—and the tales behind the photographs, intimate moments from the lives of men and women in love with the crazy notion of bringing home in their pictures the light and space and rocks and river of the Grand Canyon.

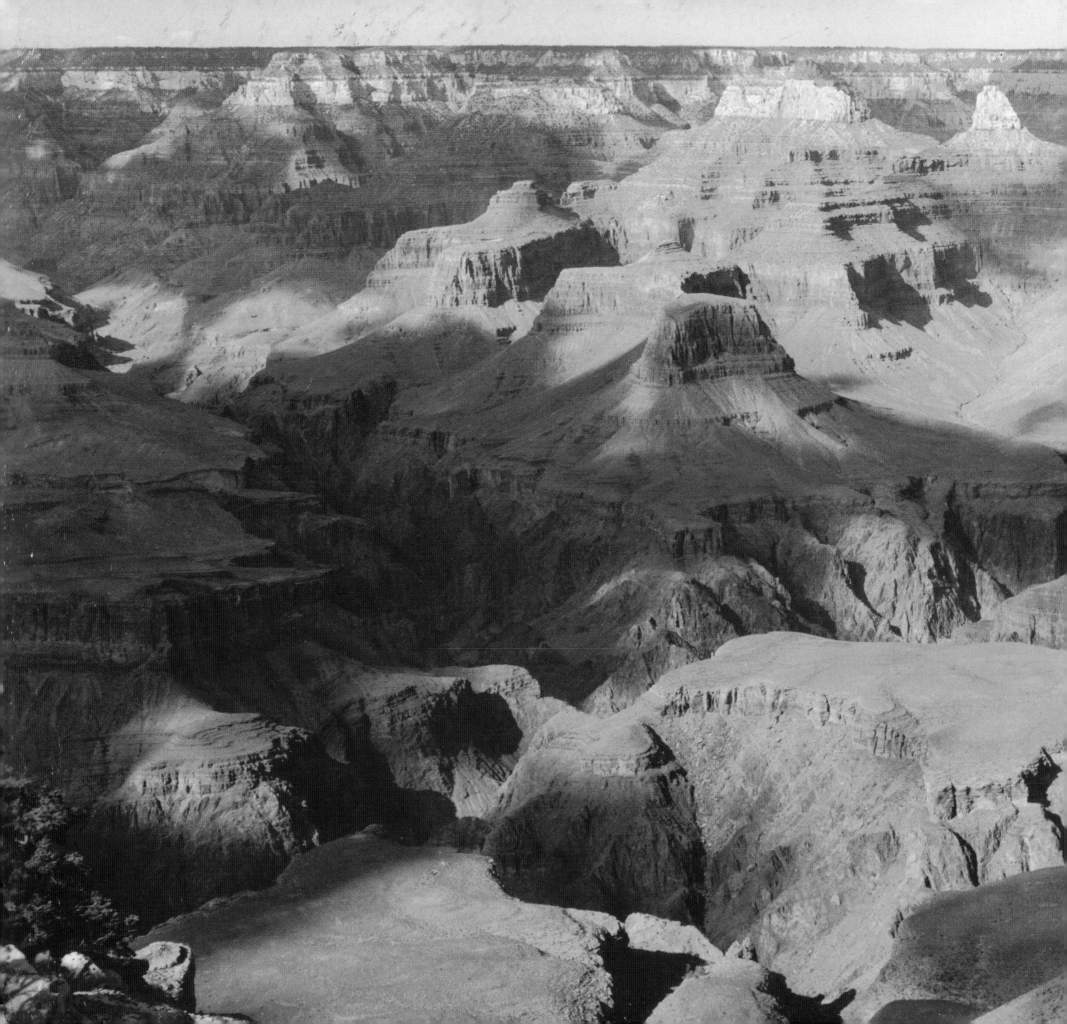

THE EARLY YEARS ~ *Prospecting for Views*

(1871-1935)

TIMOTHY O'SULLIVAN (1840-1882)
JACK HILLERS (1843-1925)
BEN WITTICK (1845-1903)
ROBERT B. STANTON (1846-1922)
JAMES FENNEMORE (1849-1941)
ELLSWORTH AND EMERY KOLB
(1876-1960 & 1881-1976)

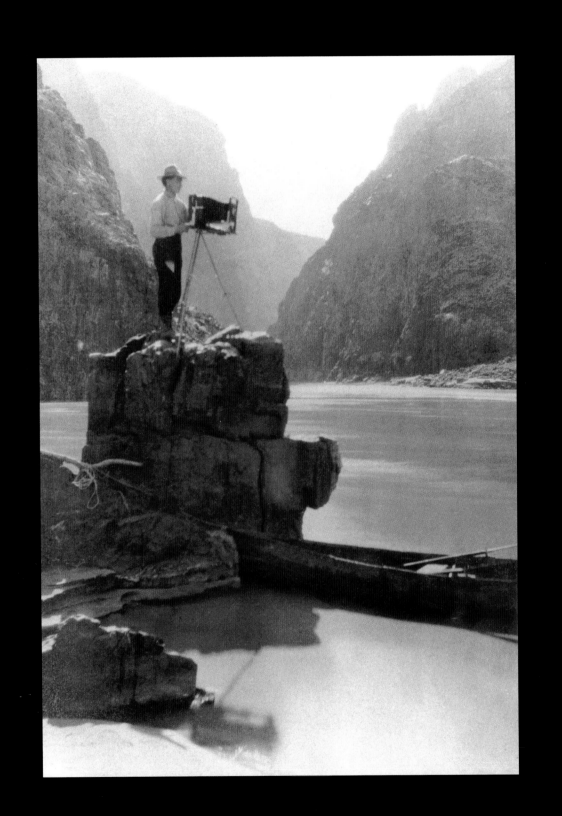

SENECA 8 x 10
VIEW CAMERA

REFLEX CAMERA
*c.*1897

BLAIR STEREO
HAWKEYE *c.*1905

R.B. GRAFLEX
*c.*1913

[*OPPOSITE*]

KOLB BROTHERS, 1914
(Courtesy of the Cline Library,
Northern Arizona University)

[*PAGES 4-5*]

KOLB BROTHERS, 1913
Man peering into Grand Canyon,
South Rim
(Courtesy of the Cline Library,
Northern Arizona University)

CONLEY 4 x 5
FOLDING CAMERA

"...the western survey photographs represented an alternative vision of America, not one fettered by the legacy of conflict, but one of boundless resources, unending wonders, and limitless possibilities. Through these pictures, countless Americans truly visualized the West for themselves for the very first time. And in these pictures, American photography itself seemed to discover its most distinctively national subject."

MARTHA SANDWEISS
Print the Legend: Photography and the American West, 2002

THE EARLY YEARS

Prospecting for Views (1871-1935)

NICÉPHORE NIÉPCE was stunned when he created the first photograph. An inventive visionary, he saw his 1827 picture as "really something magical." In the twenty-first century, photography retains its magic. We now carry digital cameras smaller than a chocolate bar to the remote reaches of the Grand Canyon and enjoy instant gratification when we look at the camera's screen to see what we've captured electronically.

In its early years, photography caught on quickly. Niépce partnered with Daguerre, and the daguerrotype followed—scattering millions of one-of-a-kind copper-plate portraits of everyday people across the world. In 1841, paper negatives allowed the making of many prints from a single negative. A decade later, in 1851, glass-plate negatives made the photographic process faster and more permanent—and Londoners who visited the famous Crystal Palace Exhibition that year strolled past seven hundred photos made by photographers from six countries.

Technology for making prints went through the same rapid evolution, with albumen prints—paper coated with egg white to create a smooth surface for sensitizing—serving as the standby for years. Albumen paper became so popular that the largest American producer went through sixty thousand eggs each day.

Those innovative glass negatives—"wet plates"—allowed exploring parties in the Grand Canyon in the 1850s and 1860s to bring along photographers. Geologists and mapmakers regarded photographs as one more scientific tool to level at the new land. And this new tool yielded results—photographic prints—that the scientists could take East to the Congress, to the Smithsonian, to dazzle their patrons and then lobby for more funding. The scientists—not the photographers—captioned the photographs in their reports. At the same time, the returning explorers brought inexpensive stereo views of the Grand Canyon to the parlors of everyday people, who had never dreamed of such a place.

In the remote West, American photography came into its own.

[7]

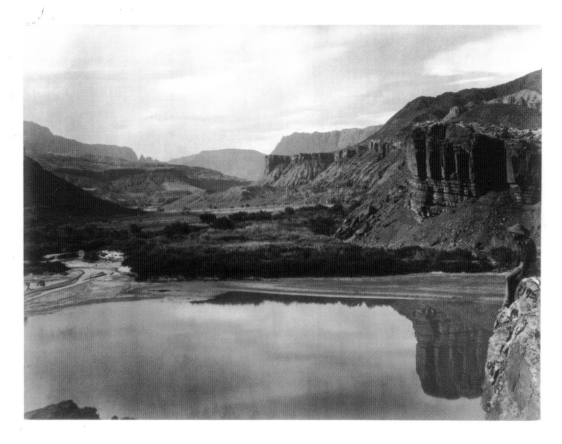

TIMOTHY H. O'SULLIVAN, 1873
Colorado River at mouth of Paria Creek
(Courtesy of the Library of Congress)

[OPPOSITE]

TIMOTHY H. O'SULLIVAN, 1871,
WHEELER EXPEDITION
Iceberg Cañon, Colorado River
(Courtesy of the Library of Congress)

Timothy O'Sullivan took the first photographs of the Grand Canyon in 1871, when the Wheeler Survey labored upstream into the lowermost Canyon. Lieutenant George Wheeler, in charge of the Army's geographical survey exploring the lower Canyon as a possible supply route, chose to haul boats two hundred miles up the river as far as Diamond Creek, relying on Mojave Indian men for muscle.

After working with famed photographer Matthew Brady during the Civil War, Timothy O'Sullivan came West for three field seasons with the Wheeler survey in the 1870s. At times roaming independently as the Colorado River expedition photographer, O'Sullivan even had his own crew and boat, the *Picture*. Sadly, most of O'Sullivan's Grand Canyon glass plates shattered in transport to Washington, D.C.

One hundred years later, critics unearthed his surviving pictures in archives and found them full of "boldness and economy," "modernity," and "natural grace." In short, independent works of art. Writer William Kittredge saw in O'Sullivan's Grand Canyon photos an artist "making sense of where we are, and why we live" in the West—a challenging homeland Kittredge called "the indifferent paradise." Photographer and writer Robert Adams judged O'Sullivan the greatest of the nineteenth century landscape photographers, "because he understood nature first as architecture...he was an artist/geologist, in love with light and rock."

To make a single photograph, O'Sullivan needed at least three-and-a-half hours, and five or six were better. The light-sensitive emulsion had to be wet when exposed and remain wet until development. This meant that the photographer needed to prepare his glass-plate negatives in the field, use them within an hour or so, and develop them shortly thereafter. *Collodion* was the base—a thick potion of "gun cotton" dissolved in alcohol and ether. It was sticky and explosive. That the photographers brought home any photographs at all was a miracle.

Photography critic John Szarkowski compared the wet-plate camera to a muzzle-loading rifle.

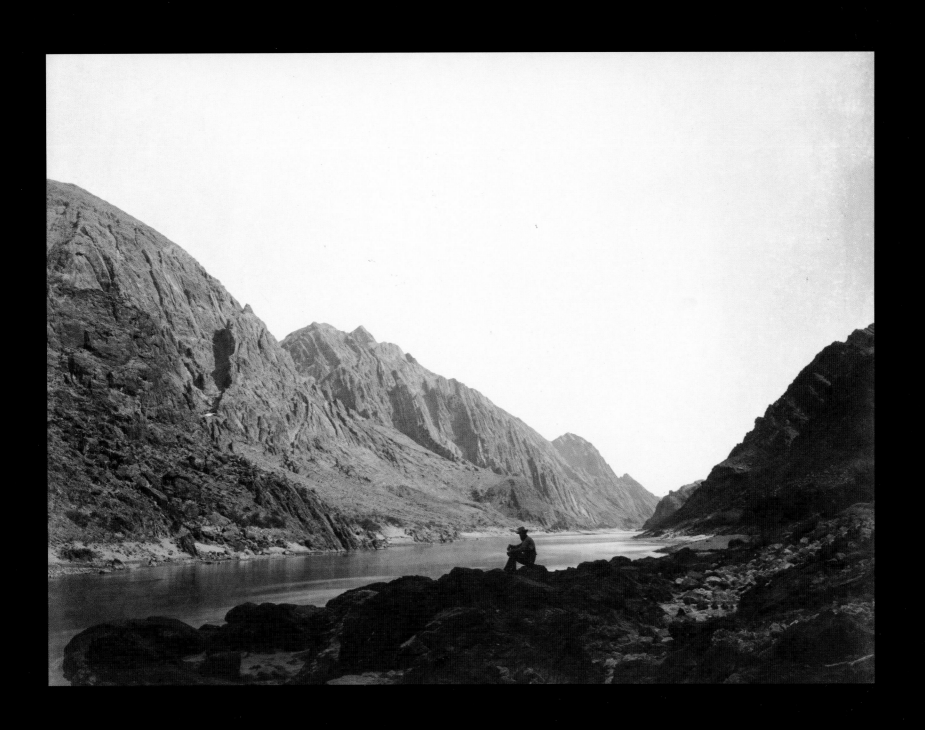

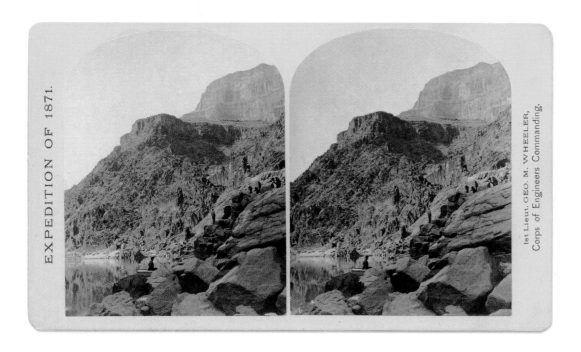

EXPEDITION OF 1871.

1st.Lieut. GEO. M. WHEELER,
Corps of Engineers Commanding.

TIMOTHY H. O'SULLIVAN, 1871,
WHEELER EXPEDITION
*Stereographic photograph—View of Grand
Canyon walls near mouth of Diamond
River (Courtesy of the Bancroft Library,
University of California, Berkeley)*

[OPPOSITE]
JAMES FENNEMORE, 1872
*John Hillers sitting on the ledge of
Grand Canyon
(Courtesy of the Library of Congress)*

"After taking one shot, the photographer was disarmed, until the machine was laboriously made ready again."

Here is what Timothy O'Sullivan did when he spotted a likely looking scene from his perch on the *Picture* in lower Grand Canyon in October 1871. His boat carried more than a ton of equipment for months in the field—glass plates, darkroom tent, cameras, and jugs of chemicals. He pulled in to shore and set up his dark tent and got to work. Robert Cahn, in *American Photographers and the National Parks*, describes his labors in detail. Even *reading* the list of tasks is exhausting!

When the desired scene was chosen and composed and the lens in the large camera focused, the photographer began an exacting series of chores. First he would take a perfect piece of glass that had been cut to specifications, clean the glass carefully with alcohol and flannel, remove any remaining particles with a soft brush, and from then on handle the glass in such a way that his fingers did not touch the surface. Then he had to coat it with collodion—that is, pour a little on the glass and tilt the glass this way and that until the sticky fluid had evenly covered the entire surface. After waiting for the collodion to set to just the right tacky consistency, he had to dip the plate (holding it carefully by the edge) in silver nitrate to sensitize it. About five minutes later, he would drain the plate, then put it in the holder, place the holder in the camera, and make the exposure of up to ten minutes. *Immediately* he would take the plate to a tent that served as a traveling field darkroom and apply a developing solution, again tilting the plate to spread the solution. Then he had to rinse the plate in water, and place it in hyposulphite to fix the image permanently. Next he had to rinse the plate again in clean water, then let it dry. Finally, he had to varnish the plate by the same tipping motion used in applying the collodion and the developing solution.

This, all in the most remote American wilderness, where dustless glass and clean water are forever rare.

While the Wheeler Survey turned around at Diamond Creek and O'Sullivan swept back downstream with his mostly doomed treasure of exposed glass plates, John Wesley Powell was just arriving at Lees Ferry on his second expedition down the Colorado River. Major Powell had begun in Green

River, Wyoming, in May, and reached upper Grand Canyon on October 26, 1871.

This wasn't the original one hundred-day adventure that Powell romanticized in his 1875 book, *The Exploration of the Colorado River and its Canyons*. This was the one-and-a-half-year working trip, with sufficient funding and personnel for many stops, side excursions, resupplies, and a photographer along to record the journey.

Jack Hillers begins his diaries of the 1871-1872 Powell survey as a boatman assisting the photographers—first E.O. Beaman and later, James Fennemore. Powell met the congenial young Hillers in Salt Lake City, where Hillers was working as a teamster. To the crew, he quickly became "Jolly Jack," beloved for his fine singing voice. He was a quick study and within months would replace the two professionals, eventually becoming a pioneer of American photography and the official photographer of the United States Geological Survey, serving until the end of the century.

Hillers learned by assisting, for there was simply too much gear for one person to handle efficiently. Two to four men assisted the photographer when he walked out from camp to make pictures. Hillers typically described these jaunts by listing the expedition members who accompanied Beaman to "carry the instruments," for a camera was an "instrument," as much as was a compass or barometer.

Hillers' journal of the voyage sounds like any river trip with enthusiastic photographers. A 10:00 a.m. start on August 15th: "The reason for not starting sooner was on account of Beaman taking pictures."

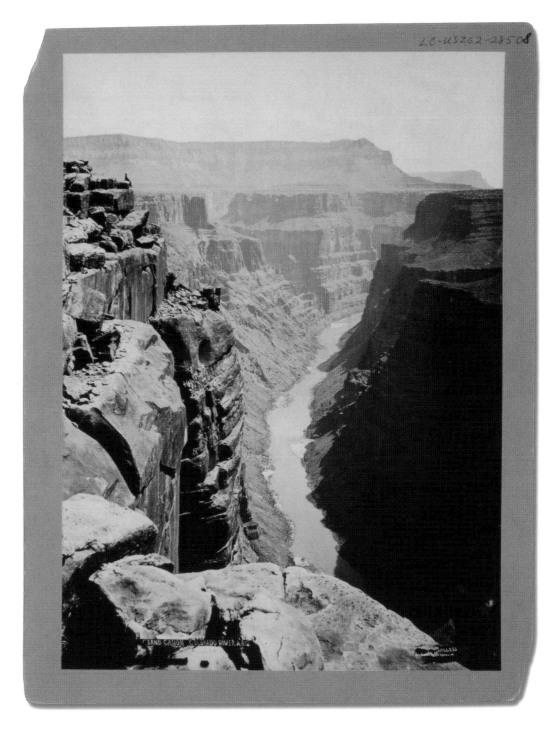

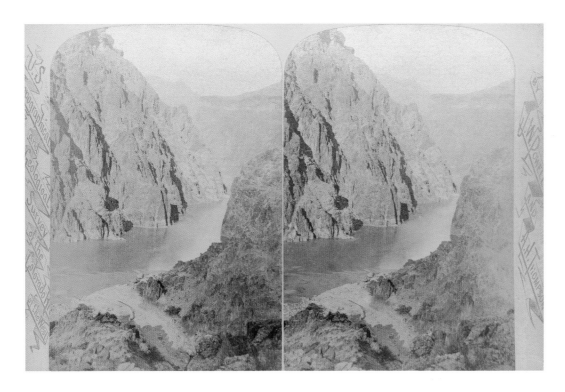

JOHN HILLERS, 1872,
UNITED STATES PHOTOGRAPHIC AND
GEOLOGIC SURVEY
Stereographic photograph—Colorado River
(Courtesy of the USGS Photographic
Library, photo #66)

August 11th: "Andy and myself got dinner while Beaman took pictures." August 8th: "Beaman saw some nice views so we stopped."

In October, when the Powell expedition pulled into Lees Ferry—pausing in their downstream run to winter in Kanab—Powell discharged Beaman. Both had assertive natures, and Beaman, the New Yorker, had tired of the Major who still delivered orders with the crisp certainty of an officer. Major Powell bought out the photographer's share of plates and equipment, but Beaman wasn't done with the Grand Canyon. He raced up to Salt Lake City for a new camera and returned to do independent work in Kanab Canyon and from the North Rim, scooping Powell before his men returned to the river.

When the Survey resumed in February, Powell wasn't quite ready to give Hillers full responsibility. Hillers became assistant photographer to Clem Powell, the Major's cousin, another amateur with much to learn. Hillers: "Tried to take some pictures but failed, bath being out of order—fixed it—while manipulating he upset it—so much for the first day."

The next couple of days in Hillers' journal chronicled more mishaps, but Clem and Jack improved quickly. March 7th: "Photographed all the best scenery." March 8th: "Took views wherever we could get them."

On March 19, James Fennemore turned up in camp from Salt Lake City; the Major had engaged another professional as lead photographer. Hillers reported that Clem Powell "felt blue because he had to turn the instruments over to Fen." Hillers and Fennemore ranged around the Arizona Strip, out to Toroweap, and down into the Canyon at Lava Falls, and in the next several months, across southern Utah.

By early August, however, the men realized that the frail Fennemore would not survive the downstream run through the Canyon, and they sent word to Major Powell. In mid-August 1872, they returned to the river without Fennemore, taking "only one photographic outfit," operated by Clem Powell and Jack Hillers. Their first batch of glass plates from Marble Canyon was ruined when the *Cañonita* took on water.

On September 3, "hellish big waves" swept both Jolly Jack Hillers and Major Powell into a whirlpool. Both survived. They righted the boat, bailed, and "landed on the right side at the head of another huge monster. Had dinner, made two pictures. Pulled

out into it, made it all right." Just six days later, concerned about big water and leaky boats, the Major announced that they would end their river journey—their "voyage of toil and danger"—with hopes to continue the survey from the rim. The water was much higher than it had been in 1869, and the Major felt that staying on the river would not yield sufficient science to warrant risking the lives of his men.

Clem Powell and Jack Hillers had their orders—to work up and out the side canyon of Kanab Creek, photographing along the way. September 12th: "Made a picture whenever we found good light on it and sometimes would wait for light. Got up about a mile." The next day: "waited a long time for light—the sun only peeps down into the cañon about half an hour, but as the cañon changes directions every quarter of a mile, we got good light often."

Upon leaving the Canyon, Jack Hillers followed Major Powell into new subject areas, taking pioneering pictures of Shivwits Paiute and Zuni Pueblo people. After Hillers' death in 1925, the United States Geological Survey destroyed many of his plates (and some of Beaman's) to free up storage space, though good archival prints of his priceless historic images survived.

Powell's understanding of the Grand Canyon as a landscape was forged on the river, through mile-by-mile challenges and his scientist's eye. It took years for him to comprehend the "sublime spectacle" of views from the rim. A 1909 Fred Harvey guide titled *Doing the Grand Canyon* got it right; the author peered over the low wall at the precipice outside his room at El Tovar. Beyond, "there is nothing. It is as though the wall marked the end of the world and the beginning of infinity."

The Major's colleagues helped him. In *How the Canyon Became Grand*, Stephen Pyne reminds us that Powell came to see the Grand Canyon through the eyes of his geologist protégés from the 1880s, Clarence Dutton and W.H. Holmes. We still do.

Dutton's great *Tertiary History of the Grand Canyon* articulated the visual identity of the Canyon forevermore. It contained Jack Hillers' photographs, to be sure. But it was Dutton's eloquent prose that succeeded in communicating the overwhelming views from the rim along with the elegantly detailed stratigraphic panoramas drawn by Holmes that gave us our "aesthetics of erosion," in Pyne's words.

☼

Photographers have always loved new gear—they are a nerdy bunch in that way—and the next photographer down the Grand Canyon was just such a technical and careful man, befitting his engineer's soul: Robert Brewster Stanton.

Stanton worked for entrepreneur Frank Brown, who had a dream: to survey the Colorado River for a railroad that would run through hundreds of miles of canyons just above water level, beginning at Grand Junction, Colorado, and leaving the lower Colorado above Yuma, Arizona. Brown hired Stanton as chief engineer and pushed his men onto the water at Green River, Utah, in May of 1889, poorly prepared and without life jackets. The expedition photographer, Franklin Nims, a gallery professional from Colorado, had few chances to document the route as Brown

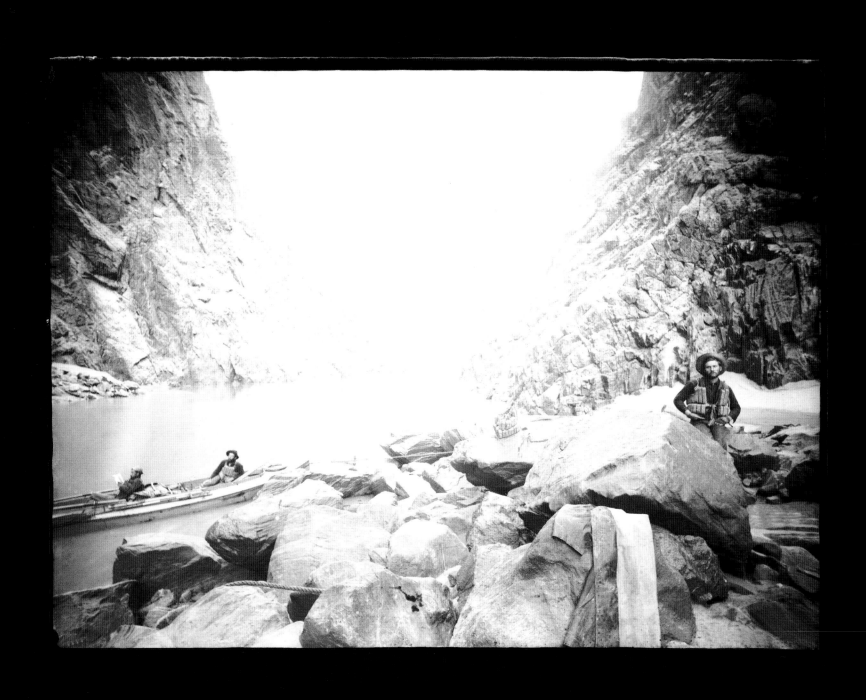

hurried the men downstream. The river was unforgiving of their haste. Brown drowned in a Marble Canyon riffle. Two more men drowned in Twentyfive Mile Rapid just five days later.

Stanton left the river at South Canyon. But he now believed in Brown's railroad. He planned a return—with stronger boats and appropriate equipment—and relaunched at the head of Glen Canyon in December.

Photographs were the key to Stanton's trip, and he brought Franklin Nims with him once again. The expedition stopped at every bend of the river, shooting upstream and downstream views to document the railroad line for potential investors. Nims worked his way through Glen Canyon and past Lees Ferry, where the group stopped for Christmas dinner. On New Year's Day, 1890, clambering after the perfect perch for a photograph, Nims tumbled off a ledge, falling twenty-two feet. Stanton evacuated the semiconscious photographer up and out of the Canyon and back to Lees Ferry. The trip leader decided to take on the role of expedition photographer himself.

Stanton wrote: "I had never adjusted a camera, had never seen the inside of a roll-holder. How did the thing work anyway?" Nims' exposure records looked like "so much Choctaw." As he began to fiddle with the controls, "every moment I became more excited and worried...I hesitated, dashed my hat upon the ground, and tore my hair in desperation at the complicated state of affairs."

The cook took a snapshot of Stanton in this state of apoplexy, but the picture, alas, does not survive.

But Stanton learned. And the Canyon seduced him. He carefully documented his railroad by camera, shooting eleven hundred views of the route, many in duplicate and triplicate, but he also began to notice and shoot "scenery." His journal grew more descriptive. He was becoming a riverman and a photographer as well as an engineer and railroad man.

Along the way, Stanton became a perceptive critic of Grand Canyon art. Although Stanton was willing to admit that the great Thomas Moran's "Grand Chasm of the Colorado" was a masterpiece, it didn't quite capture the Canyon for him. The painting "does not move. It is quiet. It is still. The Grand Canyon is never still, it is never quiet. It is a living, moving being, ever changing in form and color... How can such a shifting, animated glory be caught and held on canvas?" Indeed. And how can it be held and focused through a lens and frozen onto a photographic emulsion?

Robert Brewster Stanton used roll film—a first in the Canyon—in his 6 1/2" x 8 1/2" Scovill and Adams camera. Roll film meant no glass, no breakage, more pictures—and the luxury of developing at the end of the trip. On the second expedition, flexible transparent celluloid film was available for the first time, but Nims and Stanton didn't quite trust it, and made duplicate views at most camera stations with two of George Eastman's products, the newfangled celluloid film along with paper-backed "American film" that would require stripping and transfer to glass plates before printing.

[*OPPOSITE*]

ROBERT B. STANTON, 1890, RAILROAD SURVEY EXPEDITION *Near river mile 89, pictured left to right: John Hislop (assistant engineer), Elmer Kane, and Langdon Gibson (Courtesy of the National Archives and Records Administration, photo #441)*

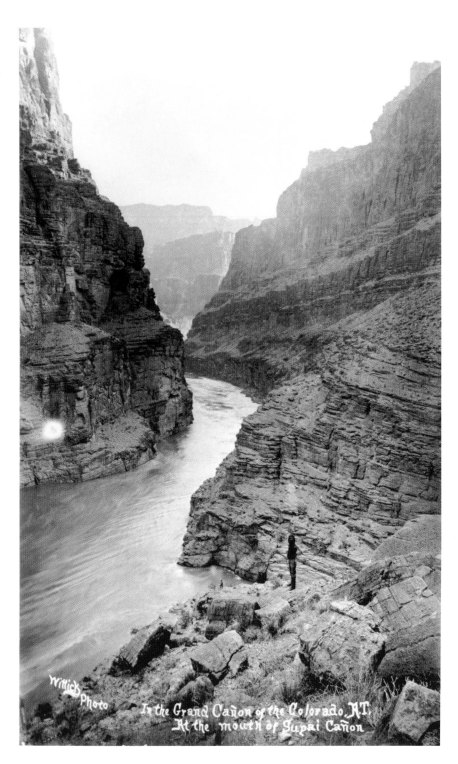

Wittick Photo

In the Grand Cañon of the Colorado, A.T.
At the mouth of Supai Cañon

As he accumulated exposed rolls, Stanton soldered the precious cargo into waterproof tin boxes and stashed duplicate rolls on different boats. Remarkably, nearly all survived the trip, and ninety percent of his exposures were usable. His pictures from the lower Colorado below Needles did not fare so well. He never adapted to the desert glare, "the bright sunlight of open country," and all these photos were overexposed.

Stanton's Grand Canyon railroad was never built. He transferred his obsessive thoroughness to writing, laboring away at a thousand-page history of the Colorado River that was eventually published in fragments years after his death. His photographs weren't as widely renowned as they should have been. Robert Webb has done much to reverse this with his rephotography work and his 1996 book, *Grand Canyon, a Century of Change: Rephotography of the 1889-1890 Stanton Expedition.*

☼

Tourists began to replace explorers when the railroad reached across northern Arizona in the early 1880s. Vacationing travelers began riding stages up to the South Rim from Flagstaff and wagons from Peach Springs down to the river at Diamond Creek. These new tourist businesses generated promoters. And promoters need pictures.

Pioneering southwestern photographer Ben Wittick came with his son to Diamond Creek in 1883. In the 1890s, entrepreneur W.W. Bass used an old glass-plate camera for the lantern slide shows he presented in the East to lure tourists to Bass Camp, where he maintained his darkroom in a small

cave. Pioneer western photographer William Henry Jackson photographed for the Santa Fe Railway; George Wharton James came through, periodically updating his popular Grand Canyon guidebooks.

After 1880, George Eastman's marketing genius transformed the market, and dry-plate technology brought revolutionary improvements to photography in a cascade. Though dry-plates were less cumbersome than glass, professionals like Jackson were still working with view cameras and tripods, composing carefully on the ground-glass of their viewfinder before they stepped back and made their exposure. Their inheritors, the large-format photographers of today, still do the same in the stunning spaces of the American West.

But hand-held cameras debuted in 1883, encouraging the photographer to take chances, to follow moving subjects, to keep shooting even though only one frame might be *the one*. The notion of cropping revolutionized composition. Amateurs shifted from the "art" of large-format glass-plate contact-print photography to the new and easy world of George Eastman.

Eastman created the Kodak camera in 1888—the magic box filled with one hundred ready-to-expose frames. Eastman's processing plants were soon busy processing film and reloading cameras for the world. Tourists with cameras began to line up at sunrise on the South Rim. Their great-grandchildren perch there today.

Eastman's first cameras were a significant investment. Not until the Brownie debuted in 1900 did photography become affordable for nearly everyone

eager to record family trips to the Grand Canyon.

The turn of the twentieth century brought the railroad right to Grand Canyon Village, and tourists came just to *see* the place, to revel in this American wonder. Historian Hal Rothman believes the Grand Canyon embodied the American identity, and tourists wanted pictures of themselves partaking of their personal and national cosmology: "Here was the entire package, a place the people of the time regarded as God's handiwork that reflected what Americans wanted themselves and their nation to be. It offered assurance and wonder, power and humility intertwined; it became the icon of the moment that explained Americans' complicated relationship with the land they possessed."

Travelers came with their Box Brownies, and the pictures returned to them from the Kodak plants were contact prints—tiny when compared to the big prints from monstrous glass plates a generation before. Not until the 1920s would enlargers with electric illumination become common—the same decade that most American homes acquired electricity.

Kodak Brownie camera, first mass-market camera to be produced, pictured left to right: #4 Bulls-eye, Art Deco Face, and Target Six-20

[OPPOSITE]
BEN WITTICK, 1883
Mouth of Supai Canyon, Havasu Canyon (Courtesy of Palace of the Governors, #16099)

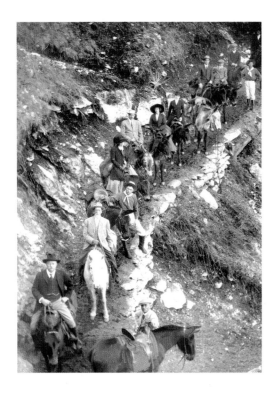

KOLB BROTHERS, 1903
President Theodore Roosevelt, lower left,
on a mule train (Courtesy of the Cline
Library, Northern Arizona University)

[*OPPOSITE*]

Emery and Ellsworth Kolb going to
extremes to get their photograph
(Courtesy of the Cline Library, Northern
Arizona University)

As in so many moments in the history of photography at Grand Canyon, notable cultural and transportation milestones paired with advances in photography. Roll film appeared just as Stanton set out to survey the canyons of the Colorado. Then the railroad and the inexpensive Brownie camera arrived at Grand Canyon within a year of each other. Each such convergence made history.

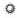

Ellsworth and Emery Kolb made their own history. Ellsworth was first, moving West with the new century, looking for adventure, arriving on one of the first trains to the South Rim in 1901. His brother, five years his junior, followed the next year. Emery brought his camera from Pennsylvania, and by the time he reached the Canyon, he had learned that a photographic studio was for sale in nearby Williams. The Kolbs bought the equipment for $425, perched their operation in a tent at the head of Bright Angel Trail in 1903, and the Kolb Studio opened for business.

Their mainstay was the head-of-the-trail picture. By 1905, a studio building replaced their tent, with a 5x7 view camera positioned permanently at a west-end window. From this aerie, they shot photos of tourists perched on muleback just as the riders headed into the Canyon. Emery then ran past them down the trail for more than four miles to the nearest water at Indian Garden, processed his glass plates and made proof prints, took orders from the riders, then headed back to the rim to arrive by the afternoon and collect money from saddle-sore tourists on the returning mule train.

The posed line of riders became an icon of the Canyon. Every Grand Canyon history book includes a Kolb trail shot, often featuring celebrity visitors: Theodore Roosevelt or John Muir or Frederick Remington. Most every American family with a footloose ancestor has a worn 5x7 contact print of a relative headed down Bright Angel, with Emery's scrawled date and frame number in the corner. Our own version features my wife's father and uncle visiting from Boston, wearing suits, neckties, and wool overcoats, ready to negotiate the snowy trail along with the flapper-hatted young women and bearded oldtimers in their mule train. The Kolbs' notation reads, "Dec. 19, 1928, #18."

Trail shots brought dependable income—but not enough. The Kolbs began exploring, looking for the unusual and startling marketable scene. They took the first views of Havasu Falls in 1907. Photos of the two men dangling from ropes and straddling chasms became iconic images in Canyon folklore. Hand-tinted albums of their photographs became a staple at their shop.

But it was their 1911 river trip that made them national figures. The brothers' retracing of Powell's voyage down the Colorado created an archive of still photographs and the first motion pictures of river-running in the Grand Canyon. The adventure provided Ellsworth with the material for his 1914 book, *Through the Grand Canyon from Wyoming to Mexico. National Geographic* devoted eighty-five pages to the journey. Emery toured the lecture halls of the East.

Others had photographed the river since Stanton.

Bert Loper and Charles Russell tried and failed to bring back an archive of salable photos on a 1907 run. Raymond Cogswell kept rich notes to bring to life his black-and-white pictures on the first true vacation trip through the Canyon, led by Julius Stone in 1909. The Kolbs spoke with these men, learned from them, and then made their successful run.

Ellsworth was daring to the point of foolhardy; Emery could match him in fierceness but was happy to be primary photographer on shore as Ellsworth ran rapids that Emery preferred to line. Such powerful personalities couldn't coexist peacefully. The brothers separated in 1913 and flipped a coin for ownership of the studio. Emery won, Ellsworth moved away, and Emery operated the studio for sixty years more. His wife and a series of assistants became his partners, and it was Emery whose eccentricities yielded three-quarters of a century worth of stories.

The Kolbs were the first adventure photographers—using nineteenth century equipment but marketing themselves as *personalities*. They were "daring." They performed "exploits." And they brought back land-scape photographs and stories to share with us from the Colorado River wilderness.

Every day, Emery photographed the mule trains. And every day, he projected his movies from the "big trip" down the river back in 1911. Millions of people saw the film and heard Emery introduce it. With Ellsworth gone off to California, Emery fought with the Fred Harvey company for business. He fought with the US Forest Service and, later, the National Park Service, over permits, and he fought with employers who hired him as guide. He drove

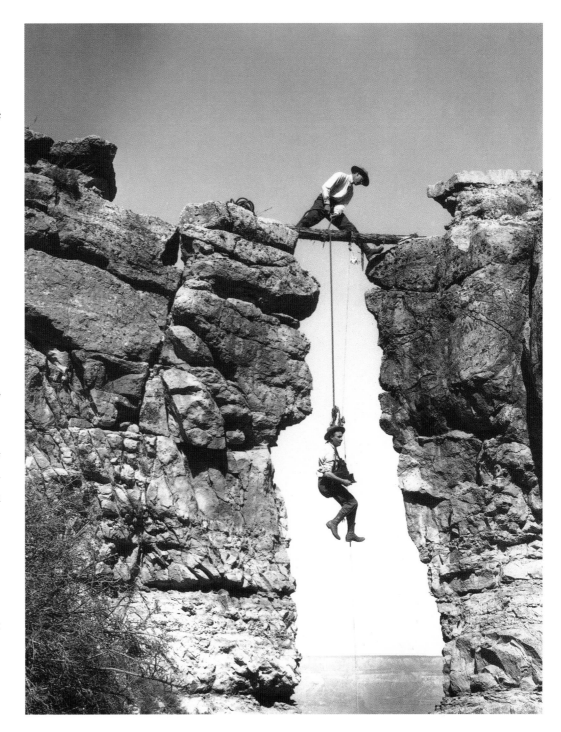

EMERY KOLB, 1913
*Ellsworth Kolb traversing the wall
four hundred feet above the mine at
Hummingbird Trail (Courtesy of the
Library of Congress)*

[RIGHT] *Kolb Brothers' Graflex Camera*

[OPPOSITE]
*Ellsworth, Blanche, and Emery Kolb at
Studio, 1904 (Courtesy of the Cline
Library, Northern Arizona University)*

too fast and never adapted to modern photographic technology. By the time Emery died in 1976, at the age of ninety-five, the Kolbs had photographed more than three million Grand Canyon visitors.

☼

The Kolb photographs helped make the Grand Canyon the first great tourist destination in the West. Emery Kolb was the eccentric artist living in a homemade studio hanging from the edge of the Canyon, a "character" for the high-end tourists staying at the El Tovar hotel to observe.

At the same time, he was helping to democratize the Grand Canyon experience. The Kolbs came to the Canyon as the floodgates opened on a century of photographs in print and in albums on family bookshelves. The Kolbs photographed for the marketplace, not for science. Their prints went to homes, not to archives. The snapshots of every tourist are the offspring of Ellsworth and Emery's photos of visitors perched on their mules, headed down Bright Angel Trail.

With the turn of the century, halftone printing allowed huge press runs of photographs combined with type for the first time. *National Geographic* published its first halftone photos in 1905. By World War I, magazines ran many photographs, with quickly improving reproduction values.

In the twenties, tourists began to come to the Canyon in much larger numbers, spluttering to a stop in their Model-Ts, camping on the rim, taking control of their own experiences—creating their own photographs while still buying hand-tinted Kolbs and mass-produced post cards. Magazine and travel photographers came to the Canyon with their giant single-lens-reflex Graflexes, which allowed them to see the image right-side up until the moment they clicked the shutter—allowing for bolder composition. Charles Lummis inherited the role of literary guide, promoter, and raconteur-in-print, and his 1925 book, *Mesa, Cañon, and Pueblo* included his photographs of Grand Canyon.

The large-format landscape tradition moved away from the gauzy pictorialists and into the modern era with Ansel Adams' and Edward Weston's crystalline black-and-white prints of the 1930s. Though Adams didn't photograph much at the Grand Canyon, his pairing of conservation activism with photography— lobbying effectively with the Sierra Club for California's Kings Canyon National Park— would influence the conservationist photographers who followed him to wild places, including Grand Canyon.

National Geographic published hand-tinted photographs in the twenties and early thirties. Color photographs could be made with expensive film and cumbersome processes. But everything was about to change, and George Eastman's company was going to change it.

Just three years after the death of Eastman himself, Kodak

introduced the first inexpensive fine-grained color film, Kodachrome—in 1935, for 16 mm movies, and the next year, for 35 mm slides.

The photographers for the nineteenth century exploring expeditions had attempted to capture the *ideas* of the geologists in their grand panoramas. O'Sullivan and William Bell for the Wheeler Survey, Beaman, Fennemore, and Hillers for the Powell Survey—all came to their photographic work as illustrators for the cause of science.

Travelers simply wanted to bring back souvenirs of where they had been. They came to the Grand Canyon and were stunned by its colors. When Kodachrome allowed for affordable, easy color photography, amateurs adopted it enthusiastically. Why not? The Grand Canyon was a place of texture and hue, and the new slide film yielded pictures that might capture not just the texture available from a black-and-white print but those gorgeous, indescribable hues, as well—all brought home to project on the screen stored in the hall closet.

Another confluence brought the colors of the Grand Canyon to the world. A prosaic state transportation magazine had started publication in Arizona in 1925. In 1938, the team of Raymond Carlson, editor, and George Avey, art director, took over at the little journal. In 1940, they ran their first color cover. These editors would serve for more than thirty years and transform *Arizona Highways*—and the world's image of the Grand Canyon—along the way.

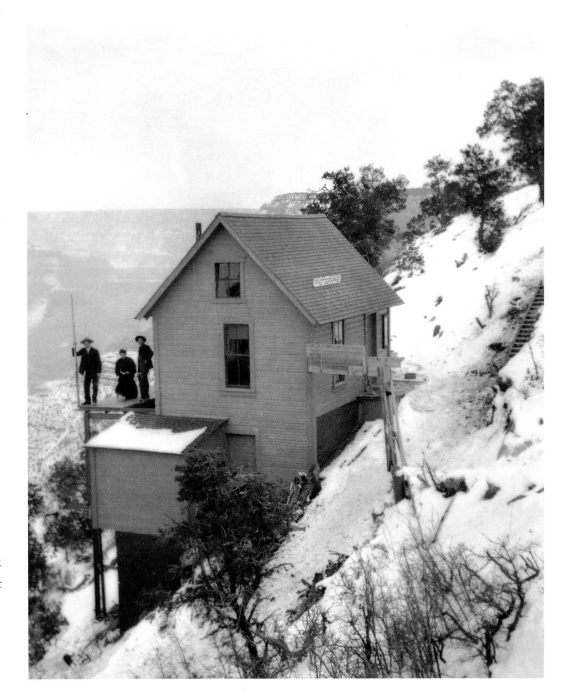

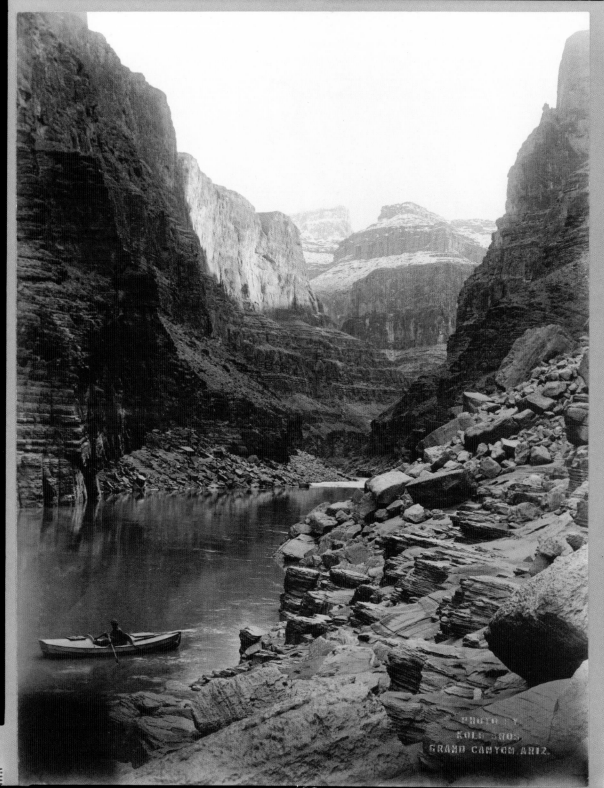

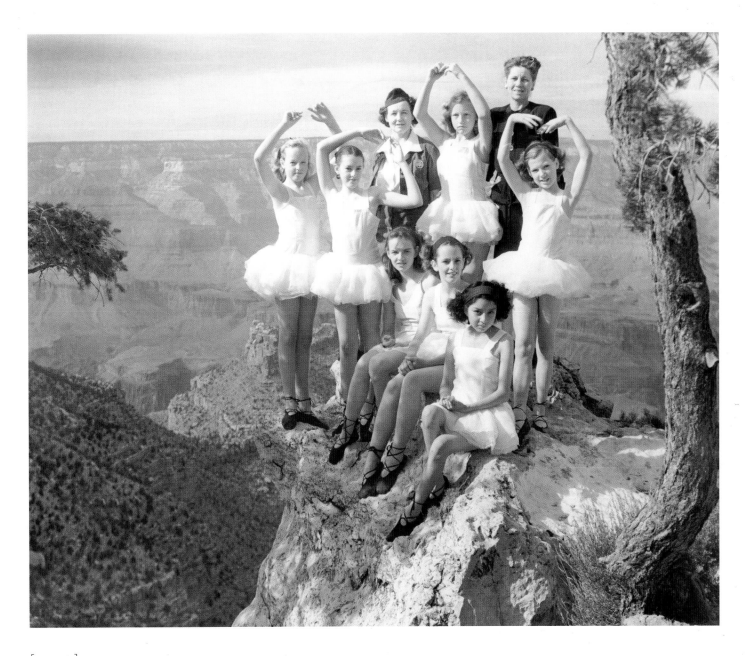

[*OPPOSITE*]

KOLB BROTHERS, 1913
Man in boat at Sockdolager Rapid
(Courtesy of the Library of Congress)

Ballerinas on the South Rim
(Courtesy of the Cline Library,
Northern Arizona University)

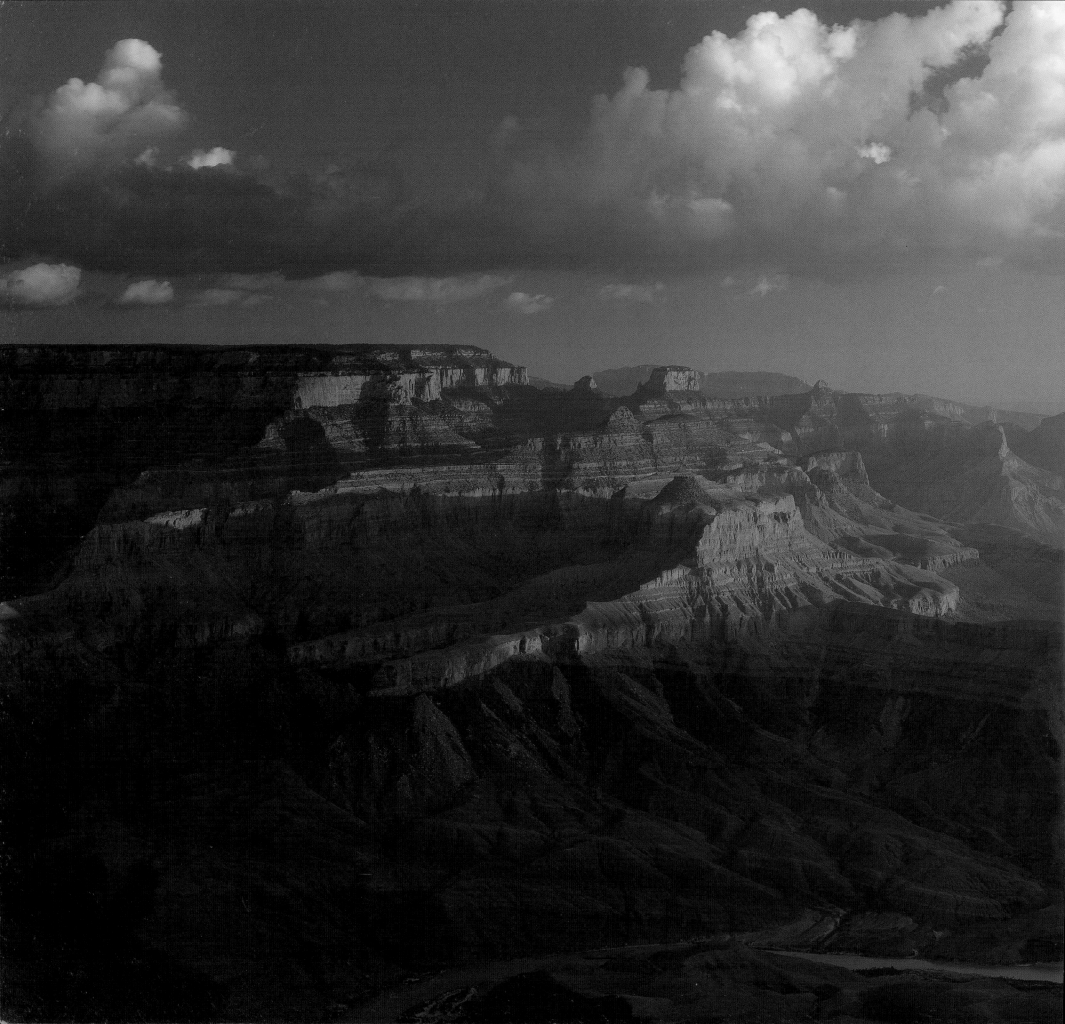

THE MIDDLE YEARS~*Icon of the Irreplaceable*

(1936-1975)

ELIOT PORTER (1901-1990)
ANSEL ADAMS (1902-1984)
JOSEF MUENCH (1904-1998)
ERNST HAAS (1921-1986)
PHILIP HYDE (1921-2006)
BOB CLEMENZ (1926-2003)
DICK DIETRICH (1927-1998)
DAVID MUENCH (B. 1936)

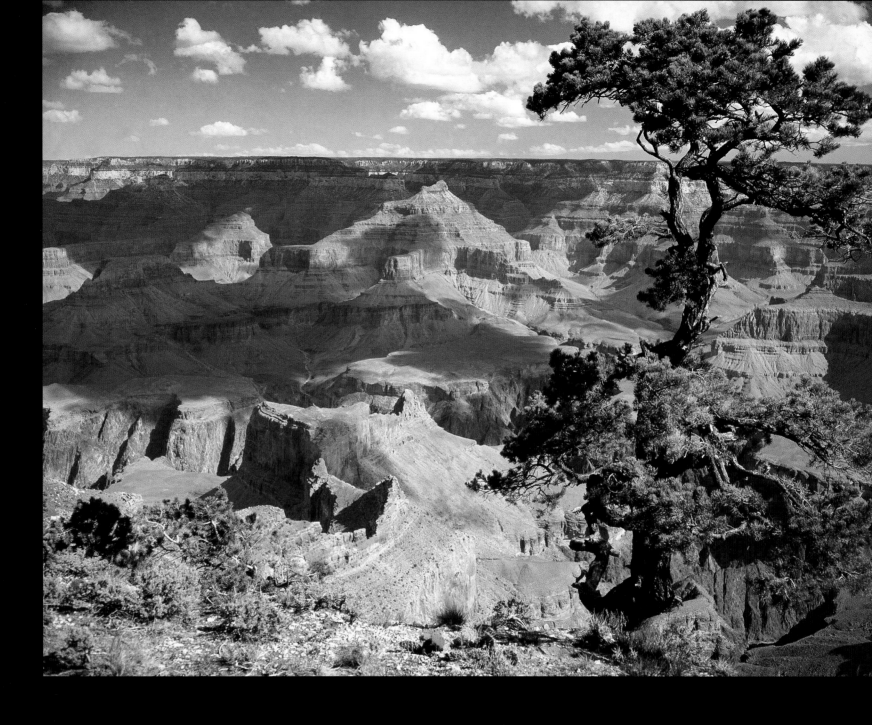

CROWN GRAPHIC
PRESS CAMERA
c.1948

ROLLEIFLEX
c.1952

HASSELBLAD 500C
c.1957

LEICA M2
c.1957

NIKON F
c.1959

[*OPPOSITE*]

JOSEF MUENCH
South Rim
(Courtesy of the Cline Library,
Northern Arizona University)

[*PAGES 24-25*]

BOB CLEMENZ
The Colorado River shimmers in
sunrise shadows from Lipan Point

"Not only have millions of American families traveled to the parks yearly for enjoyment, but generations of artists have done so as well, and what they have taken away with them when they left has become part of the 'American' in American art."

ROBERT GLENN KETCHUM
American Photographers and the National Parks, 1981

THE MIDDLE YEARS

Icon of the Irreplaceable (1936-1975)

THE PURPOSE OF *Arizona Highways* magazine was to show the world what Arizona and its Grand Canyon really looked like. Arizona's state officials wanted to lure visitors—not awe readers with the artistry of the photographers. And so, Editor Raymond Carlson became a convert to color—"to faithfully portray" the canyons and mountains and deserts.

In the early days, Carlson and Art Director George Avey reviewed photos and held onto the likely prospects, promising a $5.00 reproduction fee to the submitting photographer every time a file image made it onto the printed page. Color began appearing inside the magazine in 1939, and in 1946, the December issue was the first nationally circulated magazine to print all photos in color. *Arizona Highways* became synonymous with quality color printing and splashy landscape photography—and a powerful force in shaping public awareness of the Grand Canyon in the second half of the twentieth century.

Of course, photographic style changed in those decades. Josef Muench set the standard at the beginning. First published in *Arizona Highways* in 1938, his credit line turned up more often than any other for the next fifty years. Based in California, he counted two hundred photography trips to the Grand Canyon before his death in 1998, at age ninety-four. By the 1960s, his son, David, was taking his place. The 1969 special issue celebrating the centennial of John Wesley Powell's run through the Grand Canyon featured mostly David Muench photographs. A third-generation Muench, Marc, has grown up to be a professional landscape photographer, as well, working both in large-format and digital.

Josef Muench and his contemporaries, Ray Manley, Carlos Elmer, Esther Henderson, Darwin van Campen, and Barry Goldwater (a river-runner and photographer before he

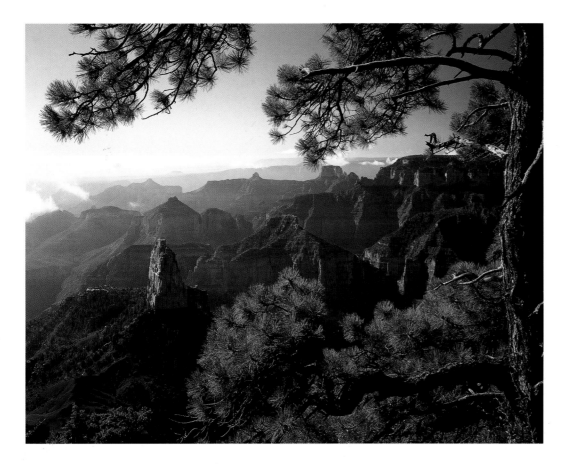

BOB CLEMENZ
Ponderosa pine needles frame Mount Hayden
and traces of monsoon clouds at Imperial Point

[*OPPOSITE*]

DAVID MUENCH
Zoroaster and Brahma Temples, South Rim

became a politician), photographed the Grand Canyon in the fifties a bit like Walt Disney photographed wildlife and the "Living Desert." The complacency of the times led to straight-ahead scenic photography—respectful and even reverential toward the landscape. The Grand Canyon bound into each new issue of *Arizona Highways* was a wild place domesticated by its capture in the magazine, organized into comfortable predictability by its arrival every month in suburban mailboxes, smoothed into a generic "magnificent landscape" by hokey captions.

Grand Canyon photographers who came just a bit later, such as Bob Clemenz and Dick Dietrich (best friends in the last twenty years of their lives), held to this conservative stance. Lots of pictures from the rim. Lots of brilliant blue skies. If the composition includes clouds, they run toward billowing and puffy rather than stormy and moody.

These photographers had no agenda other than immersing themselves in the beauty of the land—with a yearning to capture and share it. They weren't striving to be Ansel Adams or Eliot Porter and make art; they hadn't dedicated their work to conservation, as Philip Hyde chose to do; they didn't have the burning creative spark of Ernst Haas. Ferde Grofé's *Grand Canyon Suite* makes a good soundtrack for both the classic Disney mule train footage in the 1958 Oscar-winning short, "Grand Canyon," and for *Arizona Highways* photos of the time.

The modest Dick Dietrich, a lanky transplant from Maine who settled in Phoenix in 1950, serves as a gentle model for the era. He made his living with his 8x10 view camera, shooting landscape all over the country, acting as patient teacher to his daughter, Dianne Dietrich Leis, giving her a first Deardorff view camera when she was eighteen. In her eulogy to her father when he died in 1998, she remembered his endless patience, his sharing "the language of pictures" with her, his love of "God's pyrotechnics"—lightning over the Grand Canyon.

In contrast, David Muench came of age in the sixties. Times were changing. His photographs had a breathlessness—a sense of drama created by looming foregrounds, sunbursts, moods, and storms.

Human figures do not often stand in the corners of his photos for scale. Scale is subverted by the wide-angle exaggeration of rocks, flowers, and textured snags confronting the viewer up close. Muench seeks to wow us—and frequently does. In the seventies, he set out to photograph not just the light but the sun itself, and *Arizona Highways* happily published the resulting portfolio of silhouettes and sunbursts and light-struck leaves.

He is strongly present in the photographs; we know these are David Muench images—that monumental foreground captured by carefully positioned tilts and swings on his 4x5 camera, stopped down for sharp focus, bold sunrise and sunset light maximizing the saturation of the transparency.

David Muench shared Ansel Adams' theatricality, his celebration of the extraordinary. But Muench's preference for color made his pictures more like solo arias than the intense chamber music of a severe black-and-white Adams. Ansel Adams contributed to *Arizona Highways*—sometimes in color, more often with portfolios of classic black-and-white, frequently in collaboration with his favorite writer/partner, Nancy Newhall. Adams raised the stakes for the magazine in terms of emotional content. Muench continued the game.

☼

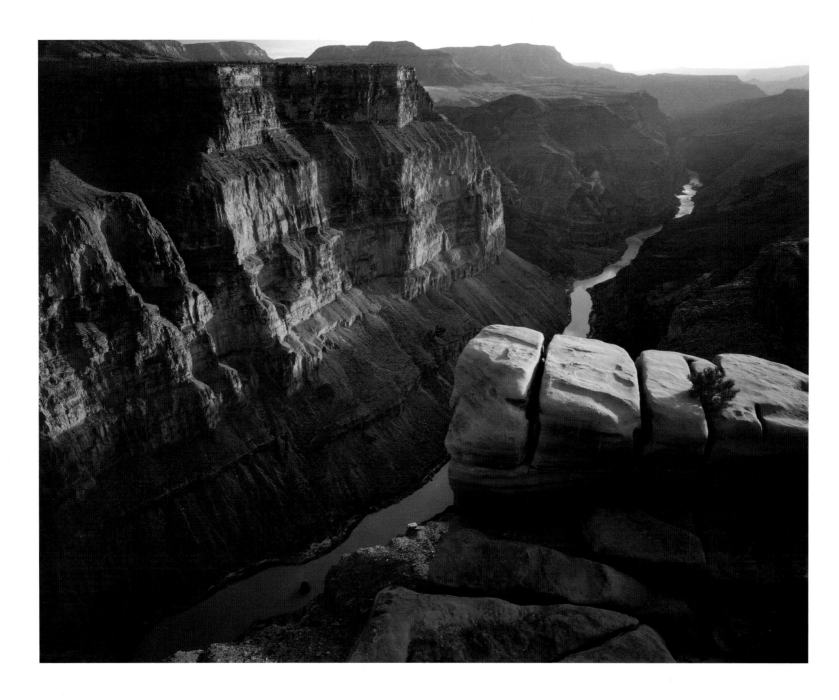

DAVID MUENCH

Toroweap West, Colorado River

[*OPPOSITE*]

Limestone window, South Rim

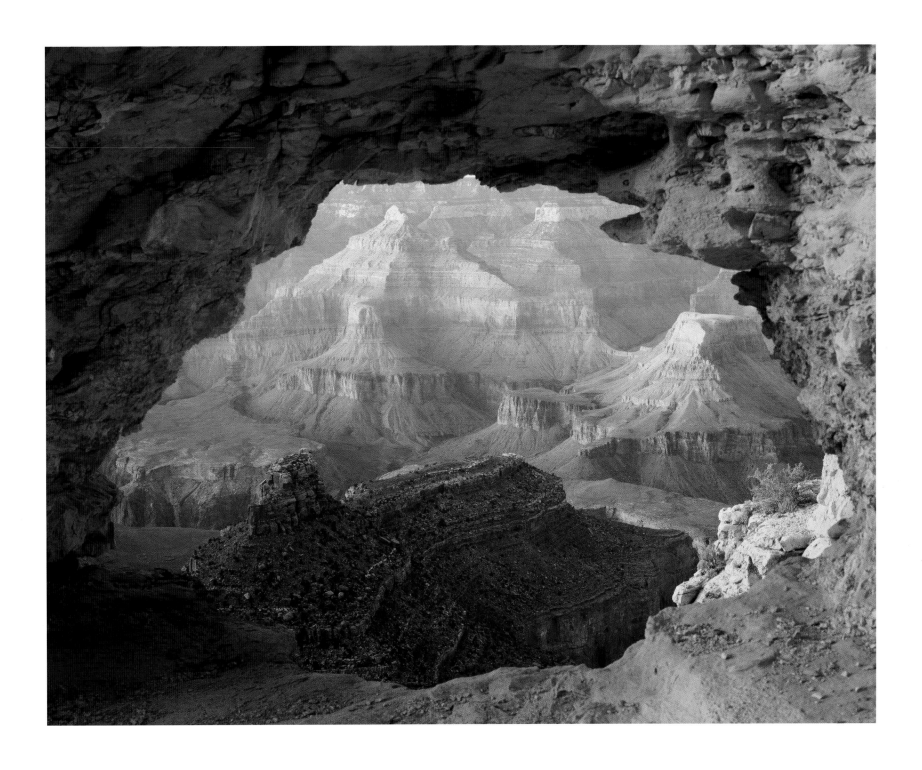

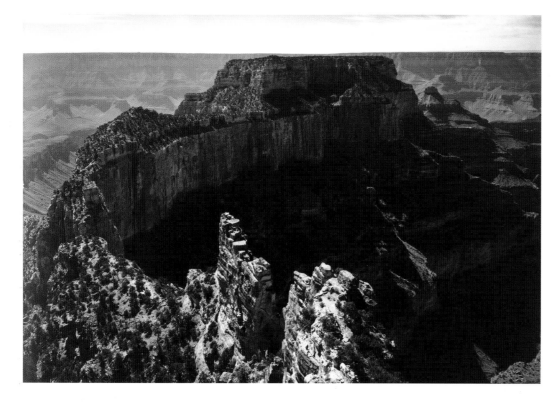

ANSEL ADAMS

Panorama of Grand Canyon with

butte in foreground

(Courtesy of the National Archives)

Ansel Adams worked for the Department of the Interior on a national park portfolio before and after World War II, and his project included work in the Grand Canyon. He believed that parks were set aside and protected as reserves not just for "recreation, but re-creation." Adams felt that parks offered "an experience, a mood" that primed the novice photographer to see a richer, more meaningful world. National parks stimulated *feelings*, and photographers could tap into them to see beauty in new ways.

In 1955, Adams suggested to the Sierra Club an activity for their underused building in Yosemite: why not mount a magnificent exhibit of photographs related to the environment? He asked Nancy Newhall

to help with an original prose-poem to tie together the photos. Sierra Club Executive Director David Brower sent the exhibit, *This is the American Earth*, on tour and turned it into a book—the first of the Sierra Club's "exhibit format" series, thereby inventing a genre and inspiring a generation. He wanted the oversize books to feel almost like standing in the exhibit itself.

Brower already had organized the publishing of one book of essays and photos in response to environmental threat, the 1955 *This is Dinosaur*, edited by Wallace Stegner, with photographs mostly by Philip Hyde (though not published by the Sierra Club). Smaller in format, this broadside against the dam proposed at Echo Park in Dinosaur National Monument was the immediate ancestor of the exhibit format books. *This is the American Earth* was published in 1960. George Huey remembers it as "one of the most important books" he owned in his high school years in New York City. He "found it extremely moving."

The first of the Sierra Club exhibit format books in color followed quickly, the 1962 *In Wildness is the Preservation of the World*, with Eliot Porter's New England forest photographs and text from Thoreau. A year later came the first title targeting a particular environmental threat. In this case the book was an elegy—Brower and Porter's heartbreaking memorial to Glen Canyon, *The Place No One Knew: Glen Canyon on the Colorado*, published as the idyllic canyon began to disappear under Lake Powell.

When the Bureau of Reclamation turned to the Grand Canyon itself for its next dam proposals, David

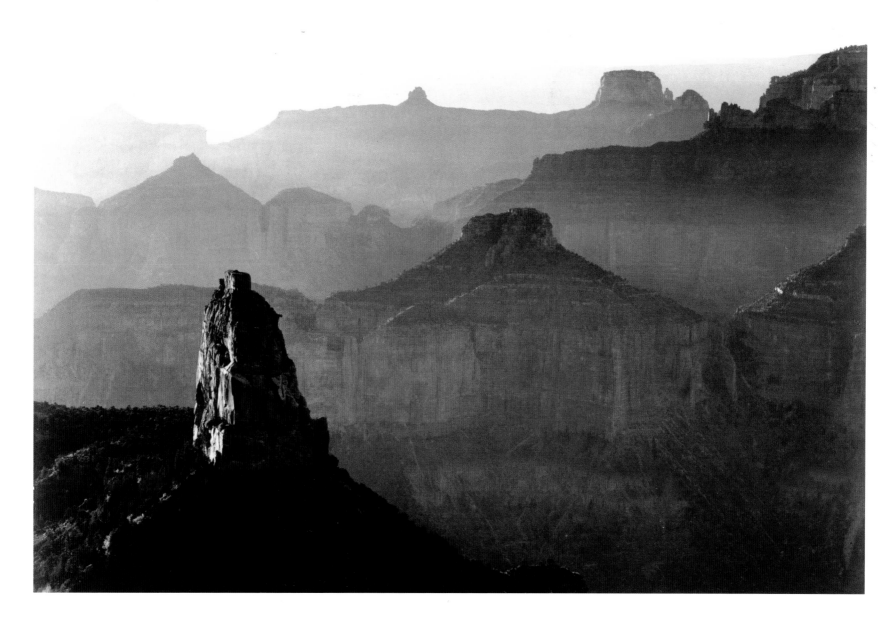

ANSEL ADAMS

Panorama of Cape Royal, North Rim
(Courtesy of the National Archives)

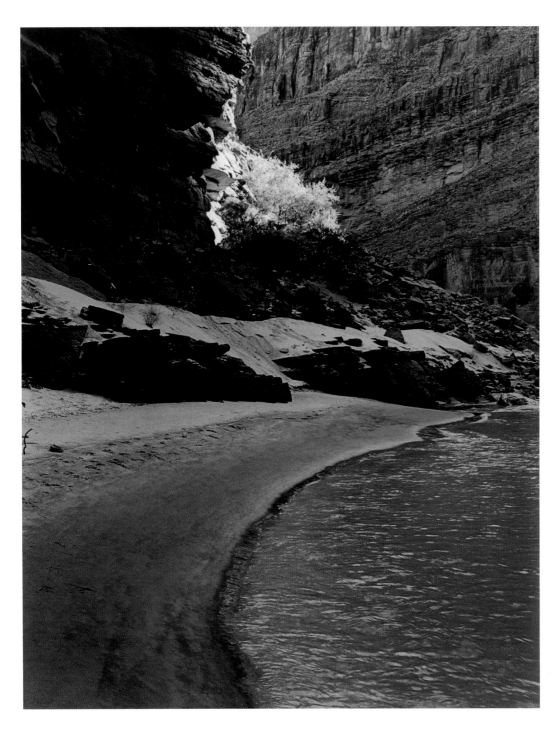

Brower knew the power of photographs as weapons. He published two Sierra Club books about the Grand Canyon, *Time and the River Flowing: Grand Canyon,* in 1964, and *Grand Canyon of the Living Colorado,* in 1970. The books featured the river, for it was the wild river that was at greatest risk. Philip Hyde was primary photographer for the former and Ernest Braun sole photographer for the latter.

Along with the full-page anti-dam ads that Brower placed in *The New York Times,* these "battle books," as Philip Hyde called them, reshaped the image of the Grand Canyon in the American imagination. The Canyon became a symbol of endangered wilderness, the Colorado a symbol of the free-flowing power of threatened rivers. The books and the campaign also transformed the Sierra Club into a national organization.

To gather material for the first book, Brower helped arrange a river trip, with Sierra Club Director Martin Litton rowing, both Philip Hyde and Eliot Porter photographing, and author François Leydet journaling away. Brower believed "that the testimony of the text, combined with the photographers' powers of observation, will serve lasting purpose by in some way stepping up the pace with which mankind preserves what is left of the world's irreplaceables."

The fight to defeat dams in Grand Canyon succeeded in 1968. The Bureau of Reclamation and Congress backed off. Brower knew that dam proposals have a way of returning, however, and so he continued to urge on the conservation community with a plea to enlarge Grand Canyon National Park, protecting

the river and its canyon from Lees Ferry to the Grand Wash Cliffs. In *Grand Canyon of the Living Colorado,* Brower delivered Ernest Braun's 35 mm photographs, "his perception of Grand Canyon, to the crusade for a greater Grand Canyon National Park."

The book included excerpts from Braun's journal. Stunned by the Canyon, he wrote of rapids and side canyons and the "skin and bones" of the "good Earth." He warned himself early on to shoot more Kodachrome, with the limitations of its slow film speed, and not use up all his high-speed Ektachrome. Brower took him high up into Elves Chasm, where he photographed a hanging garden of "exquisite detail," a place that made the whole trip worthwhile for him.

Downriver, at Fern Glen, Braun saw a rattler. "All I had loaded was Kodachrome, so I made some half-second exposures—one while he was moving. It may be beautiful." Toward the end of the trip, most of his film exposed, he admitted to being "pretty loose now…I have made my statement and also my mistakes, and anything I get now will not add too much to it." He finished the trip concentrating on the hardest images—those with people and photos shot from the moving boat—"cherishing the beauty all around me" and musing about how "the most subtle things are very fleeting. They are seen and gone a moment later, and too often missed."

Braun was intrigued with Brower. "Dave is very quiet, but he seems to have great appreciation for beauty, and also a very stubborn set to his chin."

☼

David Brower was an Old Testament personality, a prophet and a preacher. He could be relentless, self-righteous—and remarkably effective. He published twenty books in the exhibit format in the sixties, many of them classics, some without approval by the Sierra Club board on subjects not likely to turn a profit. His will and independence eventually split him from the Club.

In the foreword to *Time and the River Flowing,* published at the height of the battle against the dams, Brower was unapologetic. Like *The Place No One Knew,* the book "has a moral":

> In Glen Canyon the people never knew what the choices were. Now, in Grand Canyon, where there is wildness that can remain part of our civilization instead of fall victim to it, the people need to know before a bureau's elite decide to wipe out what no men can replace. The Sierra Club has no better purpose than to try to let people know in time. In Glen Canyon, we failed. There could hardly be a costlier peacetime mistake—unless there were a repetition of it in Grand Canyon.

The text for Brower's battle books grew from a scattering of quotes from regional literature by the likes of Clarence Dutton, Wallace Stegner, Loren Eiseley, and Joseph Wood Krutch, and essays and journals commissioned for the books. At their best, the words and photographs together reached the level of communication that Ansel Adams called "synaesthetic"— beyond synergistic, "as two creative elements join to produce a third form of communication."

[*OPPOSITE*]

ELIOT PORTER
River edge and catclaw bush below Havasu Creek
(Courtesy of the Amon Carter Museum)

[*OPPOSITE RIGHT*]

ERNST HAAS

Grand Canyon

Just what do these books communicate about the Grand Canyon? David Brower wanted them to galvanize people to action, to save the Grand Canyon. The photographers themselves are trying to communicate the spirit of the place—its rocks, its light, its essence. Philip Hyde agrees that he was down there photographing "because we wanted to keep the dam builders out," but the place itself was most important: "here was this magnificent canyon full of wonderful things to photograph. It's a matter of *seeing*, not deciding where you are going to photograph but just looking around, opening your eyes."

In Philip Hyde's preface to the 1971 Sierra Club book he created with Edward Abbey on the southern Utah Canyon Country upstream from Grand Canyon, *Slickrock*, he articulated the wilderness photographer's fear:

> The focus of this book is on a part of Earth that is still almost as it was before man began to tinker with the land…Telling thousands about it—to get their help in what must be a prolonged struggle to keep it wild—is a calculated risk…I have some hesitation in showing more people its delightful beauty—hesitation born of the fear that this place, like so many others of great beauty in our country, might be loved to death, even before being developed to death.
>
> So, if our book moves you to visit the place yourself sometime, first make sure you add your voice to those seeking its protection.

The cause trumps the risk. No more "places no one knew" for Philip Hyde. For every place, Hyde says today, "there will always be people that want to exploit it, and there will always be people—hopefully—that want to save it and keep it as it is." Better to publish your photographs and rally the troops. What's in the frame of the photograph matters artistically, to be sure, but what's *outside* the frame can destroy it.

The generation that followed him—including myself—moved forward with full belief in this fundamental teaching. We never saw Glen Canyon. We knew that the Grand Canyon was saved from dams, in part, by Philip Hyde's photographs, that Kings Canyon was saved, in part, by Ansel Adams. We knew the power of nature photography.

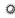

One lineage of Grand Canyon photographers runs solidly through Eliot Porter and Philip Hyde and David Muench to today's large-format photographers—through the ponderous fifty-pound 8x10 view cameras to the beautifully crafted, endlessly adjustable 5x7 and 4x5 Deardorffs, Linhofs, Graphics, Calumets, Toyos, and Arca-Swiss. For large prints and double-page spreads, the big negatives will always contain more information. This line of photographers stands patiently on the rim, heads shrouded in black cloths, peering into the inverted worlds of viewing screens.

The other genealogical line branches off not so long ago to run, briskly, from model to model of the smaller 35 mm camera.

The development of Leicas (1925) and Nikons (a rangefinder in 1948, the single-lens-reflex Nikon F in 1959), allowed the small-frame image to compete in quality with large-format originals in magazine reproductions. These photographs printed in ink became the primary market for photography, and *National Geographic* and *LIFE* magazines made clear that photographers working with the little cameras could make remarkable pictures.

News photographers took their 35 mm cameras to war and into the back streets, and their need for speed dictated working mostly in black-and-white. After World War II, color became common in magazine spreads, especially for travel and landscape. Amateurs adopted color even more widely with the addition of Kodacolor for prints and Ektachrome, the first slide film that could be processed in a home darkroom.

Ernst Haas became the most creative practitioner of 35 mm color photojournalism, photographing the natural and urban world with the sensibility of an abstract impressionist painter. The new technology and his status as a member of the premier photo agency, Magnum, gave free reign to his poetic eye.

Through the 1950s, after immigrating from Austria to the United States, Haas told editorial stories by journeying into the visual spirit of a place. His photo-essays on New York, Paris, and Venice, and his pioneering blurry pans of sports and wildlife communicated content with color and movement.

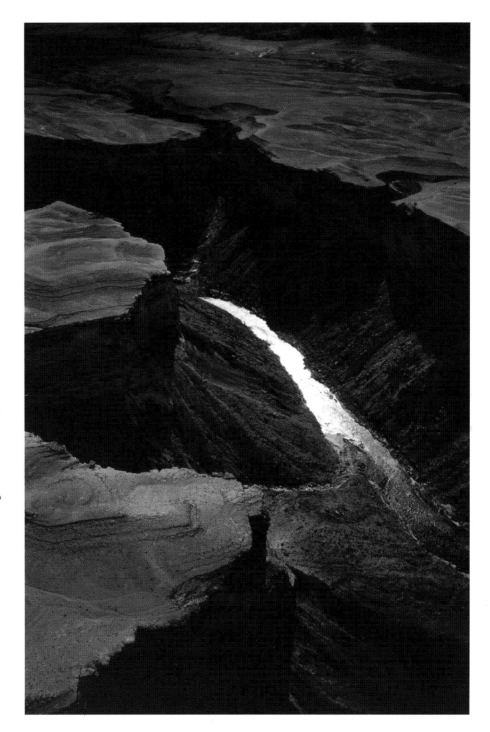

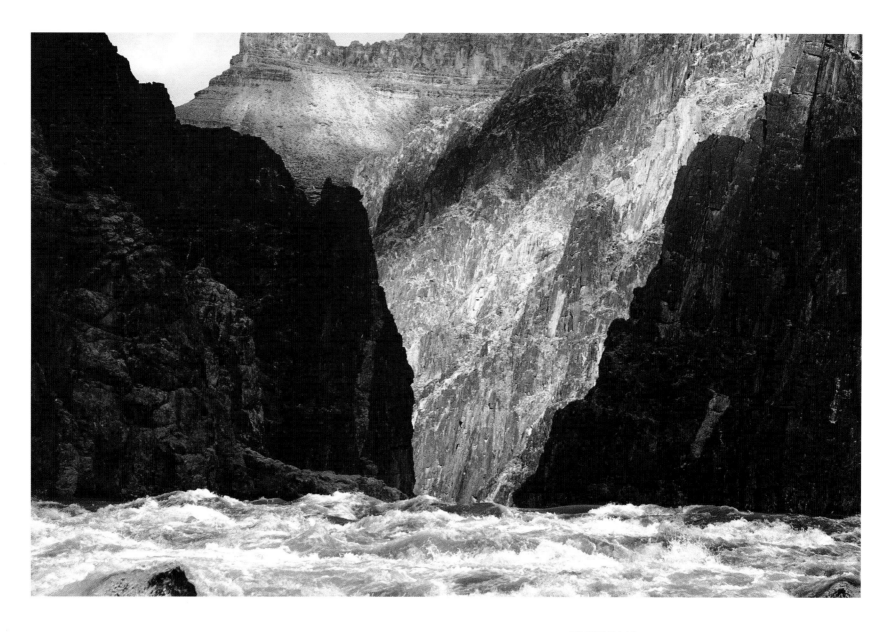

ERNST HAAS

Colorado River

In the sixties, Haas began photographing the landscape. Traveling the world for thirteen years, he photographed rock and sky and water and creatures and seasons. His emotional, joyous frames told the story of the genesis of the earth and the diversity of life. He was fifty when his pivotal book collecting this work, *The Creation*, was published. That same year—1971—he came to the Grand Canyon, on assignment for the TIME-LIFE Book Series, *The American Wilderness*.

His photographs, taken while John Blaustein rowed him through the Grand Canyon in a dory, reached print in *The Grand Canyon* in 1972, abstracting the rock and water of the Canyon in compositions that captured both the power of the place and a personal vision. It is no wonder that his approach appealed to the generation emerging from the sixties, looking for inspiration. John Running still goes looking for out-of-print copies of *The Grand Canyon* to give to friends who don't know it: "It truly is a treasure."

In 1970, Haas wrote: "Photographing *nature in the abstract* is not done as a proof for natural history. It is a trip of myself into a chosen subject matter which ends in exhaustion by trying to identify it and myself within a frame."

☼

The mid-1970s brought transitions. Emery Kolb made his last journey on the river, from the Little Colorado to Crystal Rapid, in 1974, at ninety-three years old. He died two years later. In 1971, the park acknowledged the rush to the wilderness and began requiring permits for backcountry hiking.

And in 1975, the battle for the Grand Canyon culminated with a greater Grand Canyon National Park, when President Gerald Ford signed into law a bill protecting the entire course of the Colorado River within Grand Canyon.

The seventies were the coming-of-age for the Baby Boomer generation of photographers who are featured in *Lasting Light*. In 1975, nearly two-thirds of us were in our mid-twenties—moving to the Southwest, taking our first river and backpack trips in the Canyon, galvanized by Earth Day, with the revolutionary perspective of Spaceship Earth photographed from the moon etched in our imaginations. We were falling in love with people, with landscapes, with adventure, and with photography, and when we tell stories of our journeys to adulthood, the Grand Canyon turns up often as the crucial setting.

ART PHOTOGRAPHERS in the mid-twentieth century relegated color to amateurs. Eliot Porter proved them wrong—and by doing so, became the first color landscape photographer considered a fully-formed artist. His 1980 exhibit, "Intimate Landscapes," was the first one-person exhibit of color photography shown at the Metropolitan Museum of Art.

Porter grew up in Illinois, poking around in the woods, searching for bittern nests in the Skokie marshes, and camping with his family on trips that took him to the Grand Canyon before he was ten. Summers at the family's Great Spruce Island in Maine started him on photography (with a Brownie, at ten years old, in 1911) and gave him a lifelong passion for the natural world. He "photographed the most approachable birds—gulls and terns on grass-covered islets," and gradually acquired more sophisticated equipment.

Porter had patrician roots but early on acquired a sense of adventure. He spent the summer of 1924 hopping freights and working as a laborer across the northern Rockies. He completed a medical degree at Harvard, but he loved photography more than bacteriology research. An evening with Ansel Adams "probably had more influence on me than any other experience," prompting him to buy a view camera. Encouragement from Alfred Stieglitz in the thirties, culminating in an exhibit at Stieglitz's gallery, turned Porter to photography full-time. With the invention of Kodachrome, he began to work mostly in color, largely so he could make realistic portraits of his beloved birds.

With his scientific bent, Porter became devoted to the dye-transfer print after he learned the laborious technique in 1944. He was still a romantic, however, and "that childhood camping trip to Grand Canyon" kept pulling him westward. He moved his family permanently to Tesuque, New Mexico, in 1946.

ELIOT PORTER

The Color of Wildness

Eliot Porter spent decades defending color photography from those who claimed it was too literal, too gaudy. His composition, his "selection," often framed a detail—those "intimate landscapes" of complexity, harmony and simplicity. His brother, Fairfield, a painter, said of Eliot's work: "the color is like a revelation…These photographs make wonder the natural condition of the human mind."

Porter's photographs illustrated two landmark Sierra Club books, *In Wildness is the Preservation of the World* and *The Place No One Knew: Glen Canyon on the Colorado*. Porter "didn't think about the *necessity* of becoming an advocate of nature" until the success of *In Wildness* showed him "the influence that books could exert toward protecting the environment." *In Wildness* allowed him to "see more clearly" and to be "more daring." And it was *his* book. Porter had been photographing with specific passages of Thoreau in mind, and he sent a dummy of the fully-conceived book to David Brower at the Sierra Club, who published it.

The loss of Glen Canyon and his association with the Sierra Club "transformed me from a theoretical and intellectual conservationist to an emotional and militant conservationist." He made his first trip through Glen Canyon in 1960 and returned another ten times in the next decade. He extended his river trips into the Grand Canyon twice for his 1969 book *Down the Colorado,* which paired his photos and text with Powell's journals on the centennial of the first run. He felt that "the higher the aesthetic quality of the photograph," the more persuasive it was, and, of course, he felt that color made the photograph still more powerful.

Even for the old bacteriologist, that power was emotional. "Before all else a work of art is the creation of love, love for the subject first and for the medium second."

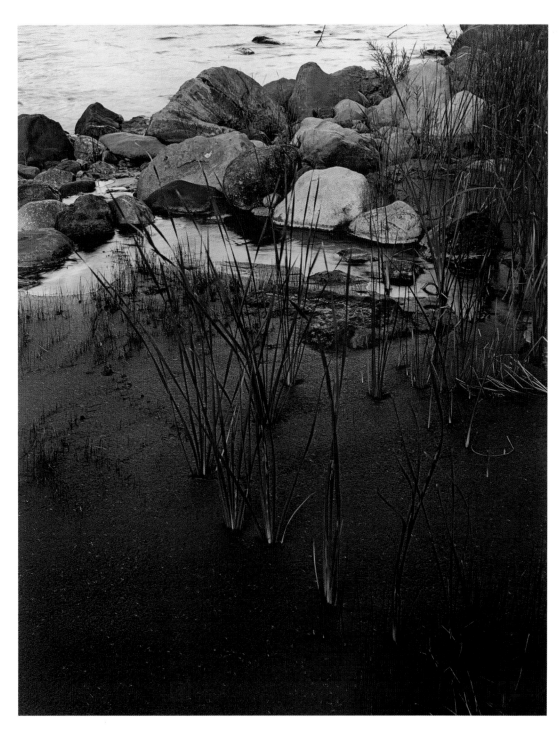

ELIOT PORTER

Reeds and reflections, Deer Creek mouth
(Courtesy of the Amon Carter Museum)

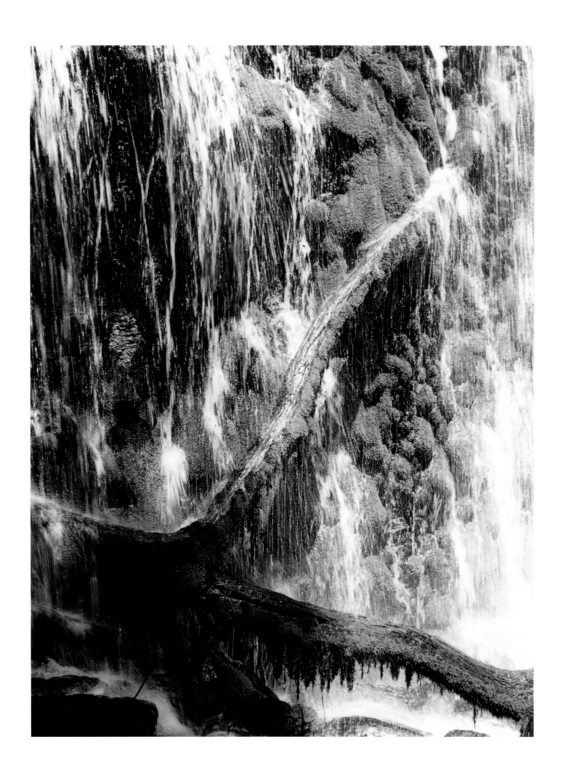

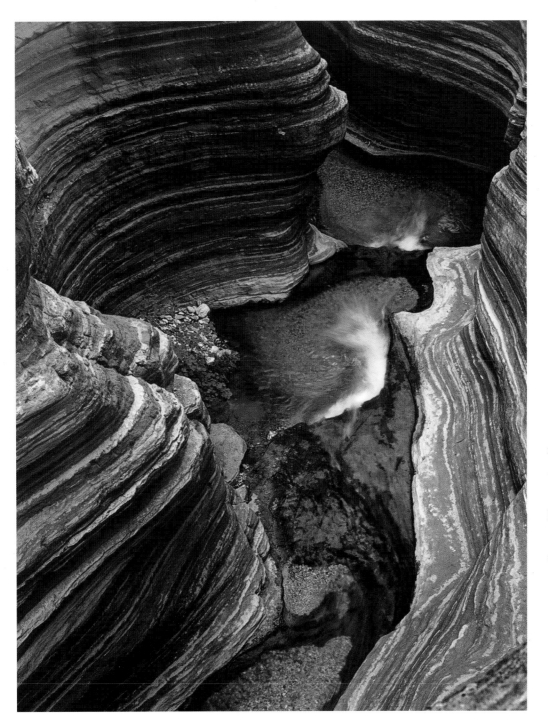

ELIOT PORTER
View into chasm, Deer Creek

[*OPPOSITE*]
Thunder River Falls with moss and log
(Courtesy of the Amon Carter Museum)

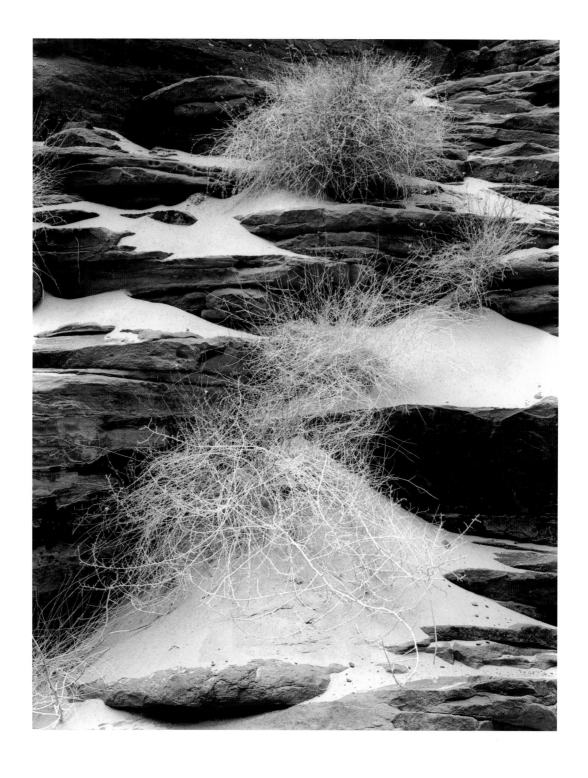

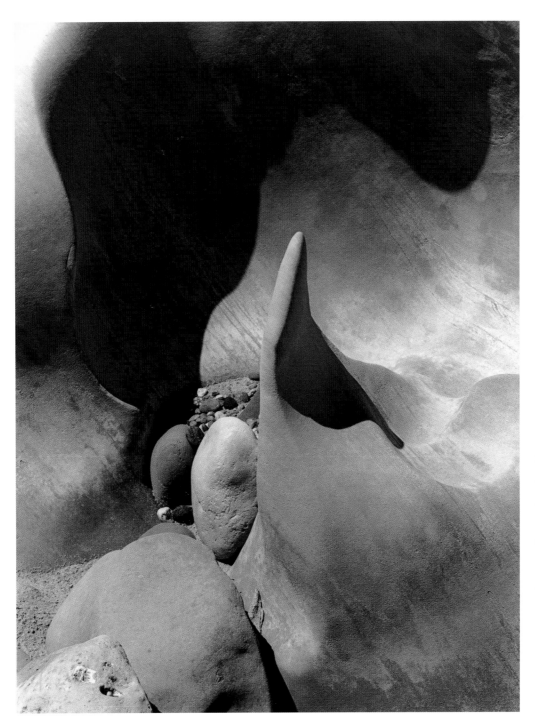

ELIOT PORTER

Sculptured rock, near House Rock
Rapids, Marble Canyon

[OPPOSITE]
Tumbleweed and cliff, near House Rock
Rapids, Marble Canyon
(Courtesy of the Amon Carter Museum)

PHILIP HYDE first saw the Grand Canyon as a boy in the early 1930s, when his father, a painter, took the family to Europe by way of a drive from California across the United States. The car-camping trip "planted some seeds" for Hyde's love of nature. When his snapshots from a 1938 Boy Scout backpacking trip in Yosemite framed more scenery than people, he knew something about where he was headed.

Hyde already had taken photography classes at San Francisco City College when he went off to World War II. Stationed in Kansas, he drove to Denver on furloughs just to see the mountains. Later, at Montgomery Field in Alabama, he pored over a set of WPA Federal Writer's Project guides to the states in the post library, dreaming of seeing those wonderful national parks and wild places—mapping his lifework.

As Hyde neared the end of his service, he wrote to Ansel Adams, asking where he might find further training. His timing was perfect. Adams was ready to announce a new photography program at the California School of Fine Arts. As Philip Hyde entered the School in the fall of 1947, Adams left to photograph for his national parks project, and Minor White became the lead instructor—with visits from Imogen Cunningham and Dorothea Lange and a field trip to Edward Weston's home at Point Lobos.

Hyde's ties to the mountains led to his first publication in the *Sierra Club Annual* in 1951. He soon became primary conservation photographer for the Club, working with its visionary leader, David Brower. Beginning with his work for *This is Dinosaur* in 1955, Philip Hyde photographs helped define the genre of "coffee table conservation book." From the house he built in the northern Sierra Nevada in the late fifties, Hyde ranged across the West, photographing for the classic Sierra Club books.

Hyde's first Grand Canyon river trip came in 1956. In

PHILIP HYDE

A Matter of Seeing

PHOTO © CEDRIC WRIGHT, *Courtesy Colby Memorial Library, Sierra Club*

Drylands, his large-scale 1987 book on the North American deserts, he tells stories from his logs—portaging gear around Lava Falls, a midnight adventure at Elves Chasm when the sandbar on which they were sleeping began to disappear into the river. The "stone landscape" appealed to him because "it struck some of the same harmonic notes evoked by the clean expanses of granite in the High Sierra I had learned to love in my youth. The place spoke to me of the same kind of purity that Emerson was alluding to when he wrote of the integrity of natural objects." Looking back, in the *Drylands* text, he concluded that "the colorful desert country undoubtedly influenced my gradual shift from black-and-white to color."

His son, David, remembers waiting endlessly with his mother when his father stopped their vehicle for a "picher," as the elder Hyde pronounced it, with a rising lilt to his voice. "I had no idea what he was even looking at," David says. "No one else would ever have seen it. He saw something…" His father says, simply, "It's a matter of seeing, not deciding where you are going to photograph but just looking around, opening your eyes. I seek to bring out what is there, rather than to impose a personal sense of design. Maybe it's a certain kind of light you don't find anywhere else. It's what you see."

In the 1960s, Hyde's Grand Canyon photographs illustrated David Brower's story of what we would lose if the Grand Canyon dam proposals passed. In 2002, he donated his photos and archives to the University of California at Santa Cruz. His son, David, says, "My Dad was just out there loving the place to death, and he wanted to show other people the place that he loved." Philip agrees: "I just went about my business, and here was this magnificent canyon full of wonderful things to photograph." He found in his work "an unending discovery of the infinite variety and beauty in the universe."

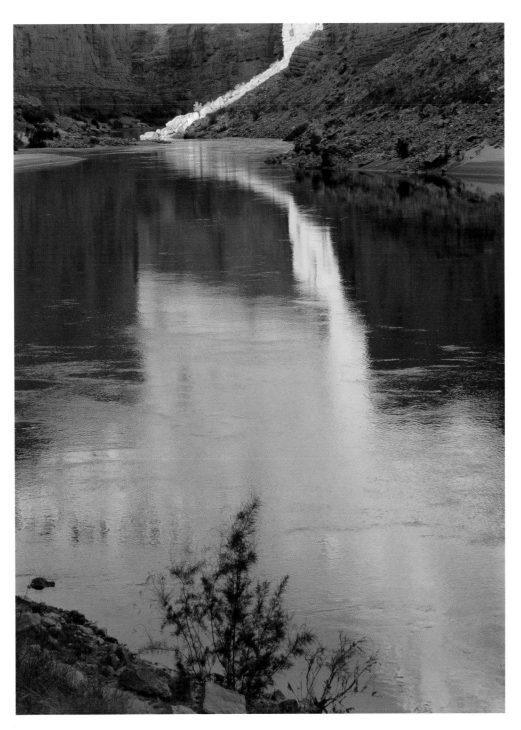

PHILIP HYDE

Marble Gorge
(Courtesy of the University of
California, Santa Cruz)

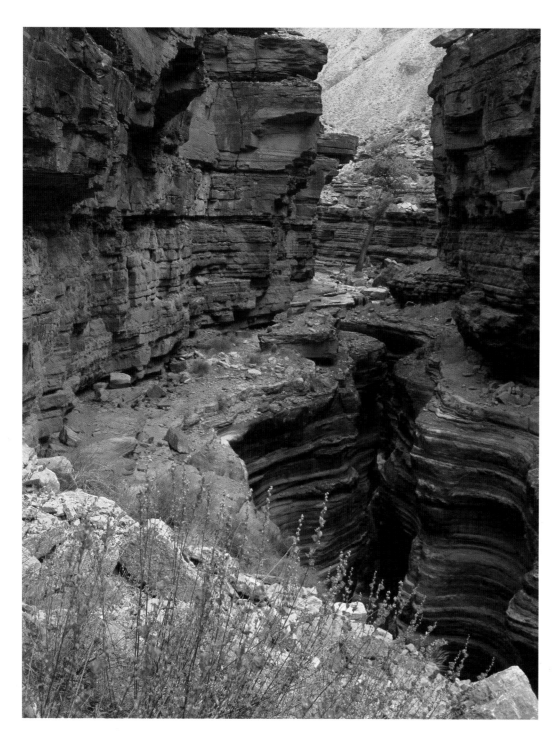

PHILIP HYDE
Deer Creek
(Courtesy of the University of
California, Santa Cruz)

[OPPOSITE]
Red Canyon at Hance Rapid
(Courtesy of the University of
California, Santa Cruz)

❂ Philip Hyde follows the "discipline" of the large-format camera that demands "careful seeing and an unhurried approach." Hyde used a 4x5 "baby" Deardorff for nearly all his color work, a model, he believes, with "no peer among field cameras."

"I rarely wait for light or for some other missing element, partly because I wish to avoid pouring nature into a mold, but also because I am impatient. Invariably, I can't find enough time to make all the photographs I want to in a place that is rich with possibilities. To wait for something to happen may well mean missing something else that is already at a climax and waiting to be photographed."
—from DRYLANDS

His friends describe him as a mountain goat, willing to walk and climb for his pictures. When asked, "What is your greatest strength as a photographer?" Hyde quips, "My legs!"

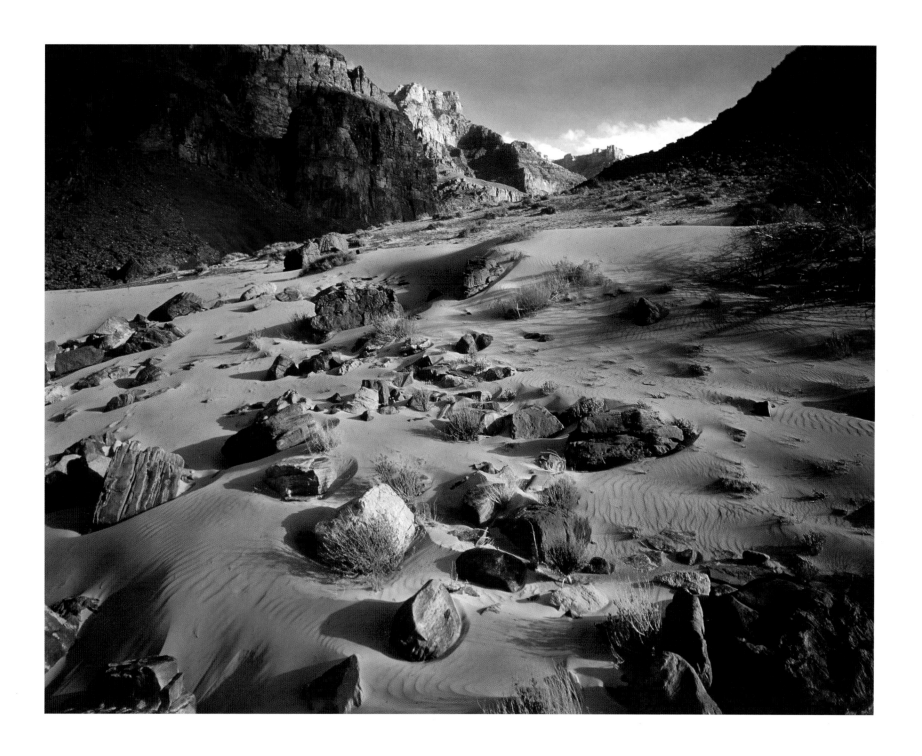

WHEN DICK DIETRICH came to Arizona in 1947, he had already taught himself to take pictures back home in Maine, where at age eleven, he photographed friends ice-fishing. He had yet to learn how to take cholla cactus spines out of his backside with two sticks—a critical item of desert lore picked up after shifting his tripod in the Superstition Mountains without looking first. He had yet to struggle to dig his Volkswagen van out of the sand when he had buried it to the axles while driving Monument Valley back roads in search of pictures. He had yet to experience the adventure of taking aerial photographs of the Grand Canyon from a helicopter.

All this would come later, during his nearly fifty years of photographing from his home base of Phoenix. Along the way, he served as mentor to his daughter, Dianne Leis, who now makes her living as a photographer, as well, and who remembers her father, who died in 1998, as a man in love with photography and with the Grand Canyon.

"Every chance he got," Leis remembers, "he would close up his commercial photography business in Phoenix and head out with his view camera and do landscapes." Those scenic images started appearing in *Arizona Highways,* and the huge stock agency FPG saw them and hired Dietrich to shoot 8x10 landscapes all over the country. Dietrich spent the rest of his life on the road with his big cameras.

The Grand Canyon and Monument Valley were his two favorite subjects. "Over the years, we returned to the Canyon again and again," Leis says. "It seemed like every time we were headed out of town going north, he'd make an excuse and we'd go via the Grand Canyon. If he was hiking, he would take the 4x5 or the 5x7 Deardorff. But up on the rim, he mostly used the 8x10, and the ones I like the best are the 8x10s. Fabulous, most of them."

DICK DIETRICH

Searching for Zingers

In the late seventies, Dietrich hiked into Havasupai with Dianne and her fiancé. Overestimating his fitness, he gave out completely at about mile nine, and the younger man "schlepped his backpack down to the falls," as Leis gleefully remembers. The next time he returned to Havasu to photograph, he told Leis, "I've hired the helicopter."

"He loved how the Grand Canyon kept changing—how he could go there time and again and the weather would be different, the lighting would be different—depending whether you hiked one way from a viewpoint or the other way, you saw all new things."

Dietrich held on to his Maine accent with pride and never lost his modest New England persona. Those Maine winters set him up for miserably cold and windy dawn shoots at the Grand Canyon, which he absorbed without complaint. He went out "photoing, fwapping the shutter." He painted his canoe red on one side and yellow on the other, for variety in photos—and chuckled at the consternation of painters trying to make sense out of his prop as it circled a mountain lake.

He was "infinitely patient," according to Leis, waiting for light. Dietrich told an interviewer in 1979, "I remember when I shot each picture—what time of day it was, where I stood to shoot it. That way when you come back to a location, you have less wasted motion. A painter could move things to fit the composition, but a photographer must position himself. Perhaps one of these days, when I can't lug a big camera around, I might try painting."

Dietrich never gave up his view camera. He knew that he never wanted to lose the feeling of "coming on something that you know will be great. I can always tell, because my heart beats faster. I'm always searching for that zinger."

[*OPPOSITE*]
DICK DIETRICH
Looking east from Yavapai Point, South Rim

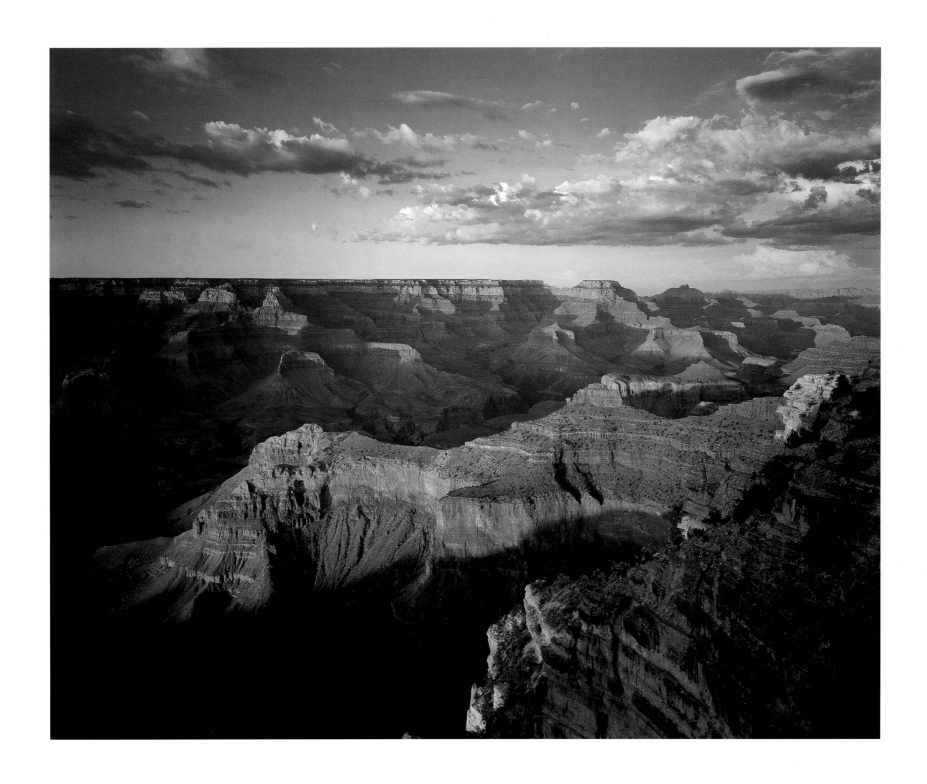

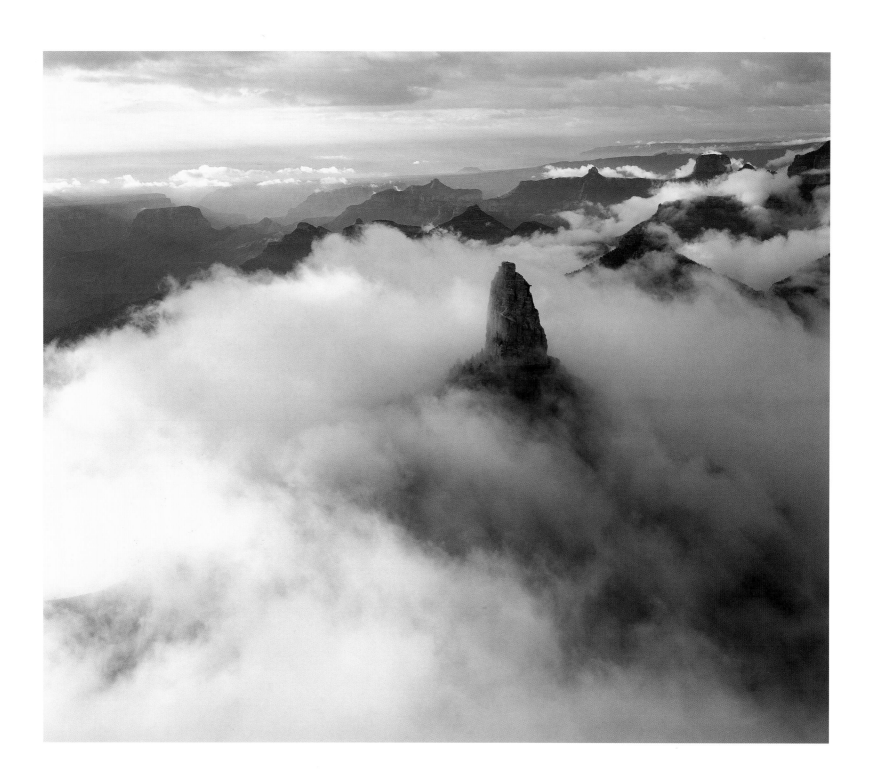

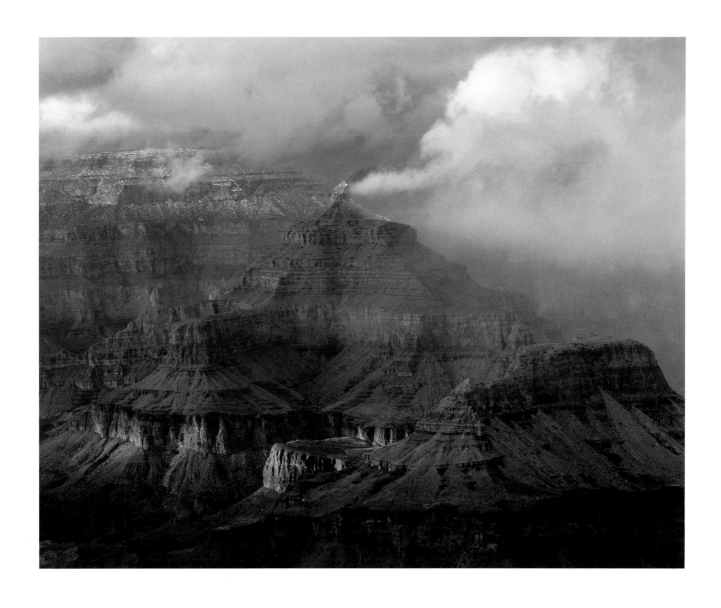

DICK DIETRICH

Winter clouds in Grand Canyon, South Rim

[*OPPOSITE*]

Clouds from Point Imperial, North Rim

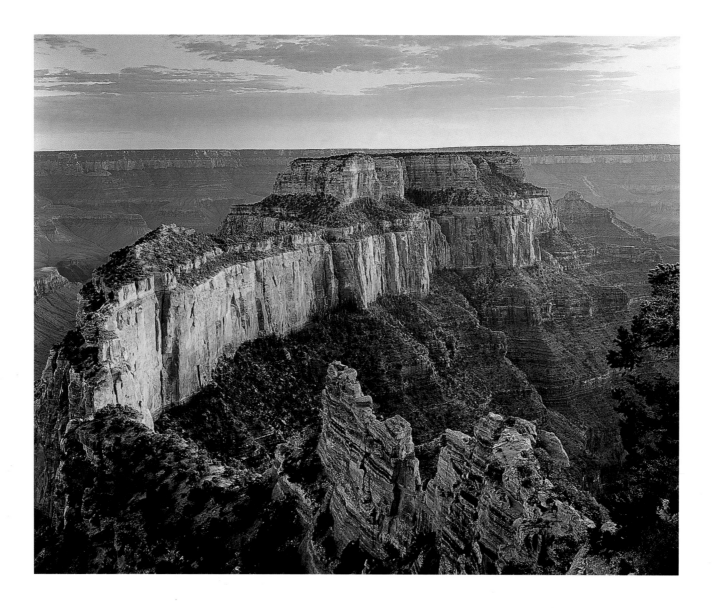

DICK DIETRICH

Cape Royal, North Rim

[*OPPOSITE*]

Sunset looking west from Yaki Point, South Rim

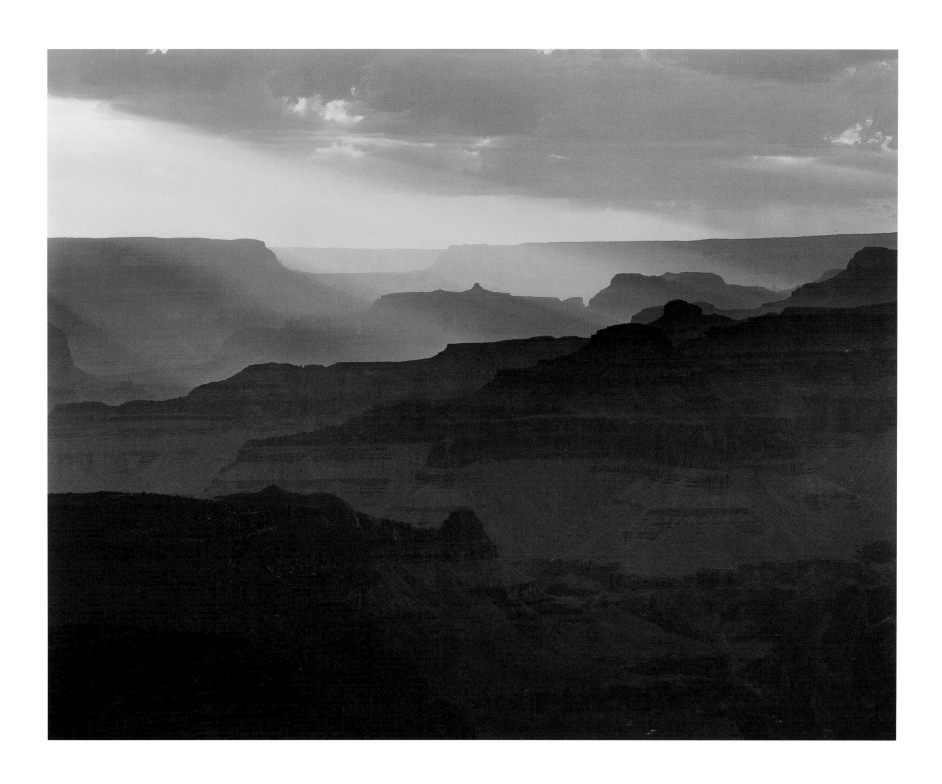

PHOTOGRAPHIC TIMELINE

Conley c.1910

R.B. Graflex c.1913

1925: Initially known as the Yaki Trail, the South Kaibab Trail is completed. It was the first inner canyon trail to follow a ridgeline, allowing for spectacular panoramic views.

1932: The height of the Great Depression, one out of every four American families is on relief

Vest Pocket Autographic Kodak c.1913

Brownie Reflex c.1941

1945: World War II ends

Reflex Camera c.1897

1889–1890: Robert Brewster Stanton leads two expeditions down the Colorado River through Grand Canyon in order to survey a route for a railroad

1911–12: Emery and Ellsworth Kolb boat down the Green and Colorado Rivers from Green River, Wyoming, to the Gulf of California

1928: Honeymooners Glen and Bessie Hyde leave Green River, Wyoming, with the intention of steering their boat through the Grand Canyon to Needles, California. They vanished and were never seen again.

1881: Jesse James commits his last hold-up on a Chicago railroad train

1901: The first train reaches Grand Canyon Village on September 17

1920: Prohibition takes effect

No.3 Folding Pocket Kodak c.1915

1933: The Mary Colter-designed Indian Watchtower is dedicated at Desert View

1885: The first stagecoach line begins service between Flagstaff and the South Rim

1900: The Kodak Brownie camera, the first mass-market camera, is introduced

1905: Hopi House and El Tovar Hotel, both built by the Santa Fe Railway, open for business on the South Rim

1915: Annual visitation to the Grand Canyon reaches 106,000

1932: The Grand Canyon Natural History Association (today the Grand Canyon Association) is founded

1880 1890 1900 1910 1920 1930 1940

1934: Fuji Photo Film founded

1885: Eastman American Film is introduced, which was the first photographic "film"

Seneca 8x10 Competitor View c.1907

1909: Halley's comet is photographed

1918: Influenza epidemic kills millions of people worldwide

1929: The Stock Market crashes

1937: The Golden Gate Bridge in San Francisco opens

1903: The first World Series is played

1912: Arizona is admitted as a state

1914: World War II breaks out in Europe

1941: The Japanese bomb Pearl Harbor

1882: The Havasupai Indian Reservation, encompassing 518 acres at the bottom of Havasu Canyon, is created

1891: George Eastman produces the first day-light-loading camera

1902: The first automobile reaches the South Rim near Grandview Point after a five-day drive from Flagstaff

1914: Kodak produces the Autographic camera, which allowed a message to be written on the film

Pacemaker Crown Graphic c.1947

Blair Stereo Hawkeye c.1905

1893: President Benjamin Harrison signs legislation creating the Grand Canon Forest Reserve, the first federal protection of land in the Grand Canyon region

Kodak Graphlex 3A c.1907

1921: The original Kaibab Suspension Bridge is completed. The rope-and-wood bridge was replaced by a steel structure seven years later, a bridge that still stands today.

1932: The zoom lens and light meter are invented

1882: Thomas Edison successfully turns on the lights in a one-square-mile area of New York City

Kodak No.4 Panoram c.1910

1919: On February 26, President Woodrow Wilson signs the bill to create Grand Canyon National Park

1935: Kodak introduces Kodachrome film

1890: Battle of Wounded Knee

1906: San Francisco is devastated by earthquake and fire

1930: Photo flashbulbs replace the dangerous flash powder

Rolleiflex Automat 35c c.1954

1954: Legendary river-runner Georgie White Clark lashes three inflatable rafts together, creating the G-Rig. Her innovation helps create the river-running boom in the latter half of the twentieth century.

1951: Amateur prospectors discover radioactive material at the Orphan Mine. The claim becomes the most productive uranium mine in the country.

1953: The structure of DNA is discovered

Nikon F c.1959

1964: Civil Rights Act is signed into law

1968: Martin Luther King Jr. is assassinated

1967: The first human heart transplant takes place, led by Dr. Barnard

1986: A sightseeing helicopter and tourist airplane collide over the Grand Canyon killing all twenty-five people aboard

2006: Nikon announces plans to discontinue five of seven film cameras to concentrate more on digital

1975: Annual visitation to the park exceeds three million

Arca-Swiss Field Monorail 2005

1958: The United States launches its first satellite, Explorer I

1973: United States ground troops cease involvement in the Vietnam War

Nikon F2 c.1972

1996: Six California condors are released at the Vermilion Cliffs, north of Grand Canyon National Park, marking the return of the birds to the region for the first time in at least seventy years

1969: Apollo 11 lands on the moon

1961: Bay of Pigs: American invasion of Cuba

Leica M2 c.1957

1975: President Gerald Ford signs the Grand Canyon National Park Enlargement Act, which nearly doubles the park's size

1976: Emery Kolb, pioneering photographer and South Rim resident for more than seventy-five years, dies at the age of ninety-five

2001: Terrorists use planes to attack the Pentagon and attack and destroy the World Trade Center, killing three thousand people

Pentax 645 2000

1957: 4.3 million Baby Boomers are born

1963: Glen Canyon Dam is completed and Lake Powell is created behind the dam

1977: Elvis Presley dies

1983: Glen Canyon Dam nearly overflows, the Colorado River runs at 90,000 cfs.

1956: Seatbelts are added to automobiles

1963: Polaroid produces instant color film

1980: Small Pox is eradicated

1992: Annual visitation to the park exceeds four million

1950 1960 1970 1980 1990 2000

1981: Scientists identify AIDS

1969: Annual visitation to the park exceeds two million

1990: Kodak introduces the Photo CD as a digital image storage medium

1955: On April 10, Bill Beer and John Daggett hop into the Colorado at Lees Ferry and begin to swim. They arrive at Pierce Ferry, battered and shivering on May 5.

Hasselblad 500C c.1960

1975: Linda Forney, a twenty-five-year-old nurse, takes a wrong turn when hiking to Supai on the Havasupai Indian Reservation. She spends twenty days surviving by drinking water from an eyeglass case and eating the pulp of prickly-pear cacti.

1984: Canon demonstrates the first digital electronic still camera

1997: Park entrance fee is doubled, from $10 to $20

1948: The Polaroid camera is produced by Edwin Land

1973: Polaroid introduces one-step instant photography with the SX-70 camera

Calumet 45 Series c.1990

Nikon D-70 2004

Polaroid Land 700 c.1955

1956: United Airlines Flight 718 and TWA Flight 2 collide over Grand Canyon National Park, killing all 128 aboard. The resulting investigation leads to the creation of the FAA.

1966: An early December rainstorm dumps twelve inches of rain on the North Rim. The flash flood washes away long sections of the North Kaibab Trail, and creates new rapids on the river, including Crystal rapid.

2000: On January 12, outgoing President Bill Clinton signs legislation creating Grand Canyon–Parashant National Monument northwest of the national park

1953: The Korean War ends

1963: President John F. Kennedy is assassinated

Canon AE-1 c.1976

1945: The first electronic computer is built

1958: The price for a first-class stamp increases to four cents

1981: IBM introduces the PC (personal computer)

Background photo by James Cowlin, *House Rock Rapid, Marble Canyon.*

Timeline compiled by Todd Berger, Katie Jennings, and Claudine Randazzo.

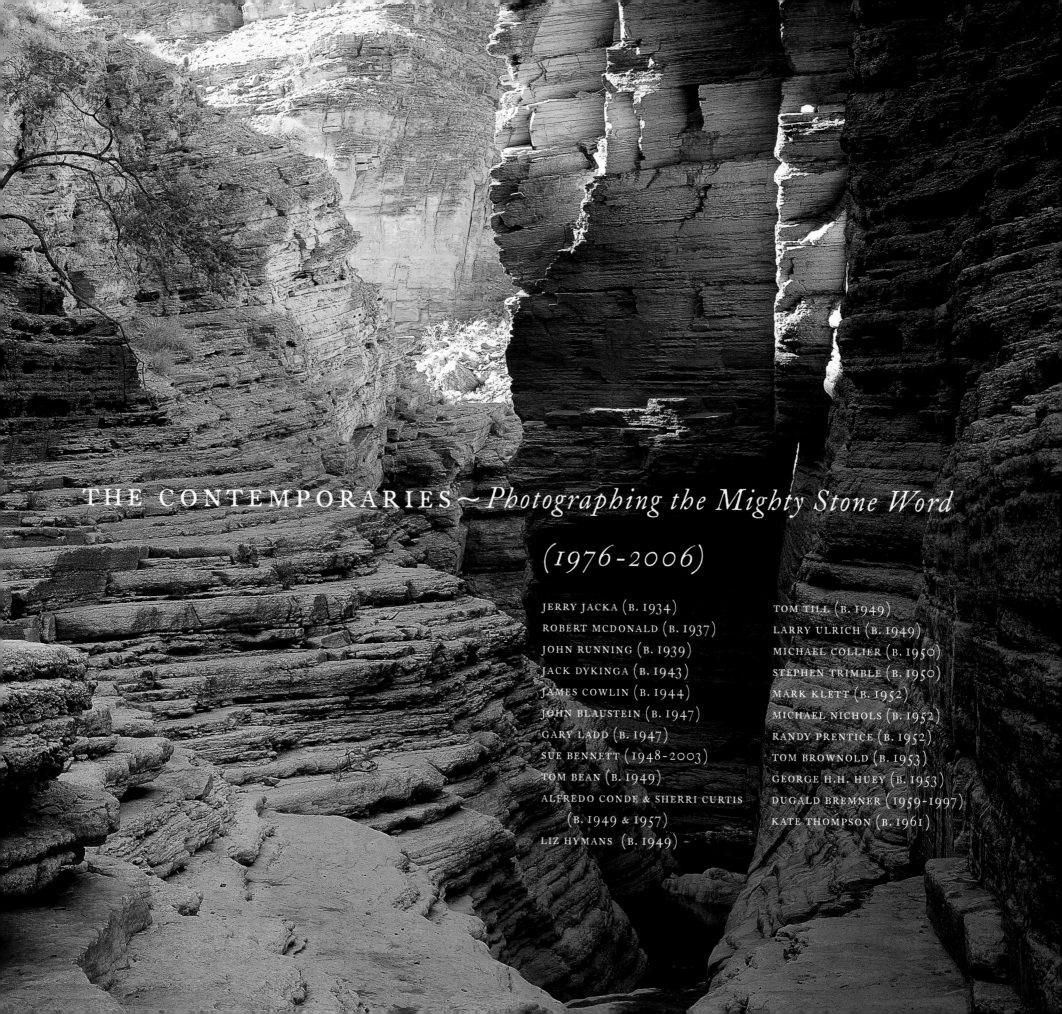

THE CONTEMPORARIES ~ *Photographing the Mighty Stone Word*

(1976-2006)

JERRY JACKA (B. 1934)

ROBERT MCDONALD (B. 1937)

JOHN RUNNING (B. 1939)

JACK DYKINGA (B. 1943)

JAMES COWLIN (B. 1944)

JOHN BLAUSTEIN (B. 1947)

GARY LADD (B. 1947)

SUE BENNETT (1948-2003)

TOM BEAN (B. 1949)

ALFREDO CONDE & SHERRI CURTIS

(B. 1949 & 1957)

LIZ HYMANS (B. 1949)

TOM TILL (B. 1949)

LARRY ULRICH (B. 1949)

MICHAEL COLLIER (B. 1950)

STEPHEN TRIMBLE (B. 1950)

MARK KLETT (B. 1952)

MICHAEL NICHOLS (B. 1952)

RANDY PRENTICE (B. 1952)

TOM BROWNOLD (B. 1953)

GEORGE H.H. HUEY (B. 1953)

DUGALD BREMNER (1959-1997)

KATE THOMPSON (B. 1961)

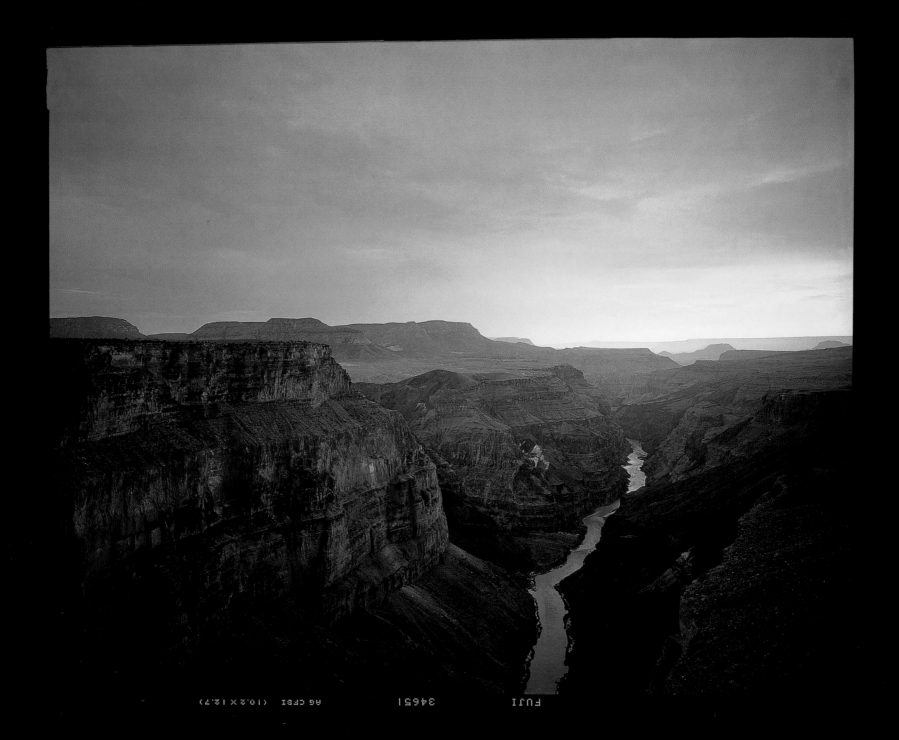
FUJI 34651 A6 CFBI (10.2 x 12.7)

NIKON F2 35MM
*c.*1972

CALUMET 4 X 5
*c.*1980s

PENTAX 645
*c.*2002

NIKON D70
2004

ARCA-SWISS FIELD
4 X 5 2005

[*OPPOSITE*]

LARRY ULRICH

Sunset from Toroweap overlook

[*PAGES 58-59*]

GARY LADD

*In Matkatamiba Canyon near its
confluence with the Colorado River*

"It seems a gigantic statement even for nature to make, all in one mighty stone word…"

JOHN MUIR,
Steep Trails, 1918

THE CONTEMPORARIES

Photographing the Mighty Stone Word (1976-2006)

MANY OF THE PHOTOGRAPHERS working in the Grand Canyon over the last thirty years have come as naturalists, explorers, and scientists as well as artists. They know the names of the rock formations in their pictures. They know the history and the stories. They know that the river's flow through the Canyon depends on computer models of the electrical needs of suburban homes in Phoenix, for those distant air conditioners demand release of river water through hydroelectric turbines at Glen Canyon Dam.

And so photographers find it hard to approach the Canyon in purely graphic terms. As remarkable as the light falling across a butte, they find it difficult to separate this visual drama from the historical, cultural, and scientific weight of its context.

The Grand Canyon is a "park," which contributes to its wonderfully confusing power. At Grand Canyon Village, sitting at a rim-side bench with a camera and a cappuccino, the Canyon abyss looms. Once you pierce the two-dimensionality of this scenic view and walk a few steps down Bright Angel Trail, however, you can die of heatstroke and dehydration. You can wear out the muscles stretched along your leg bones. You enter a wilderness. Gary Ladd, who has spent twenty-five years photographing every backcountry hiking route he can dream up, remains awed by the difficulty of the place.

In the nineteenth century Grand Canyon, Hillers and O'Sullivan came to a scene new to them and to us. By taking pictures of what they saw, they increased what we knew. Now, the more analytic photographers say that we can't just photograph the Grand Canyon or look at Grand Canyon pictures for what they are, for what we see. We know too much. We look at the Canyon with the full knowledge of pollution and population and political issues informing the interaction between place and photograph.

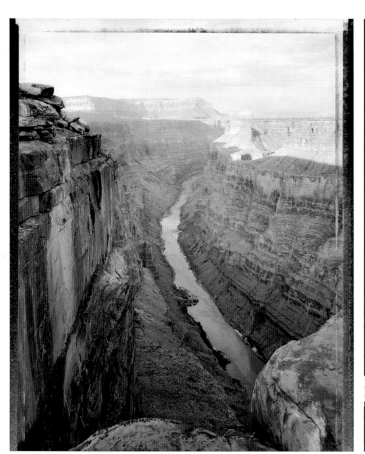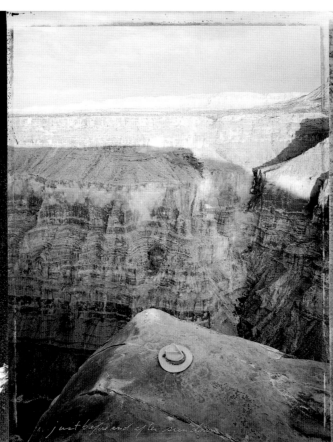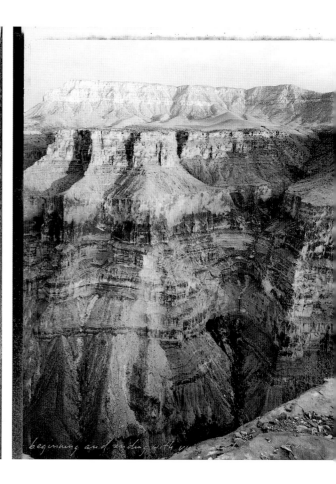

Landscape photography in the gallery world acknowledged this shift in interest toward the inhabited vernacular landscape with a 1975 exhibition called "The New Topographics." The artistic emphasis on irony and severity, humor and metaphor, left the Grand Canyon out of many contemporary artists' work.

When David Brower moved on from the Sierra Club in the 1970s, the mainstream use of photos as weapons quieted. The Sierra Club's showcase for photos shifted from battle books to calendars. These annual compilations still provided a market and haven for stunning landscape photography, but their political content grew less overt. Utah writer and bookseller Jose Knighton realized after a few

years of living complacently with Sierra Club calendars that if he really looked at them, they turned into "eco-porn," showing nature only at its prettiest—titillating urbanites with the romance of mythic wilderness, leaving out the flaws, the crowds, the development. His observation made many photographers rethink their work.

Today's photographers may or may not grapple with Knighton's summons to capture the paradox of modern landscapes—a thesis that dismisses any photography as virtually immoral if it neglects the human relationship with nature under siege. And yet that space, that light—that overpowering vista from the rim—still confronts every photographer

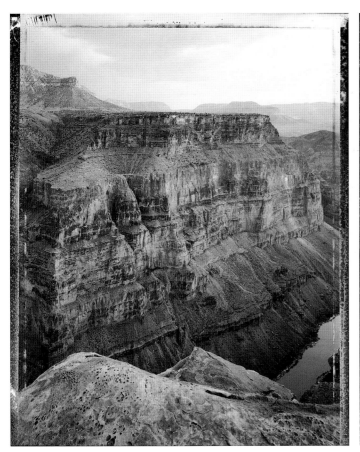 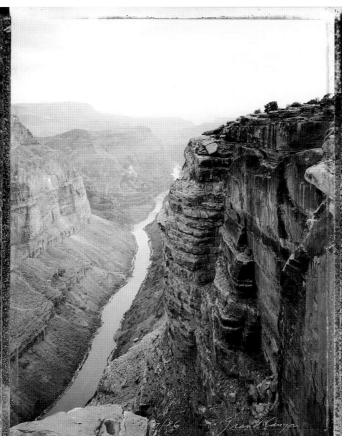

MARK KLETT
Panorama, Around Toroweap

with the power and pyrotechnics of the Grand Canyon itself.

The antidote to both a mythic Grand Canyon and a purely interior image lies in the work of photographers like Mark Klett and Len Jenshel, who came to the national parks either on rephotography missions or in search of the ultimate juxtaposition of big wilderness with mundane everyday elements like cattle guards, traffic cones, and tourists. These photographers don't just observe, they *participate* in the scene and the photo—and pull the viewer into the act of photography.

The best-known Grand Canyon picture in this style is Mark Klett's five-panel panorama, "Around Toroweap," (above) repeating Jack Hillers' views at far left and right, and with the modern photographer's hat resting in the foreground of a central panel. Critic William Fox writes about this 1986 salute to the continuity of art, "one of the most gorgeous yet thoughtful photographic representations of a scenic climax ever made":

the permutating angles, colors, and shadows during a perceptible span of time are exactly how we experience the Grand Canyon. The addition of the hat, a nod to Hillers and acknowledgement of Klett's presence, completes the picture by adding to our sense of geological time the passage of human history…

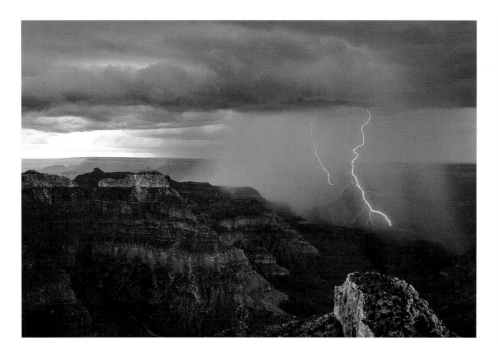 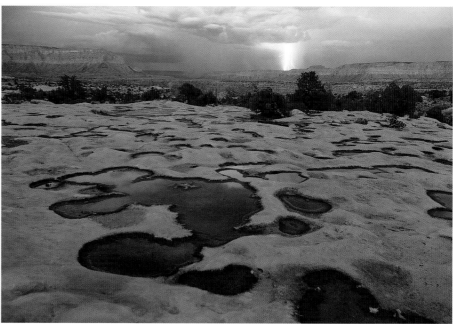

Fox has traveled extensively in the field with Mark Klett as the photographer "reinvents landscape." When Klett puts his shadow or his hat in the frame, Fox understands that, "it keeps both Klett and the viewer mindful...that there is no such thing as 'just a picture,' but rather a complex relationship among subject, photographer, viewers, and history. The picture isn't a monologue, but a multilogue."

Klett himself writes about photographing at Toroweap: "it didn't feel possible, or wise, for me to avoid commenting on this landscape as an occupied territory."

☼

Arizona Highways' photographers continue to celebrate the real wilderness and extraordinary light they find at the Canyon. The sublime version of the Grand Canyon has been left to them, just as the river is left to the boatmen/photographers who

carry on from Hillers and the Kolbs and post-war rivermen/journalists like Tad Nichols and Bill Belknap, recording their own adventures while traveling through a genuinely wild place.

The most recent photographer to come to the river, Michael "Nick" Nichols—fresh from his Mega-Transect of Africa following the route least affected by twentieth century development—spent a month on the river for his *National Geographic* assignment published in January 2006.

Flagstaff photographer David Edwards organized the Nichols trip but didn't shoot on it. He watched Nichols sit "up on a cliff with his assistant for five days in the rain. *Five days.* We were taking soup up to him. He came down and I said, 'Nick, I know that it was miserable up there for you, and I just want you to know that I really admire that.' And in his Alabama accent he said, 'You know Dave, I'm not a great photographer. But I don't

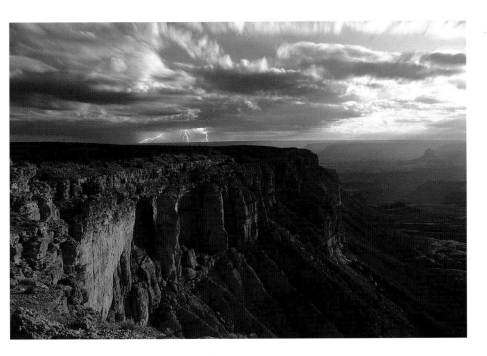

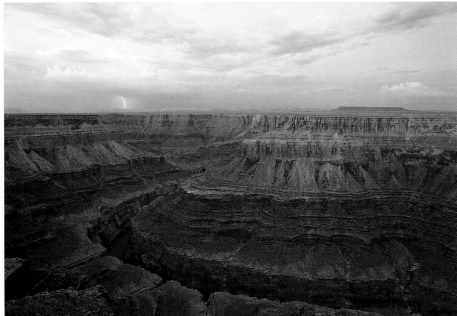

quit.'" In the *Geographic*, Nichols wrote, "As a photographer, you've got to work through the clichés so you can get to the good stuff." Each of the ten images that ran in the article—"the good stuff"—required about a week in the field.

The Grand Canyon runs more to such dogged naturalist/explorer/photographers than to art photographers. My generation of Baby Boomers was shaped by David Brower's battle books, which we purchased in their miniaturized $3.95 Ballantine paperback editions when we couldn't afford the full-size hardbacks. We pored over the books, absorbing Eliot Porter's sense of design—small and intimate landscapes elegantly contained within the frame—and Philip Hyde's warm response to big views. I still journey downcanyon accompanied by a memorized inventory of their pictures, just as I did the first time I came to Grand Canyon.

We read Edward Abbey's *Desert Solitaire*, published in 1968. We were stunned by Ernst Haas's *The Creation*. We came to photography and the land at the same time, with an idealism and imagination on fire. The Grand Canyon is our bedrock cathedral.

We yearn to tell stories with our photographs—telling those stories as gracefully and elegantly as we can in our graphics and color. We remain more concerned with the subject than our inner muse. Most of us are happy to donate our photos to conservation organizations, to see the pictures *used* rather than simply admired.

Take Tom Till. He has three "heroes": Philip Hyde, David Muench, and Eliot Porter. "From Philip Hyde, I learned that having your image used in service of the environment was an important part of what you were doing. I also learned to not always shoot at sunset and sunrise, that sometimes the middle of the day has some interesting things going on.

"Dave Muench says, 'bad weather means good

MICHAEL NICHOLS
From SB Point on the North Rim looking east with moonlit monsoon storm (Courtesy of National Geographic Image Collection)

From Buck Farm Point overlooking Marble Canyon at dusk (Courtesy of National Geographic Image Collection)

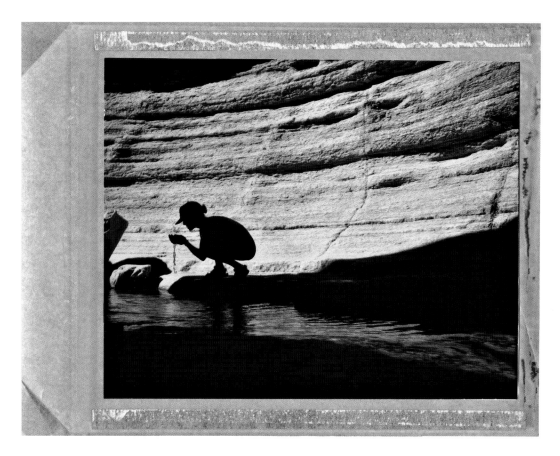

JOHN RUNNING
Bennett at Matkatamiba Canyon

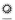 *Here in the Canyon depths silhouettes often reveal more than direct illumination.*

I've got a file cabinet drawer full of pictures of the Grand Canyon and one folder in there is from the rim. The rest are from the river. That's probably because I'm lazy. I'd rather be on the river than hiking around. ~JR

pictures.' And that pushed me in that direction. You've got thousands of possibilities on a bad-weather day and only a handful on a blue-sky day. And he's got a work ethic that's second to none. It's really important to maximize the number of days you spend in the field, to get lucky.

"From Porter, you learn not only to just do the big scenics, but that the intimate stuff is important. And the photography he did all over the world inspired me to shoot overseas."

The ideal balance for a landscape photographer, as photography critic John Szarkowski has pointed out, might be "a nicely calculated middle position between scientific detachment and self-expression." Szarkowski circles around this notion. Landscape photographers find that the camera is "not simply their tool, but their teacher." They strike a stance of "patience, openness, and a certain modesty of emotional means." They don't tend to be wracked by inner turmoil. They don't commit suicide or die as war correspondents. They are looking for the perfectly pitched balance between recording nature and constructing illusions.

At the Grand Canyon, the rim emphasizes *content*. It's easier to achieve personal artistic vision on the river, in side canyons, in detail—in landscapes more intimate and less burdened by Grand Canyon mythology and fact. On the rim, you look *into* sacred space; below the rim and on the river, you enter it.

☼

There is some history to recount. In the seventies, a community of river-runners and photographers germinated in Flagstaff. John Running and his life partner, photographer Sue Bennett, formed the nucleus. Running rented out extra space in his downtown studio, and in the early 1980s I took my turn in an office in his hallway, neighbor to other photographers and painters.

Running, Bennett, and David Edwards proved powerful mentors to each new wave of young Grand Canyon fanatics arriving in Flagstaff. Many of the photographers profiled in this book learned from them and lived within this circle. Some still do, meeting occasionally to critique one another's work

in a loosely organized group, the Knights of the Light Table. As Dave Edwards says, "People don't protect their techniques, they share what they are doing, knowing everybody has a different style."

At the same time in the late seventies, Rick Stetter became director of the Museum of Northern Arizona Press in Flagstaff. He loved fine photography, elegant book design, and the Grand Canyon, and persuaded the Museum to take the financial risks necessary to publish the best Grand Canyon photography he could find in books like Barry Thomson's *The Enchanted Light* (1979) and in portfolios in the museum magazine, *Plateau*.

T.J. Priehs, another young publisher with ambitions to make beautiful books, came to the Grand Canyon Association in these same years and dramatically raised the quality of photography in park publications—hiring many of the photographers in this book at the beginning of their careers.

John Blaustein's 1977 book, *The Hidden Canyon*, served as inspiration, too—an Ernst Haas-like response, in passionate and emotional pictures, to the river in Grand Canyon.

Much of the subsequent history plays out in the photographers' profiles featured here. River-running led to adventure photography. Park ranger jobs led to commissions to work on park publications. Scientific research in the Canyon led from technical photography to editorial photography. Hikers enamored with *Arizona Highways* bought themselves 4x5s and began taking photography workshops.

Their pictures fill this book. Some of these photographers lie squarely within the tradition of the

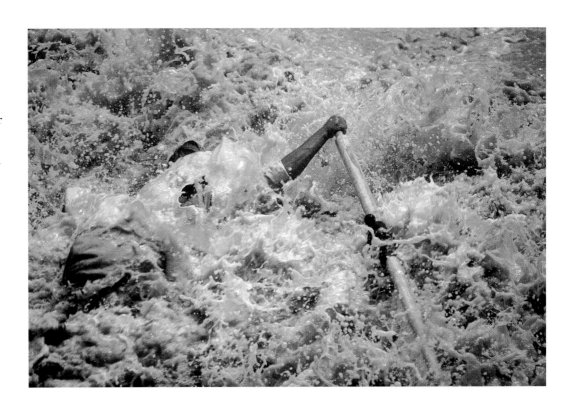

DAVE EDWARDS
River-runner engulfed in rapids

explorer/celebrant. Others aspire more to recognition as artists. Many work energetically with varying styles and levels of content.

For example, Kate Thompson's photograph of jet contrails across the entrance to Matkatamiba Canyon (page 68) offers the same multilayered story beloved to critics as Mark Klett's hat in "Around Toroweap." River guide and photographer, Thompson was camped at Matkatamiba when she heard military fighters buzzing the Canyon. She hated the noise, but she loved the stripes of vapor trails against the sky. Fully aware of the anti-romantic content of the photographs, she struggled to find her comfort level with that meaning even as she

KATE THOMPSON

Salute to Matkatamiba

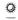 *The contrails were very serendipitous. At first, I thought, 'Oh my god, those jets are annoying.' I thought they weren't supposed to be flying through here; it is a no flight zone. But I'm always questioning myself when I pass judgment—from 'That was annoying. That's wrong.' To 'How about I go set up my tripod and see what happens?' The contrails expanded as the sun was setting. And I just played with that, played with all kinds of different compositions at the opening of the canyon. It was an emotional moment for me.*

To me this photo symbolizes patriotism both in the graphic element of the stripes and in the moment. There it is—incredible camaraderie right there—the jets are flying side by side, four of them, streaking across. That's really not any different than what we do down here on the river, camping and drinking beers and having great camaraderie and talking about our runs.
~KT

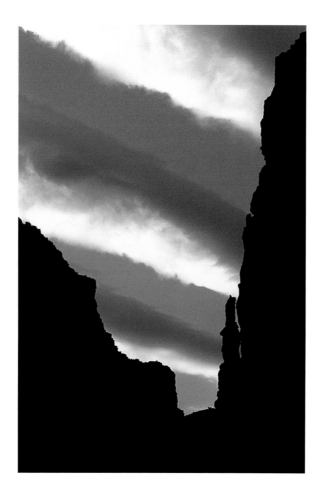

made pictures and responded exuberantly to the light and patterns.

Meanwhile, those issues of *Arizona Highways* keep coming, year after year, decade after decade, a flood of pictures that circles around to Grand Canyon subjects every few months. The pictures range from straight scenes that form the bread-and-butter of the magazine and the bedrock income of a dozen 4x5 photographers to adventurous articles about backcountry trails that use pictures that look more like hikers' snapshots.

Leaf through the last twenty years of *Arizona Highways* and it's clear that Jack Dykinga has emerged as the contemporary master of view-camera color landscape photography, consistently adding to those big clean scenes a surprise perspective, a flair for elegant design, a dash of whimsy, a richness of color.

We live in an outrageously visual culture. We see hundreds of images every day. In 1998, Americans took seventeen billion snapshots. With the shift to digital in the years since, that number has multiplied beyond counting. The flow of imagery runs the gamut from product shots that say something straightforward about the subject to strange and wonderful images that reveal the vision of the artist.

In the twenty-first century, everything is faster and busier. At the Grand Canyon, this results in limits on where you can drive and hike and fly. More infrastructure, more urbanization of the rim. Photographers fret about this, grumpy about shuttle buses that make it difficult to chase the stormlight from overlook to overlook and rules that make it tricky to be at their chosen tripod spot at the far end of Hermit Road past sunset or before sunrise. They register their sorrow at pollution that often fills the Canyon and grays their views.

The commercial marketplace demands digital. *Arizona Highways* still favors large-format film. Photographers such as Larry Ulrich strike a middle ground by shooting in film and spending enormous amounts of time making master digital scans of their thousands of transparencies.

Many photographers speak of being surrounded by their files, as if the pictures inside those filing cabinets form a living wall for their homes, companions and friends for them in their studios. It's hard to feel the same affection for a bank of external hard drives backing up the information digitized in your file boxes of CDs and DVDs.

Nevertheless, photographers who want their work to be published must become computer-savvy. To keep up, many of the best-known landscape photographers meet annually to swap stories and advice, to share tips on Photoshop and digital workflow.

More and more amateur photographers have high-end equipment. The last time I threaded my way through a forest of tripods set up for sunrise on the South Rim, it seemed that every other camera I saw was the same Nikon digital that I was using. And these advanced amateurs are good. They know the work of the pros, though Larry Ulrich laments that too many "are 'copy machines' just running around the country copying the work of everybody else. So I just go where the other photographers aren't going."

☼

The Grand Canyon will continue to draw new generations of photographers. Some will come as twenty-first century artists, looking for raw material to digitally enhance. Others will come primarily as naturalists and travelers, seeking to capture the spirit of an ongoing story called the Grand Canyon.

This place will always challenge those who think of it as one place, *the* Grand Canyon, to be captured in its entirety in a single picture—a daunting notion,

JACK DYKINGA
Matkatamiba Canyon reflections in the sinuous banded narrows with water cascading toward the Colorado River

a fool's errand. It's like expecting to photograph in one inclusive frame and instant: "New York City," "The Nile River," "Argentina."

"The Grand Canyon" is an abyss, a river, a rim, and an infinitely folded relief map of side canyons. It is time and vastness, luminosity and illumination. Its extravagant complexity grants to photographers more revelations than they can capture and more stories than they can tell.

Photographers will continue to capture that magic light, and their pictures will last. Their stories will teach and beguile and exhilarate. And, always, the Grand Canyon will nourish us all.

JERRY JACKA GREW UP ON A DESERT HOMESTEAD north of Phoenix and met his wife, Lois, in first grade at a one-room schoolhouse in New River. He took photography classes in high school and dreamed of getting "one picture published in *Arizona Highways*." Now retired after fifty years of photography and countless images published in *Highways* and elsewhere, he jokes that he's gone full circle from "wannabe" to "has-been."

His high school photography classes first made him "aware of the shapes and colors and light of the landscape." Jacka went north to Indian Country as a teenager on a YMCA trip organized by Barry Goldwater. Within a short time, he and Lois were camping on their own with their infant son at the Hopi Mesas. By 1958, that first *Arizona Highways* image was in print, and, by 1974, the magazine began to devote entire issues to his work—especially his studio photos of Indian art, often with text by Lois.

Jacka spent years as a forensic photographer, documenting ballistics and tire tracks and fingerprints, before becoming a freelancer in the late seventies. He has realized that "the detail that I had to present in law enforcement photography was the same kind of detail I had to present when photographing a Navajo bracelet or a piece of sculpture."

"I could lose myself in the studio, playing with this wonderful Indian art, with light and arrangement. In the studio, you had ultimate control. The break was to get out and throw a bedroll in my Suburban and hit the road with a lot of bologna in my ice chest, taking what God had to offer in terms of lighting and weather.

"Heading up to Indian Country, I might veer off and spend an afternoon at the Canyon rim and see what's happening.

JERRY JACKA

A Retreat from the Studio

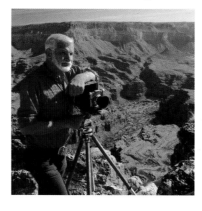

When I seemed unable to be productive anywhere else, a trip to this place of magic light and stone always renewed my creative energy. I think God may have created the Grand Canyon just for photographers."

Once at the rim, Jacka rediscovered patience. "It gets so hazy. Sometimes it was so absolutely bland that I pulled my rig up in a shade tree and took a nap and read and waited—for the light, for the rainstorm, the rainbow, the snow. I went back later in the afternoon to see if the light and mood of the Canyon had changed. And indeed it did."

Storms changed everything. "It's so vast; the light doesn't do its magic unless there are storms. And then you can shoot all day long."

At first, when Lois was with him, she would sit in the car and read even when the light turned to magic. "I'd get frustrated. I'd say, 'God, this is gorgeous!'" But she felt she'd already seen the Grand Canyon. Then, they took their first trip down the river. "From then on, whether we were on the river or on top, she would be out there, looking. The river gave her a new appreciation—as it did myself."

Jacka appreciates the paradox of the long wait and, then, "being ready for when there is a hole in the clouds and the light is going to come through. These things are *fleeting*." That requires anticipation, especially with the slow and precise positioning required by a view camera. "I believe large format forces one to be more of an artist."

The Jackas have moved to a historic ranch on the Mogollon Rim, and their daughter, Cindy Jacka, owns and manages Jerry's stock file. And though he says he is no longer shooting, he hasn't given up his old Linhof 4x5 or his Hasselblads or his 35s. "It's so beautiful, you can't pass up a few shots around here."

JERRY JACKA

Deer Creek camp, mile 136

◉ *In later years, I spent more time down in the Canyon than up on the rim. My wife, Lois, and I put together groups of people for Colorado River trips five or six times. We called them photo workshops, but they were more or less photo adventures. There's nothing like being out in a beautiful place with a whole group of people who are crazy about photography and eager to learn anything they possibly can.*

On this trip, we had stopped for the night near Deer Creek Falls. Camp had been set up, dinner was over, and small talk about the preference of film and other 'photoisms' was underway. For a brief period, the setting sun illuminated the horizon and lightning flashed as thunder rolled through the Canyon.

There was a large outcropping of rock nearby. Everyone grabbed their cameras and scrambled for a position on top, on the side, and below these boulders. I heard shutters clicking, motor drives whirring, and shrieks of delight as the storm and sunset continued as if on cue for the end of another great day along the Colorado River in the Grand Canyon.

I took this photo with a Hasselblad and an 80 mm lens.

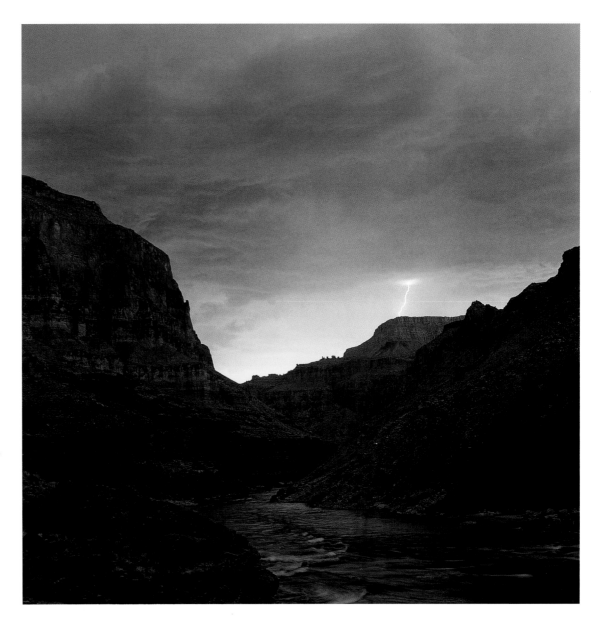

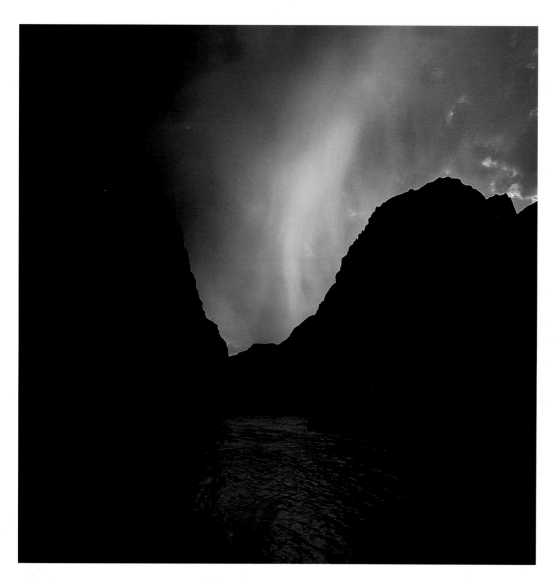

JERRY JACKA

Summer thunderstorms in the Grand Canyon along the
Colorado River, below Lava Falls

[OPPOSITE]

View from Hopi Point

❂ *I made a brief trip from Phoenix to the Grand Canyon in anticipation of stormy conditions. At first, there seemed to be nothing but overcast skies, with no light in the Canyon. However, patience paid off as light began to penetrate the clouds.*

I set up two cameras, my 4x5 Linhof and a Hasselblad, a technique I often use. The latter was to give me flexibility in case something dramatic appeared quickly—and out of the immediate coverage of my 4x5.

I shot four sheets of 4x5 film. Each shot was different, as the light and small storms drifted across the Canyon.

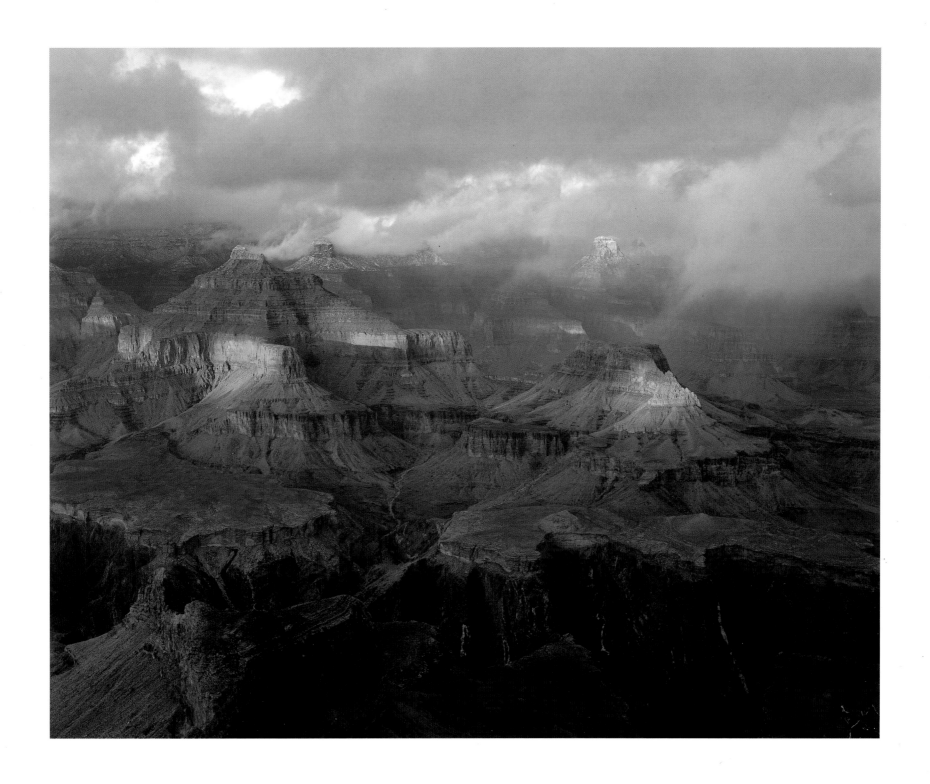

ROBERT MCDONALD BELIEVES that "the Grand Canyon is the mother of all scenic showcases." When it came time to try his own hand at photographing the Canyon—after a lifetime in Arizona, including more than thirty years as a US Forest Service civil engineer and decades of admiring those Josef Muench and Jack Dykinga photographs in *Arizona Highways*—there was little doubt where he would begin.

McDonald planned his retirement from both the Forest Service and from hunting. "I didn't want to keep killing animals, so I got a Nikon and thought, well, I'll shoot wildlife. I've always had a love affair with the natural environment, and so this was an opportunity to keep going out there."

While he searched for wildlife, "all the nice-looking landscapes" seduced him. When he began to submit to *Arizona Highways*, where the editors favor large format transparencies, he moved to a 4x5 camera. "Oh man, it tried my patience— and it still does. It is so slow, and you've got to be meticulous. I guess my background as an engineer helped me to understand how these tilts and swings operated."

He "kept working at it till I got to where I could see some scenes that made sense." Today, his photographs appear in *Arizona Highways* and in books published by Northland Publishing. He could have shifted to engineering consulting when he retired, but "I'd rather be doing what I'm doing by far than piling up a big bank account and taking trips to Tahiti."

McDonald began with the rim—trying to capture the classic sunset shot from Mather and Yavapai points. It took four or five years before a summer storm yielded

ROBERT MCDONALD

A Love Affair with the Rim

that "amazing light," and he remains absorbed by the rim. "It's only eighty miles from where I live in Flagstaff, and I have made close to a hundred photo trips up there. It's all in the weather. I hope for stormy weather, with the sun popping out just before sunset or at sunrise." And it's always a risk: half of those trips produced "no shot worth keeping."

He plans most of his visits during the summer thunderstorm season or during winter snowstorms. Other times, he just "goes up there and sees what happens." "Maybe more than composition," McDonald dreams of light and shadow. "I think about it in my head ahead of time, about how it's going to look at sunrise, sunset. More often than not, it doesn't turn out that way. You have to improvise on the spot when it happens."

His outdoor skills prove useful, "particularly at Toroweap, where you have the tripod on the edge of a thousand-foot vertical drop. It makes you watch where you put your feet real carefully. I had a sandbag that I tied to the leg of the tripod that would hold it down to make me feel more secure, particularly if any wind blew. As you get instinctive about the limitations of the view camera, what it takes to keep it steady, then things smooth out. It takes a few years."

Robert McDonald shoots elsewhere: Arizona's White Mountains in summer; the desert with spring wildflowers and monsoon thunderstorms; California. But he is "never bored" by the Grand Canyon. "Every time you go up there, it's always different. You can never duplicate exactly any shot that anyone ever made. The way the sunset paints all those buttes and temples, there's just no place comparable."

ROBERT MCDONALD
Mather Point, view of Zoroaster and Brahma Temples as a winter storm clears at sunset

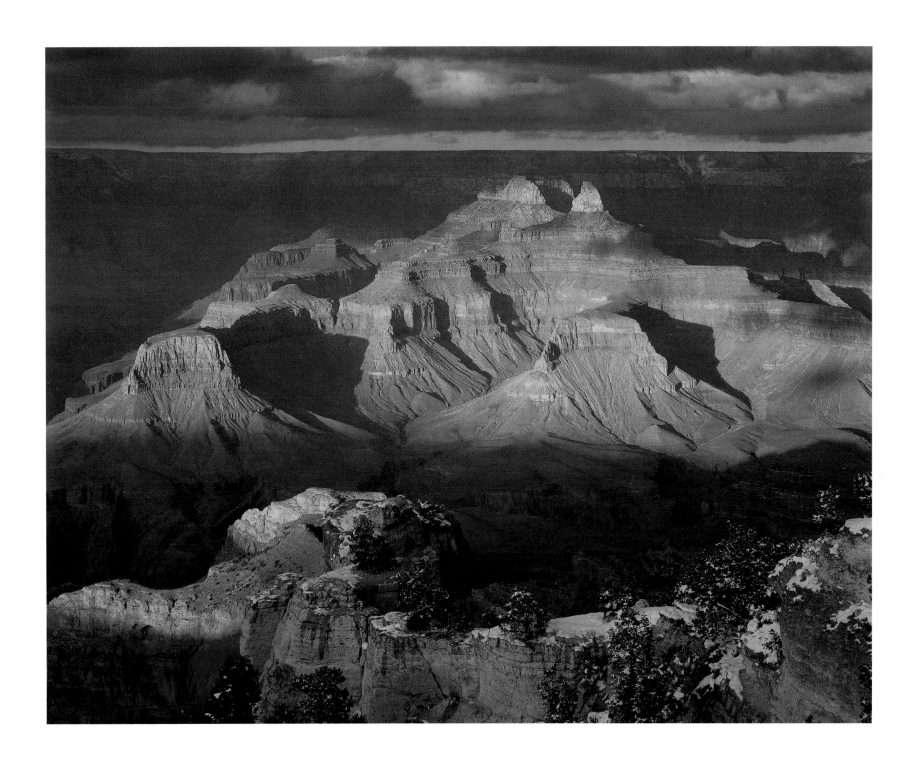

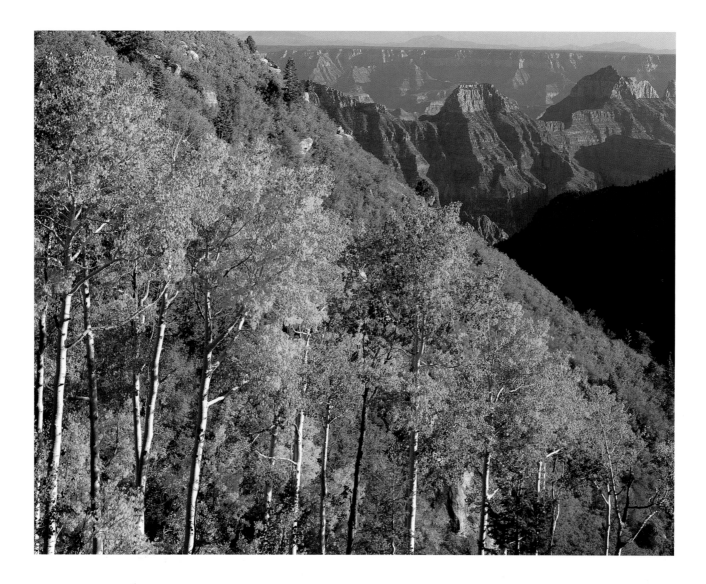

ROBERT MCDONALD

*Uncle Jim Point, aspens and maple, view of
Brahma and Zoroaster Temples*

[OPPOSITE]

View of Yavapai Point from the east at sunset

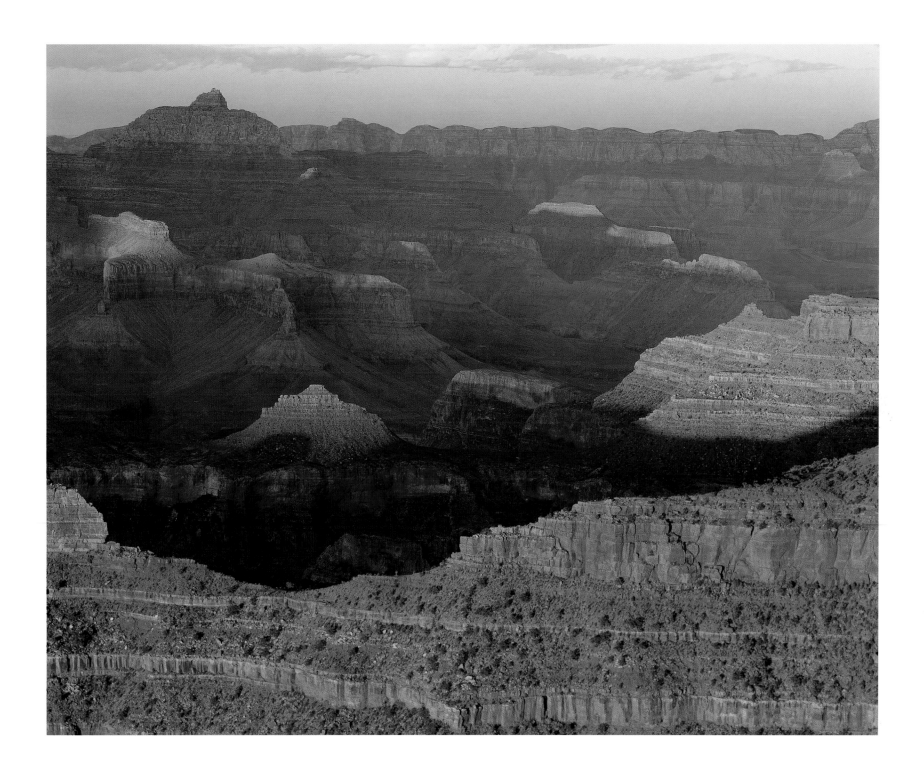

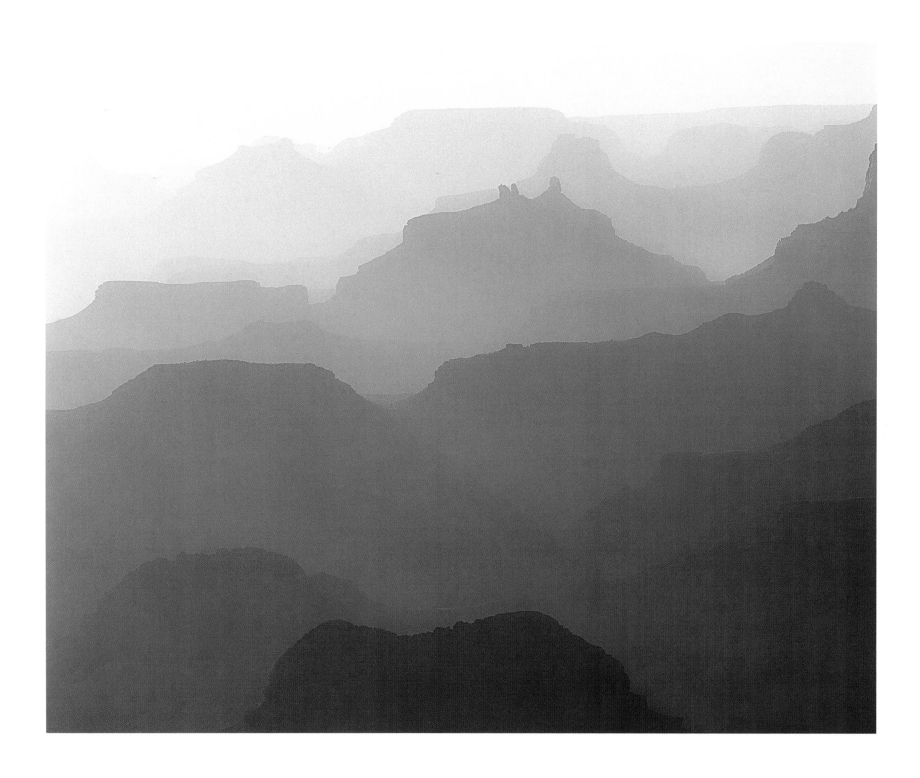

ROBERT MCDONALD

Angels Window at sunrise

[*OPPOSITE*]

*Solomon Temple, Angels Gate, Zoroaster Temple, Shiva
Temple: ships sailing in fog*

✦ *The shot of "haze" (it's smog) in the Canyon was made during a
summer trip. It reminds me of a bunch of ships sailing in fog out there.*

*I went up and looked off into the Canyon at Mather Point and thought,
'God, there's nothing here, I might as well go home. But I'll take the
East Rim drive.' When I stopped at Navajo Point and looked to the
west, I could see the haunting look of all of the buttes and temples
as their outlines varied from dark, foreground, to light in the distance.
It was blowing a gale where I set up. I had to scurry around and find
some rocks to set on the bed of my 4x5 view camera to try to steady
it. I used a 600 mm telephoto lens. I exposed several sheets of film,
but that one shot was the only one that turned out without a little bit
of camera shake.*

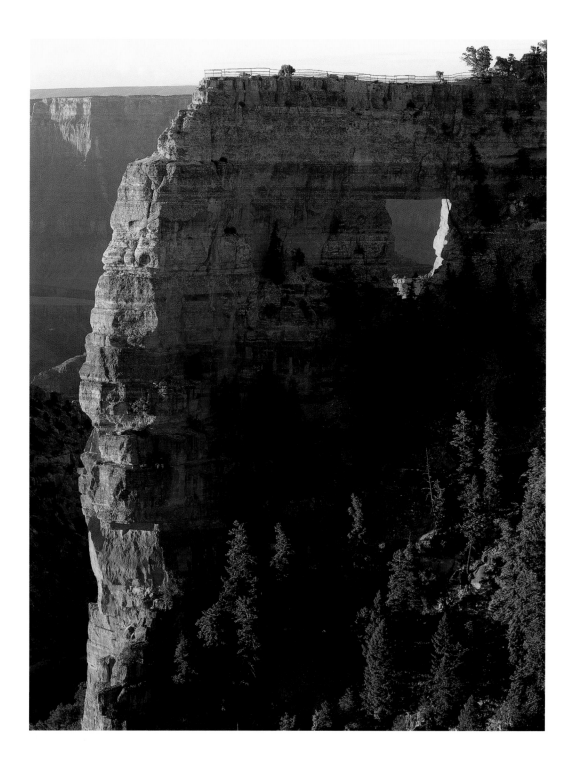

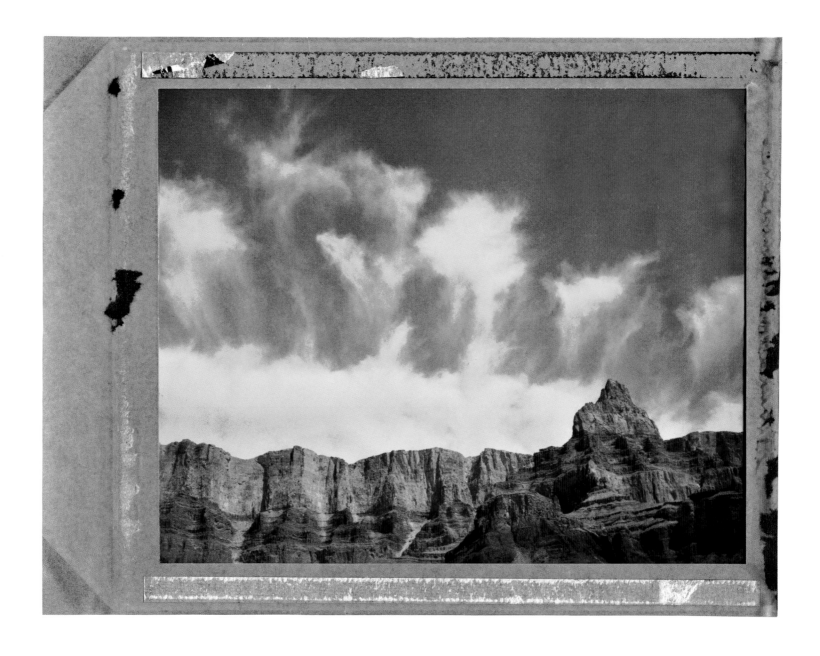

JOHN RUNNING HAS RUN THE RIVER in Grand Canyon at least once every year since 1972. This is remarkable not because he lives in Flagstaff or because his son has been a river guide for twenty years or because his daughter has run the river more times than he has. It's remarkable because he has worked on so many other photographic projects along the way—from the Gaza Strip to Mexico, from Jamaica to Scotland—and, still, the Colorado River holds him.

He has traded photography for trips. He has rowed science trips for the Museum of Northern Arizona. He has worked as his son's swamper on commercial trips. And he still photographs. "Every time, I see new things."

Running studied earth sciences and anthropology in college and landed in Flagstaff after four years in the Marines. For nearly forty years, his downtown studio has been the central node in a lively community of photographers. Now, he shares the studio with his daughter, photographer Raechel Running.

A John Running photograph has a strong sense of design. He muses that this is "studied, and studied enough to be internalized. I've been taking photographs since the late sixties. I'm always looking at photographs in books; I'm always looking at the world around me. And then, you just try to figure it out. All we have as photographers is just our frame."

William Albert Allard wrote in the foreword to Running's book of Native American photographs, *Honor Dance,* that John takes "honest photographs." The photographs were "given to the photographer willingly, and you can't steal what is meant as a gift." Running has given back, in his relationships with

JOHN RUNNING

What the Canyon Gives You

his Indian friends, and in his mentoring of a generation of younger photographers.

The Canyon is part of John Running's life. He wears a silver bracelet that records the number of trips he made with his partner, Sue Bennett, before her death. "I made one for myself and one for Bennett, and I would file a new notch after each trip we made together." He pauses and counts the deep grooves. "Sixteen trips. Bennett and I have done sixteen trips together." He is philosophical about the pictures yielded on each of those trips. "I look for things to happen. I wait for them. Maybe you won't get them this year, but maybe you'll see them next year." And these aren't the "big landscapey pictures" necessarily. "When I'm down there, I'm always kind of overwhelmed by the Canyon. And so I tend not to make very big pictures." Instead, he photographs raven tracks and datura and waves.

John Running has worked primarily in 35 mm, in both color and black-and-white, and now works nearly exclusively with a digital camera. "I love it. I have more control. I can do more. I can be more precise."

Shooting nudes lately has taught him that "if you submit to the model rather than try to control what the model is giving, I think you make better pictures." And Running has realized that this applies equally to photographing what the Grand Canyon has to give. "You have to submit to the individual cactus flower. If you are doing a landscape, you are going to make a photograph of what it gives you. This idea of communication isn't just between a photographer and a model; it can be between a photographer and a California kingsnake."

PHOTO © RAECHEL RUNNING

[OPPOSITE]

JOHN RUNNING

"Mister W" mare's tails over Comanche Point

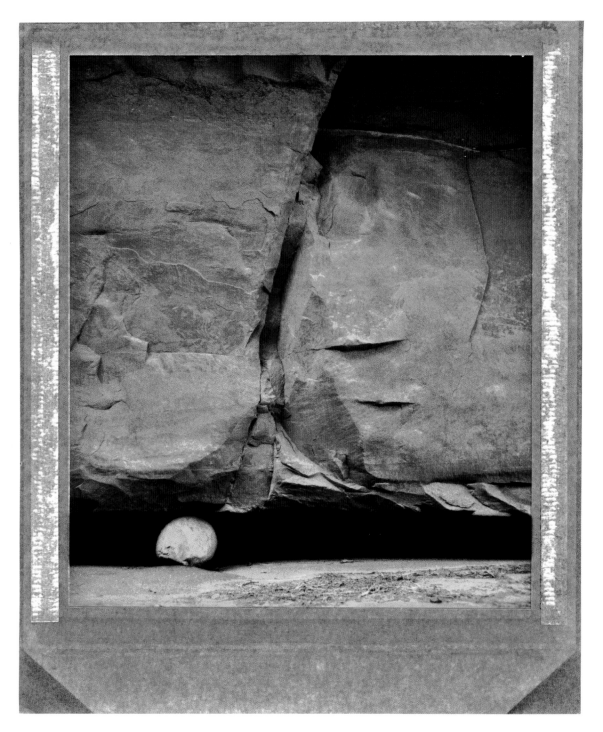

JOHN RUNNING

Rock in Rider Canyon, homage to John Bennett

❂ *There's one rock up Rider Canyon. It was one of the first pictures I did with the 4x5, and, to me, one of the more successful ones. I just really like that picture. When Sue Bennett's dad was dying, he had brain cancer. When he was in the hospital, I took him a copy of that picture and told him, this reminds me of you. He was fighting it real hard. He was determined to lick this thing. To me, he was like that rock, with all that stuff above him. And he was holding it all up there. That's a very personal picture to me.*

Photograph taken with a 4x5 camera on sepia Polaroid film

JOHN RUNNING

California king snake

✿ *I was above 75-Mile and I was rowing a boat, and I saw this snake swimming. I think he fell in the river someplace. The snake was right in the middle of the rapid, and I grabbed the snake and threw him in a bucket and then ran the rapid and took him out and put him on a rock. He was kind of cooled down so he was a little bit docile. Here is what I wrote about him:*

A California kingsnake rescued from the middle of the ice-cold river warms itself, calmly warms itself on a rock before resuming its search for food. Rattlesnake is its favorite meal.

Photograph taken with a 4x5 camera on sepia Polaroid film

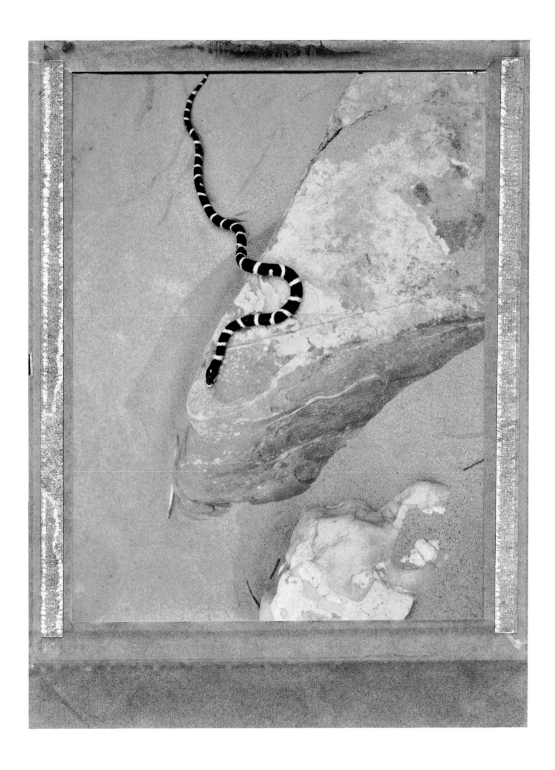

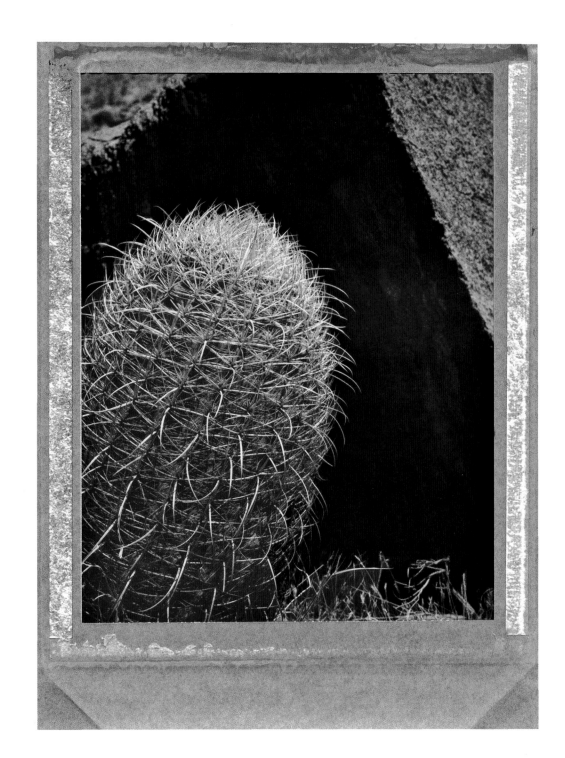

JOHN RUNNING
Barrel cactus near Three Springs

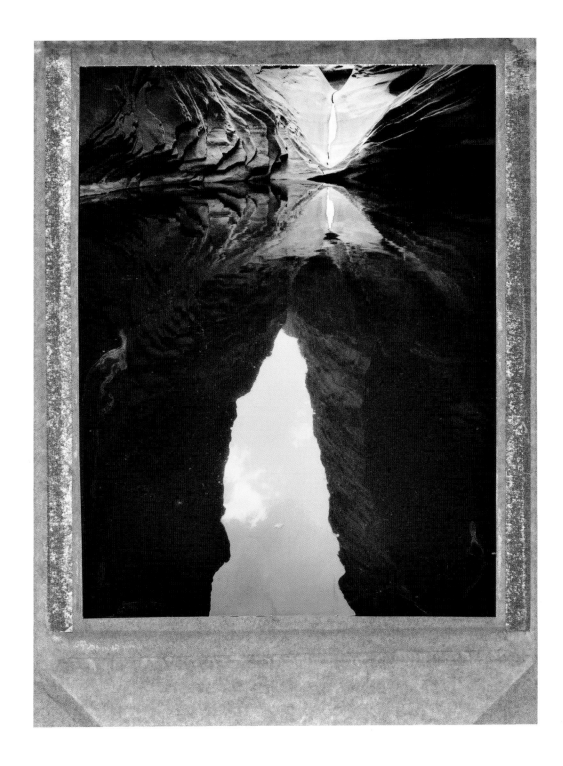

JOHN RUNNING

North Canyon reflection, Mother Earth and Father Sky

✿ *How do you photograph one of these slot canyons? I don't know. But here is my thought about North Canyon. To me it's an ultimate image of the Canyon, and it's a very female image. I responded to that. The notch up at the top of the picture is almost vaginal to me. Where the light is a male kind of image. It reflects some of my beliefs that are parallel to Navajo beliefs about Father Sky inseminating Mother Earth. I don't have specific words for it. I just totally reacted to that when I saw it.*

I walked up there and I had four sheets of film with me. I had taken two on the way. I had two sheets of film left. I think I screwed up one. I looked at it and adjusted the exposure and took this one. Everybody was surprised that I included more of the water in the reflection of the sky than showing the rock up above. In other words, I showed the sky by looking down.

Photograph taken with a 4x5 camera on sepia Polaroid film

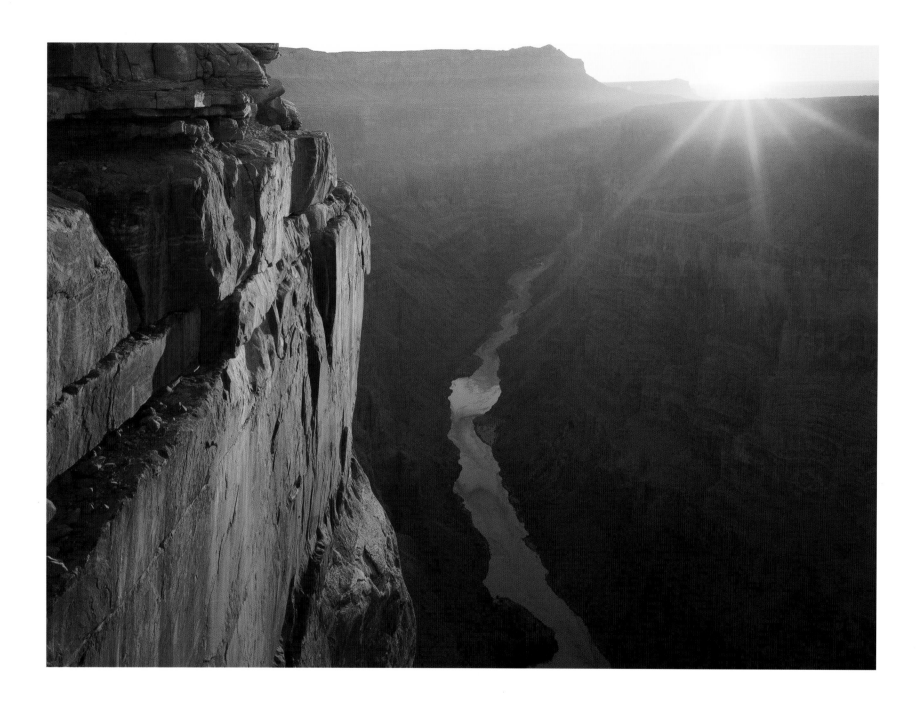

JACK DYKINGA CAME TO THE GRAND CANYON for the first time as a "windshield tourist" in 1971—but with a newly-won Pulitzer Prize in feature photography already at the top of his resume. For that prize-winning *Chicago Sun Times* assignment, he had photographed patients at what was then the Illinois State School for the Retarded. Five years later, when the *Arizona Daily Star* offered him a job as photo editor he was ready to leave the "dreams and nightmares" still roiling around in his brain and head west.

Living in Tucson nourished his environmental ethic, and he began to shift his photographic energies to landscape. Philip Hyde served as a model: "His work has done even more than Ansel Adams to foster land preservation and conservation."

JACK DYKINGA

Patience, Punctuated by Impact

Dykinga left the paper in 1981 but kept Tucson as his home base. After twenty-five years of publishing images in *Arizona Highways* and *National Geographic* and eight books to his credit, the title of his recent *Jack Dykinga's Arizona* has multiple layers of meaning. This is his place—and the Grand Canyon is on the cover of his book.

Dykinga is devoted to his Arca Swiss 4x5 camera. He embraces the solitude "that lifts your spirit and allows you to do great work" with this "very demanding camera that requires absolute attention." If he gets two photographs a day, he is happy. "The Canyon teaches you patience. I start with the details. I'm always looking for that great view—and then you have to wait for the weather to come to you. I look at hundreds of locations and edit down in my brain. It's very methodical and deliberate."

Doing good work means "going back time and time again, getting up at three in the morning, hiking up for the first light, wearing headlamps, and doing crazy things." The crazy things include setting up his tripod on the side of a cliff perpendicular to the wall after a rappel; using a fixed rope to get a good angle on a balanced rock near Cape Royal. "The harder you work, the luckier you get." He is looking for weather, to create mood, for "mood is what elicits impact and emotion—and I think I've experienced every single mood, from sandstorms to icestorms to waiting out a storm in a cave on the Kaibab Trail."

Dykinga understands storytelling. His work often grows into books about the deserts of the American Southwest and Mexican Northwest with a strong conservation message. He paces the reader visually: "You sometimes want to create a sense of quiet or peace and then punctuate it with impact. So it's like writing: some verbs are more active than others." It's no accident that Dykinga favors verbs as a metaphor for his style. One art commentator traveled the same path when he concluded that Dykinga's muscular "photographic prose" makes use of few adjectives.

Dykinga loves the "distance" of the Canyon: "A canyon photographer is able to see the long view, and you tend to gravitate to wide-angle lenses. You see a whole storm cell isolated over one butte. That's the beauty of the rim."

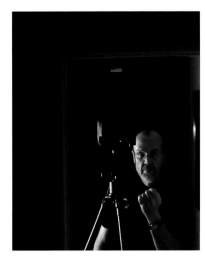

"The place is more important than the individual. This is everybody's park," says Dykinga. "After a really great shoot, I always say, 'thank you.' And it's not to a particular deity; it's 'thank you' to the place."

[OPPOSITE]

JACK DYKINGA

Toroweap overlook in morning light

✿ *I start by zeroing in on little details and then I'm always looking for that great view—and then wait for the weather to fill in the blanks.*

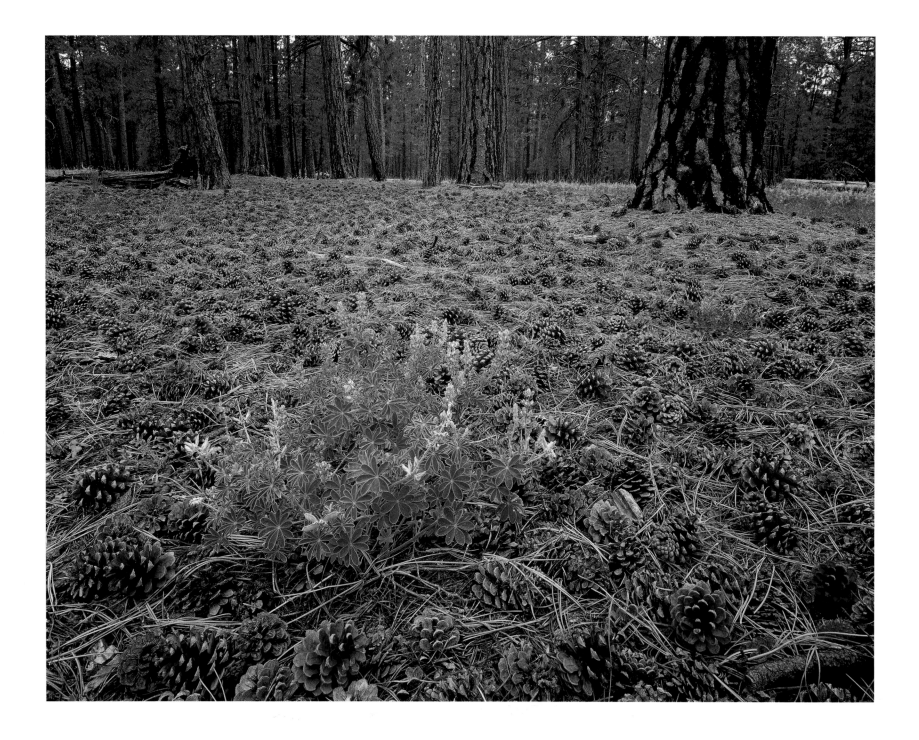

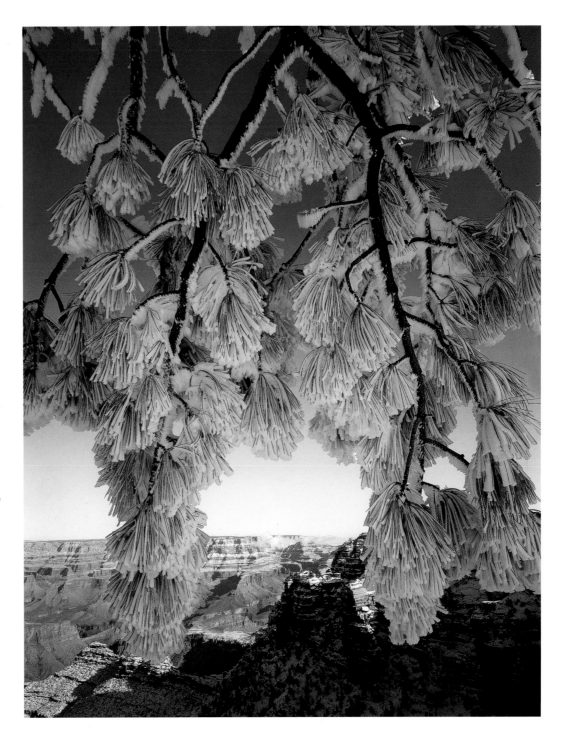

JACK DYKINGA

Snow-covered ponderosa pine, North Rim

☼ I think I've experienced every single mood, from sandstorms to ice-storms to waiting out a storm in a cave on the Kaibab Trail. For a photographer, mood is what elicits impact and emotion.

I've skied across the Canyon five or six times. Once, skiing into the North Rim with Bruce Babbitt, his bodyguard got hypothermia. He wore a downhill ski outfit and just cooked inside and then he got cold. Another time we skied into North Kaibab. The boatman marooned us there and we had to get evacuated by helicopter. The boatman just didn't show.

[*OPPOSITE*]

Lupine in sea of ponderosa pine cones near
Tiyo Point, North Rim

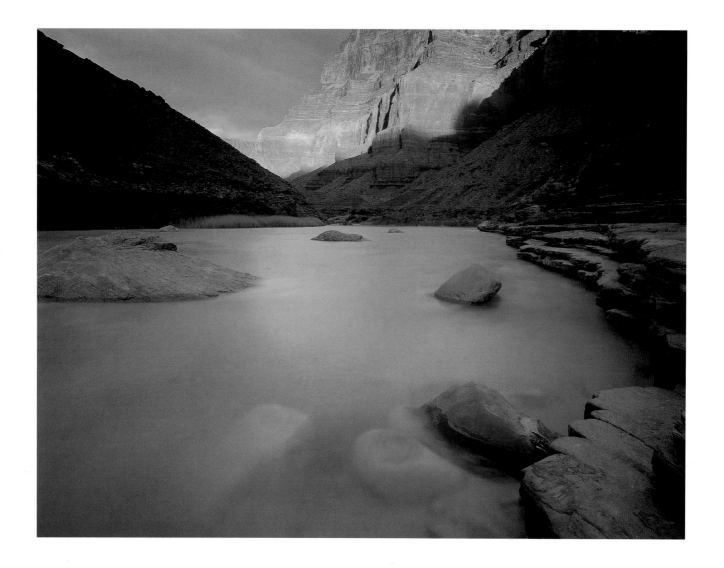

JACK DYKINGA

Little Colorado River at dawn

[*OPPOSITE*]

Toroweap. Beargrass at dawn
over the Colorado River gorge

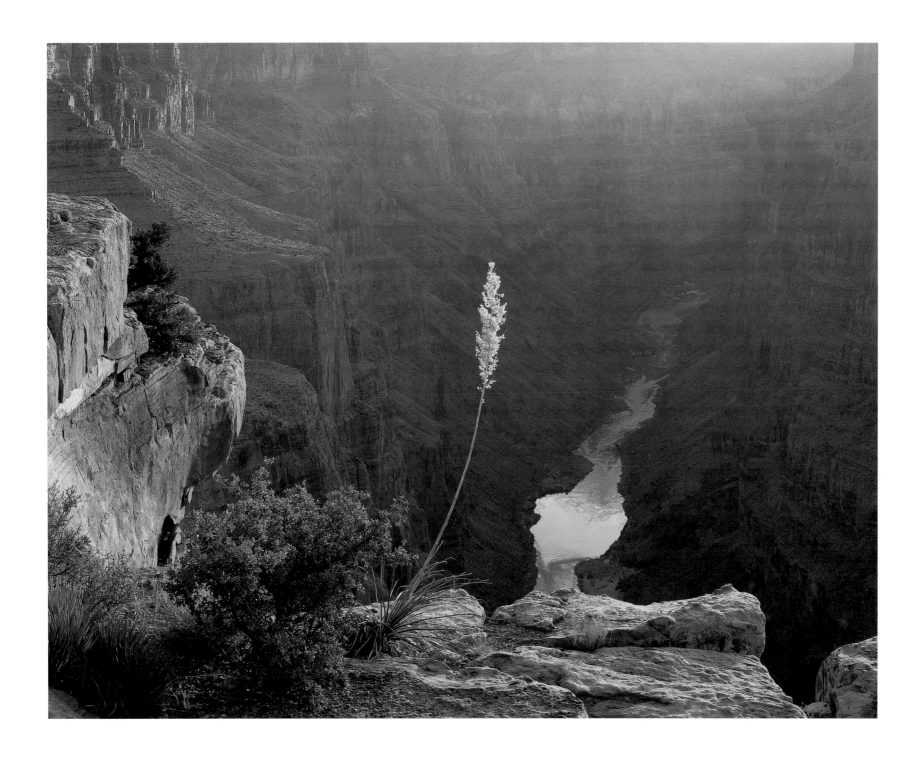

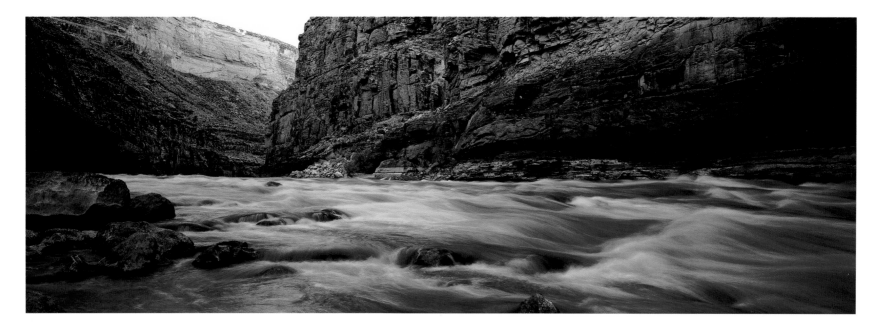

JAMES COWLIN
Panorama, The Colorado River at House Rock Rapid,
Marble Canyon

IN 1976, JIM COWLIN TRAVELED ACROSS ARIZONA with the painter Merrill Mahaffey. They went to Toroweap, gathering images on which to base the monumental, realistic paintings that Mahaffey creates. Ever since, Cowlin has thought of his photographs as painterly and has looked to Grand Canyon paintings more than photographs for inspiration.

Cowlin established his credentials as a landscape photographer by walking the length of the Verde River with his camera in 1979. He loves big projects with "unifying themes" that tell stories, and years later he took on the CD-Rom project, *Explore Grand Canyon*. Cowlin spent the better part of 1994 photographing from every viewpoint on the North and South rims and shooting nearly mile-by-mile coverage along the river. Every click on a map pops up one of 1,300 James Cowlin Grand Canyon photographs on the disk.

A paradox lies at the heart of Cowlin's relationship with the Grand Canyon. On the one hand, "when I'm standing next to the Vishnu Schist, it always makes me feel like my lifespan is miniscule—a piece of dust in the grand scheme of things. While I feel insignificant, it's also exhilarating to have this awesome feeling that all of those billions of years of evolution got me to the point where I'm here to take pictures and share my feelings and my consciousness of the Grand Canyon with other people."

Cowlin began shooting panoramic photographs in 1986 when a hotel in his hometown of Phoenix gave him a mural commission. The client had a vision: a 6x37-foot image of moving water in front of red rocks. Jim knew that he could find this in the Grand Canyon,

JAMES COWLIN

*Shooting the Space
in Between*

probably in Marble Canyon, and likely at House Rock. He was right, but "I had to come out of that canyon with a photograph. If I didn't get it, I'd just wasted $6,000 of my client's money! I didn't really enjoy the river trip—until I got back and saw the film and realized I had the shot."

Cowlin speaks comfortably of scale and space. "I enjoy stacking planes: I call it shooting the space in between—finding a way to differentiate the planes as the view recedes." He goes on, in his painterly vocabulary. "When you put a horizon in, it defines the scale. For about ten years, I almost always cut the horizons out. I liked the mystery, the undefined scale."

He also likes color. In fact, he has played with making photographs where "the forms were revealed not by their lightness or darkness, not by their luminosity, but by pure color. That's what led me to eliminating direct light from the photograph by shooting a half hour before sunrise and a half hour after sunset, when the light is nothing more than that wonderful red stuff that's reflecting off of the sky."

Jim Cowlin knows that "every landscape photographer in the world has been to the Grand Canyon and made Grand Canyon pictures." But it doesn't matter. "Because it's never the same—and so there is always a picture to be made, if you are in the right place at the right time. But you have

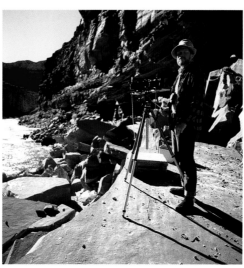

to be willing to get up at five in the morning, put your boots on, put the tripod over your shoulder, have your light meter ready, be thinking, be prepared, have an idea of where you want to go, have all that background, have all that technique down, and be ready for it when it happens."

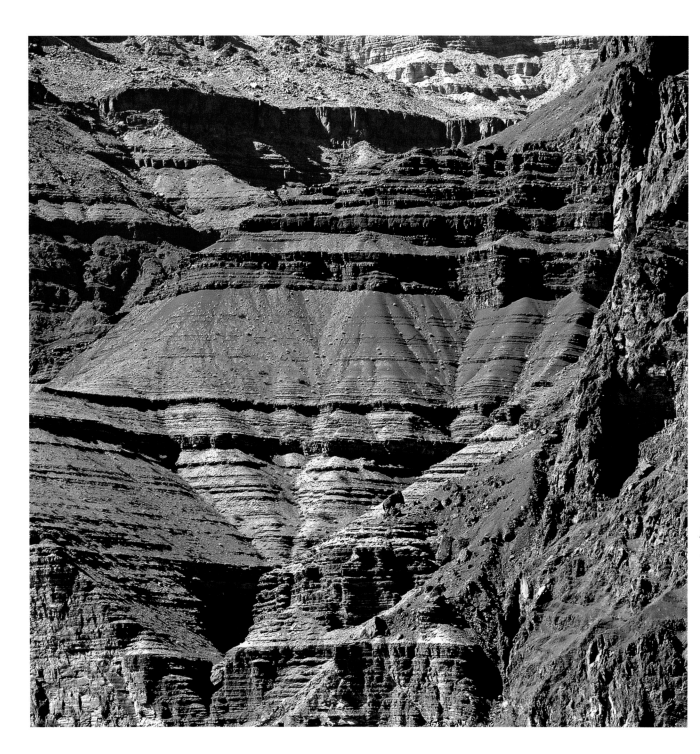

JAMES COWLIN

Basalt Canyon

JAMES COWLIN

Sunset on the edge of Horseshoe Mesa

◉ *The picture looking back on Horseshoe Mesa—that was the last night of a hike. We hiked down New Hance and across the Tonto to Grandview, and the next to the last day we hiked to the Grandview campground at the top of Horseshoe Mesa.*

I like to shoot the rocks, but there is another thing that I always have enjoyed finding, and that's stacking planes. I call it shooting the space in between. What's important to me in the photograph is finding a way to differentiate the different planes in the photograph as the view recedes into the background. This is a really good example of that idea for me.

In a lot of my work for about ten years, I almost always cut the horizons out. I liked the mystery. When you put a horizon in, it defines the scale. And I've always liked the mystery of the undefined scale. You can't tell sometimes whether the shot is a closeup of a little rock or a huge view of a great big wall of the Grand Canyon.

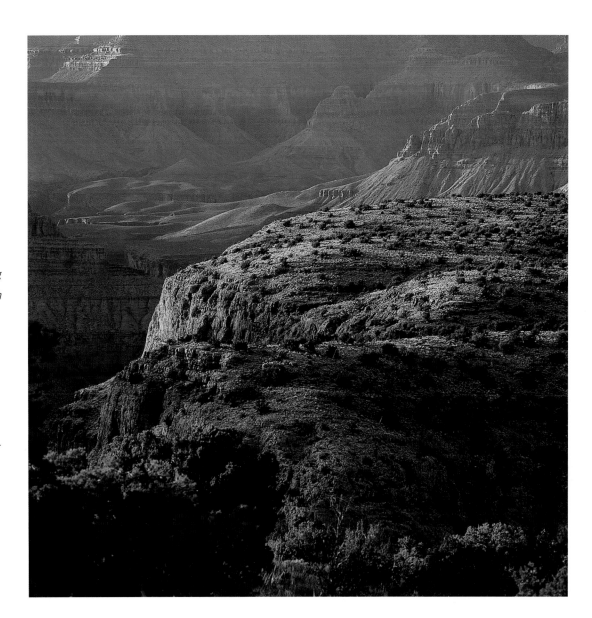

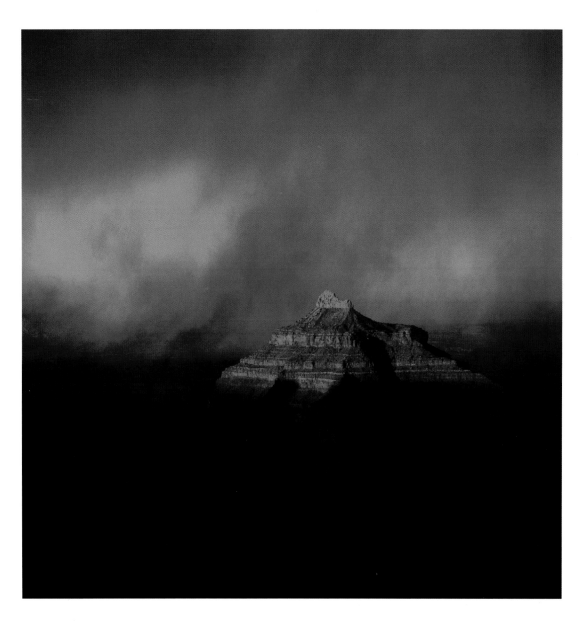

JAMES COWLIN

Snowstorm at sunset over Isis Temple

⊘ *That snowstorm picture has been a favorite of mine. It looks so warm and inviting, it's always been hard for people to grasp that that's swirling snow, not clouds.*

The picture was taken at the end of a four-day hike. I had just gotten married—back in 1984, and I had been wanting to take my wife, Barb, on a Grand Canyon hike. At Thanksgiving, we hiked down the Grandview to the Boucher then across the Tonto and then it was about our third night, we camped at the rapids at Hermit. We went to sleep and it rained almost all night. We could hear the rocks tumbling down all around us. We woke up and got out of the tent and looked up at the rim and it was solid white.

It was our last day, so we had to hike from Hance Rapid to the rim. By the time we got to the top, we were both exhausted, both frozen, and just wanted nothing more than to get back to Grand Canyon Village and get a room for the night and get warmed up.

We had left our car at Hermit, and we piled the backpacks in the back of the car and turned on the heater and started back toward the village. And it was just before sunset, we were driving by and I looked and said, 'Oh my god, look at that!' I said, 'Barb, I've got to stop. You can stay in the car.' I fumbled the camera out of my backpack and I think I got it onto the tripod and I set it up and my fingers were so cold I could hardly manipulate the camera. I think I got all of about two shots. There wasn't even time to bracket. And then the light died. It just completely went away. I was absolutely thrilled when the film came back from the lab and there it was.

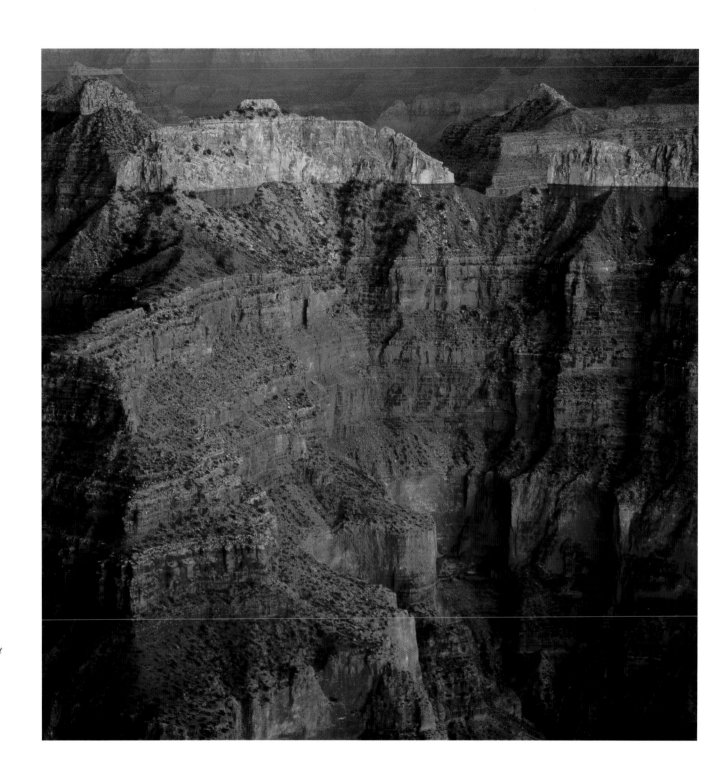

JAMES COWLIN
*Confucius Temple at twilight
from Point Sublime*

JOHN BLAUSTEIN'S 1977 BOOK, *The Hidden Canyon,* is a classic. It grew, serendipitously, from his love affair with the river.

Footloose after graduating from the University of California at Berkeley in 1970, Blaustein met legendary Grand Canyon boatman Martin Litton, who offered him a job as cook's assistant on a dory trip, and then called back and said he'd need him as a boatman for a second trip. Blaustein said, "You're crazy. I've never been in a rowboat and I've only been camping once or twice in my life." Litton persevered, and Blaustein learned well. For more than a decade, he spent a third of each year rowing a dory through Grand Canyon, and he still returns for one trip each year, playing hooky from his commercial photography business in Berkeley to row a baggage raft for dory trips.

At Berkeley, Alaskan wilderness photographer Dave Bohn taught him how to take pictures, and that first year on the river Blaustein took his Hasselblad and black-and-white film, trying hard to be "the next Ansel Adams." He says, with a self-deprecating laugh, "That didn't work out!"

The next year, he decided to bring his father's old Nikon and an ammo box full of Kodachrome. That was the same year—1971—that TIME-LIFE Books sent a photographer for their *American Wilderness* series down the river with Grand Canyon Dories. John Blaustein spent three weeks rowing Ernst Haas through the Grand Canyon, alternately peering through the "incredibly generous" older photographer's viewfinder and listening to him say in his elegant Viennese accent, "This is incredible! I can't believe the book is done. This would have been so perfect for the book."

"The book" was Ernst Haas's newly-published *The Creation,* one of the fundamental documents of twentieth

JOHN BLAUSTEIN

The Magic of the River

century American photography, and Blaustein later pored over it "for hours and hours and hours." Inspired by Haas and in love with the river, Blaustein discovered the "magic to the light there, the magic of being on the river. Light transforms the Canyon. It's simply the rocks and the light."

He stayed with 35 mm "because it allows me to connect more intimately to the subject." On some trips Blaustein shot two rolls, on others, sixty. He cut holes in an ammo can to create a waterproof housing and rigged a trip wire with a $1.50 micro-switch so he could fire his motor drive as he rowed through rapids, the ammo can bracketed to the gunwales—a child's life jacket clipped on so it would float if he lost it.

At the end of each season, he would develop his film and spend hours and weeks "going through the little yellow boxes from Kodak," editing, looking for the gems from those experiments in the rapids, from his explorations from camp.

Blaustein's pictures grew from a relationship with the river that is about more than just photography. "It's those wooden boats, those dories, and running the river and navigating it and the challenge of the rapids. I think that exhilaration over the years combined with the excitement of seeing the place through a viewfinder—that chemistry worked to my advantage. If I'd been a passenger sitting in the boat on trip after trip with my camera, I don't think it would have been the same."

When his friends told him he had a book in his harvest from those little yellow boxes, Blaustein said, "Oh my god, the last thing in the world anybody needs is

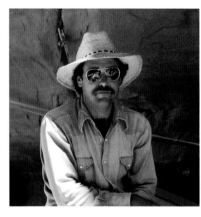

another book on the Grand Canyon!" But his friends said, no, this isn't "another book." "You've *lived* at the bottom of the Grand Canyon."

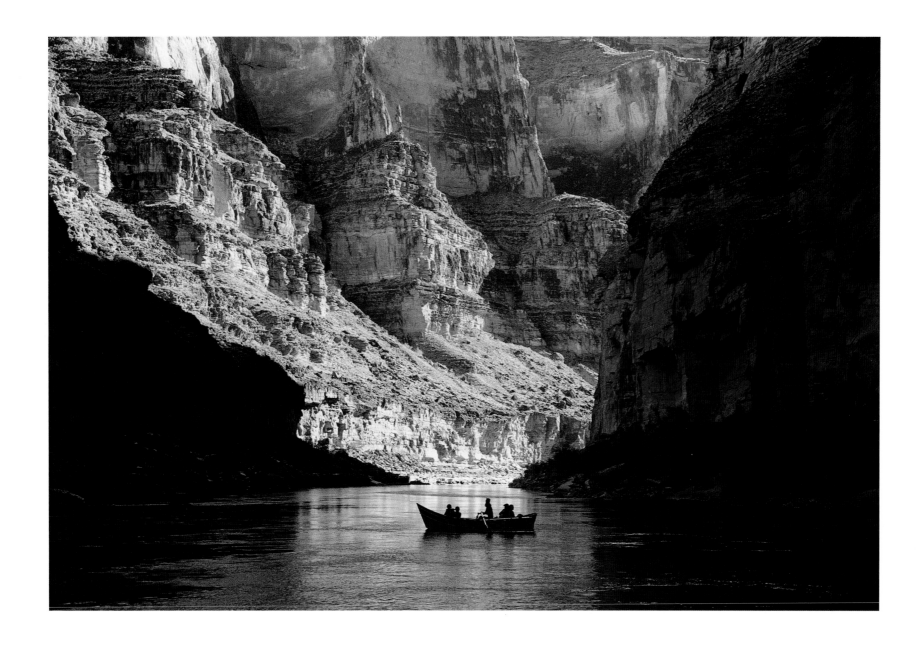

JOHN BLAUSTEIN

Downstream view in late afternoon of dory at mile 162

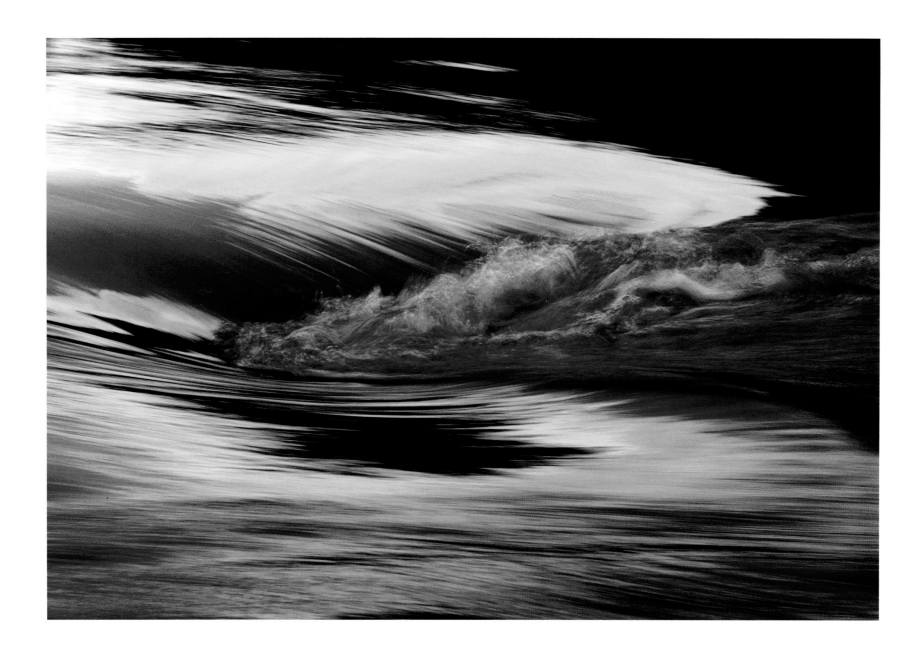

JOHN BLAUSTEIN

Blue wave abstract, mile 202

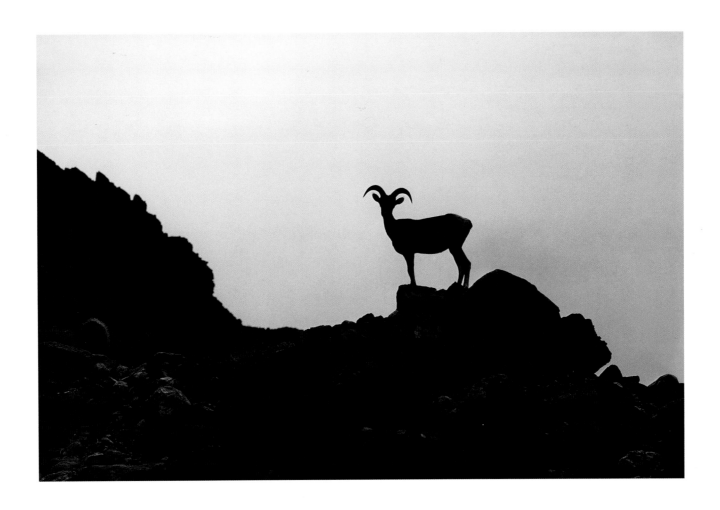

JOHN BLAUSTEIN

Bighorn sheep in 140-Mile Canyon

✿ *I'm not a risk taker. I hate ledges and cliffs. You'll laugh at that, when you know I run this dory down the river. But I'm not a hiker or backpacker or wilderness photographer.*

The Grand Canyon taught me a way of seeing. How to see light and design.

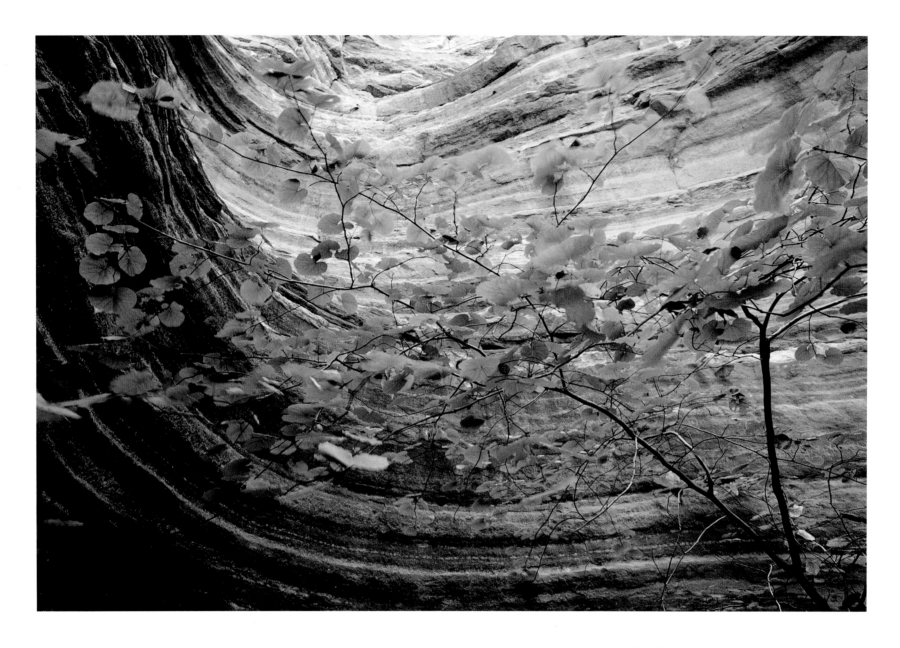

JOHN BLAUSTEIN

Redbud tree in Deer Creek

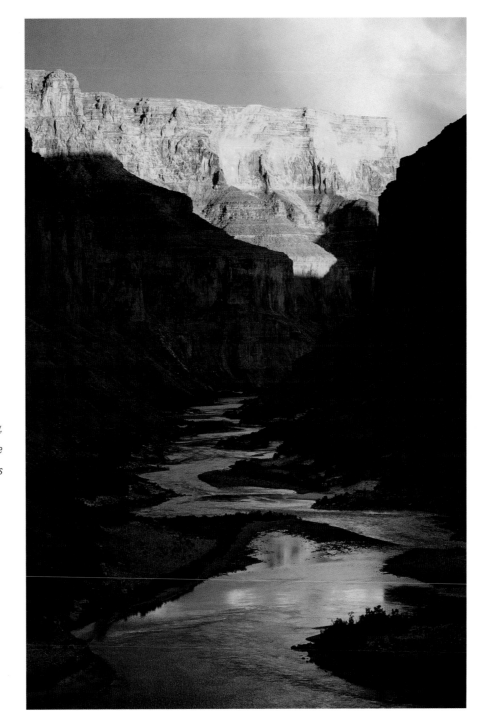

JOHN BLAUSTEIN

Nankoweap, mile 52,
view downstream at sunset

✹ *Realtors say there's three things about real estate: location, location, location. For photography, it's light, light, and light. It's light! It's being aware of what's possible in terms of amazing light, always looking for beautiful light. I can't think of a place for which it's more true: the light transforms the Grand Canyon. It's just bare to the light. You don't have a canopy of trees, forest, fog. It's simply the rocks and the light.*

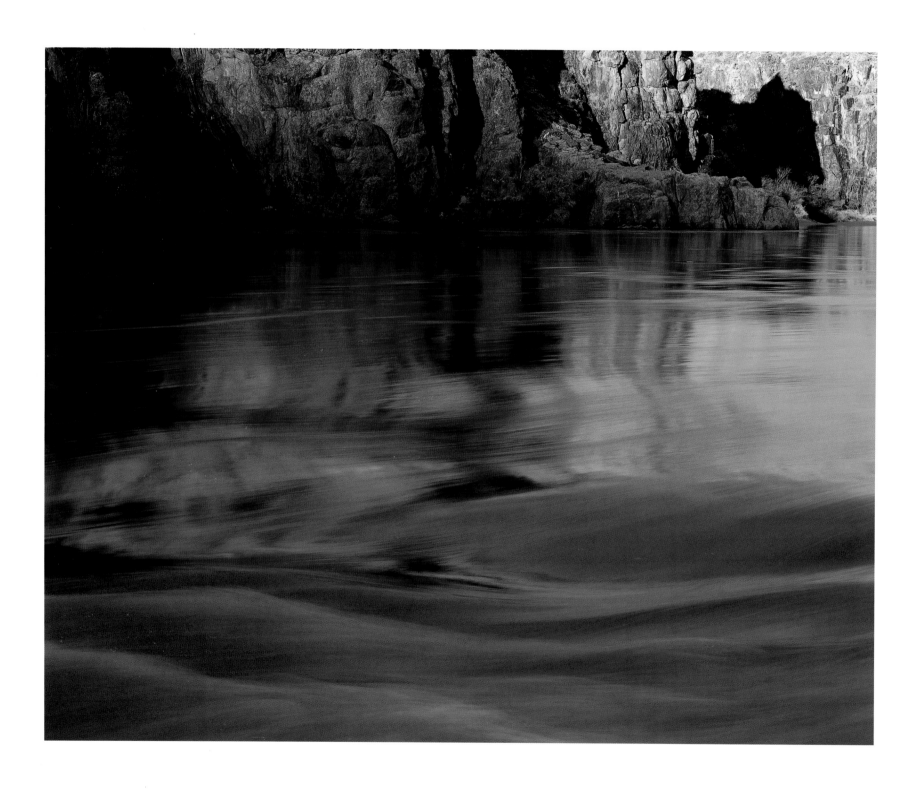

ASK GARY LADD about his Grand Canyon photography, and he will tell you about extended backpacking trips through remote country—hiking around the Walhalla Plateau in 114-degree heat, a nighttime flash flood nearly sweeping him away in Saddle Canyon, backpacking the river corridor from Lees Ferry to Lava Falls, minus just eight miles. Then he'll say, "The 4x5 was taken" on these trips—speaking of the view camera more as a companion, a separate being, than simply his preferred gear.

Ladd came to Arizona from Missouri as a vacationing high school kid. A few years later, he took his first dory trip with Martin Litton. "Dazzled by Grand Canyon," he moved to Arizona in 1972, bought his own dory, worked for a few years as a camera technician in mountaintop observatories (surely why he loves his large format camera), and moved to Page in 1981 to "shorten the commute" to the land that had captured him. He has devoted himself to photographing the Grand Canyon and Lake Powell ever since.

An enduring friendship with legendary backcountry hiker George Steck led to "difficult and fabulous" loops through remote reaches of the Canyon. Ladd remains stunned by its size. "The place is too big, too dry, too well-guarded by rough terrain, poor access, and National Park Service regulations" for a photographer ever to run short of possibilities. "It's maddening and quite wonderful. I look up at those huge vaulted chambers that loom over the river between Kanab Canyon and Cove Canyon and wonder what photogenic wonders are waiting up there. I doubt if anyone has visited most of them. The huge Esplanade—who's seen even one percent of it? No one, I'll bet."

He loves both the river in the Canyon and Lake Powell—and, to his amazement, for many of the same reasons: "it's that boundary between land and water." Ladd admits that Glen

GARY LADD

*Dazzled by
Land and Water*

Canyon Dam "took out one hundred percent of what the river-runners knew." But "a change in lake elevations of five or ten feet can mean that most of what is appealing about a photograph comes or goes with that change. You forget about what Lake Powell did to Glen Canyon, and just *look*."

After twenty-nine river trips and eighty backpacking trips in Grand Canyon, he is still "consumed by the river corridor. I'd like to think that I've about exhausted all possible routine, predictable photos of Grand Canyon—those images that everyone starts out with—but I'm convinced there are still hundreds of great images waiting at river's edge."

For Gary Ladd, the Grand Canyon is "irresistible,"—from its "library of wonderful details overlooked by others" to the "amazingly pleasing photogenic orderliness of its rock units." He figures he still has "enough material in my files for five pretty darn good books" in addition to those he has already published on Lake Powell and Grand Canyon. And he keeps gathering more. He may not have many of those extreme backpack trips left in him, but he thrills at the chances he has to lead *Arizona Highways* photo workshops on the river and to discover the Canyon through the eyes of the geologists whose research trips he has joined.

Working with those geologists can be seductive for the man in love with the Canyon. He must remind himself not to pay too much attention to the bedding planes in the Supai Formation, for it leads to dull pictures. "You have to look for only one thing in a landscape—what it *really* looks like, not what it is or what it represents." And so, Gary Ladd keeps "trying to see. Trying to understand and photograph variations on a theme, a new facet of an old and valued friend—" trying not to let the Canyon's "authority" and "power" overwhelm his understanding of its "coherence."

[*OPPOSITE*] GARY LADD

River in Upper Granite Gorge at top of Granite Falls Rapid

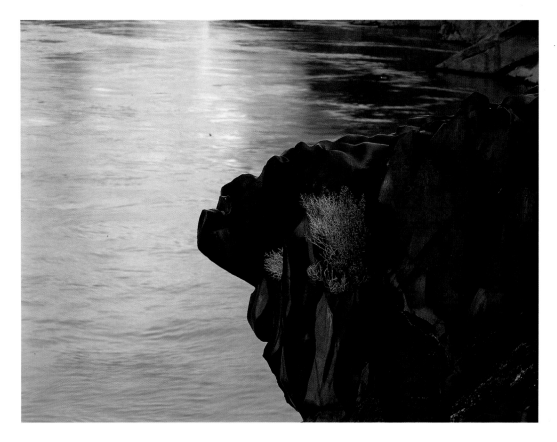

GARY LADD

Precambrian rock, amphibolite, along the Colorado River,
near river mile 127

In 1987 I rowed Grand Canyon on a private permit. We pulled in at the mouth of Sinyala Canyon, the first time I had ever stopped there. I was thrilled to find a sculpture garden, a quarter of an acre of magnificent polished, fluted, carved and engraved limestone boulders. Unfortunately, they really required a cloudy day or the shade of a cliff to portray them adequately in a photograph. This began a long series of frustrating years—not being able to get on the river or not being able to stop there at the right time of day or not being able to guess when there might be a cloudy day.

Finally, about ten years later during a photography workshop river trip, I managed to schedule a visit for early one morning when shade would still cover the debris fan. Dave Foster, our boatman, pushed the raft up to the beach on the downriver side of the mouth of the canyon and I jumped off to scramble up on the boulder field. I was so disoriented that I turned back to Dave to ask if this was really the mouth of Sinyala Canyon. Yes, it was. I turned back to the debris fan and looked again: the entire field was blanketed by basketball-sized angular, rough rocks. Dave then mentioned that Sinyala had flashed big time a few months earlier.

My boulders were still there but they were covered with rubble. We had arrived just a little too late.

[OPPOSITE]

Sunset and sprinkling of rain, view from near river mile 68

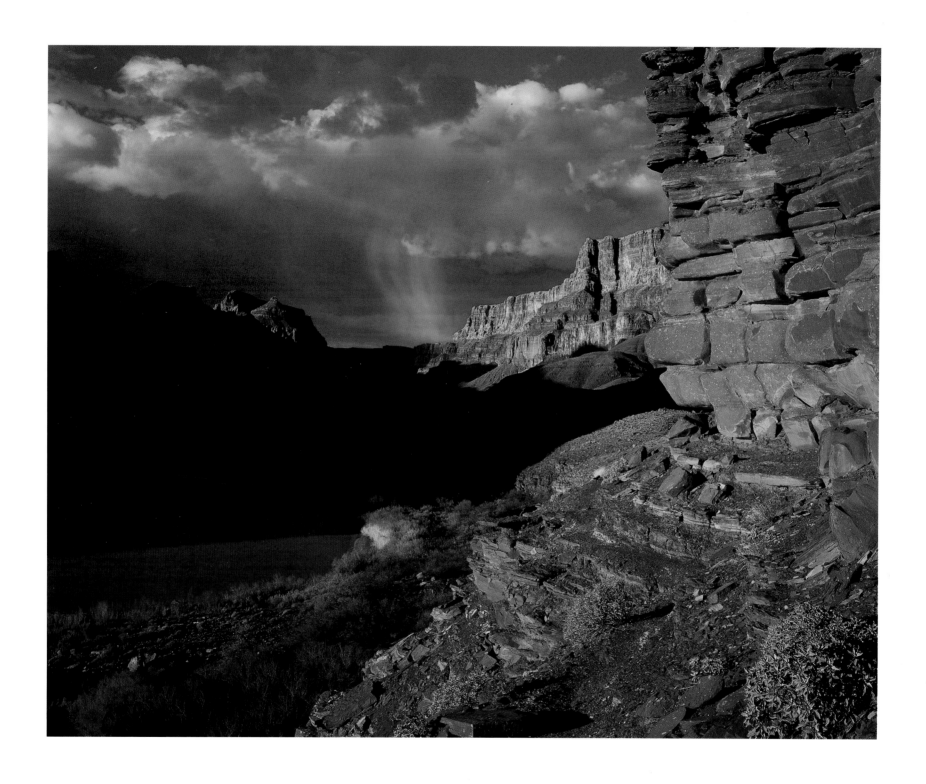

GARY LADD

Sunset at Cape Royal, buckwheat in foreground, Vishnu
Temple in background catching the dramatic final light of day

[*OPPOSITE*]

Reflection, mouth at Cathedral Wash

⊛ I find the Grand Canyon irresistible. It has everything: true wilderness, a fabulous visual interaction between a powerful flowing river and immovable rock, sheer size, an interesting and (still somewhat) mysterious geologic story, and an amazingly pleasing photogenic orderliness of its rock units.

Taking photos of the Canyon connects me with it. When friends are sitting in camp enjoying dinner or a cold drink, I'm often still out there trying to see, understand, and photograph more of the Canyon. The river corridor, the side canyons, the rims, all seem to be variations on a theme. I find it extremely interesting seeing how the variations play out from place to place. Every visit to a new side canyon, every visit to an unfamiliar rim is a chance to uncover a new facet of an old and valued friend.

I would like to think that I've about exhausted all possible routine, predictable photos of Grand Canyon, those images that everyone starts out with as they become familiar with Grand Canyon. If true, I can use my time in looking deeper, looking elsewhere, looking more carefully. And yet, there are still scenes that I just can't resist, even though I know they're already well represented in my files.

SUE BENNETT CAME TO ARIZONA from Los Angeles to study journalism and moved to Flagstaff in the late 1970s. She kept her tie to California, visiting grandnieces and grandnephews she held dear, and it was on a drive back from California on May 1, 2003, that she died in a car accident near Palm Springs. Her life partner, John Running, imagines that she was blown off the road by a gust of wind and overcorrected.

Bennett and Running formed the heart of the Flagstaff photography community for twenty-five years. Bennett shot major advertising campaigns for the biggest possible clients: American Express, Nikon, McDonalds, Dupont. Running believes her success stemmed from the fact that "she did not submit to the subject. In the commercial world, she always chose to make the picture that the client needed, not the picture that the client wanted. She could be very precise and very controlling about her pictures. She even exerted control over what color shoelaces you have on. Really!" Running doesn't mean to be negative: "I mean it a little bit as hero-worship."

Keiji Iwai, Bennett's longtime studio manager and assistant, says that "compromise was not in her dictionary." She couldn't stop trying to improve *everything*, from locations to prints to her portfolio. Iwai sees pride in the faces in her portraits. "The integrity of that person shows in her photographs." Affinity. Empathy.

"Sue went to the Grand Canyon to switch gears," according to Iwai. "Everything she did up here in Flagstaff was so controlled." In contrast, her trips to the Canyon, usually on the river with John Running, gave her a place to "recharge and explore herself in a personal way. The work she did was her personal work. It wasn't what a client hired her to do. It was

SUE BENNETT

Controlled Empathy

PHOTO © JOHN RUNNING

all about her. She had total freedom, and I think that shows in the pictures."

Bennett and Running "went down there to be together in that place," Running says. "It's a nourishing place. Even when it's difficult, it's nourishing." They photographed their way through life, but had "different eyes," in Running's words.

Bennett described her engagement with people in a *Nikon World* portfolio: "Ask questions, observe, be curious." She made friends with her subjects. She laughed with them. And then she took great care with composing her photographs. "The 35 mm negative is quite small, and I don't like to crop, so I make sure that everything in the frame belongs there. I plan my compositions with the full frame in mind."

Both Iwai and Running remember Sue Bennett as someone who did not flaunt success. Running says, "If you asked Sue to show pictures, she probably wouldn't show you pictures from her most successful campaign that she was getting paid thousands and thousand of dollars to do. What she would show you would be pictures of her greatnieces and nephews." Iwai operates Sue's downtown Flagstaff studio as a gallery displaying her photographs, "because she was private about it; she was shy about showing her work. Not many people saw Sue's work before she died."

Iwai respects both John Running and Sue Bennett for their "open-heartedness. They inspired so many people here, including me. I learned a lot from Sue's life and from her pictures. I have tried to approach landscapes the way she approached her models. With the patience...not compromising, just going back to the same spot. Her principle of 'never-give-up, never-compromise,' it's a lesson."

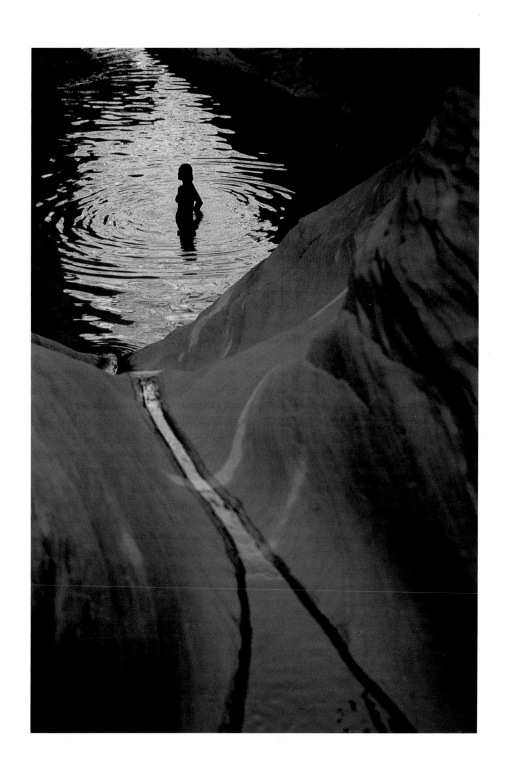

SUE BENNETT

Woman in canyon pool

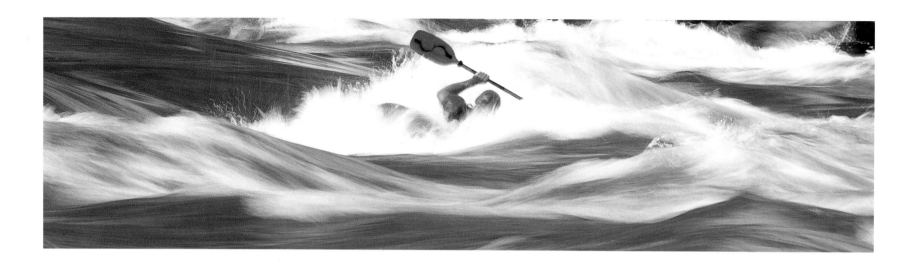

SUE BENNETT

Kayaker in rapids

○ *When the light was right, Bennett rode backward in the front cockpit of a two-man kayak to shoot Belgians kayaking in the Grand Canyon. She described this trip to* Communication Arts: *"Unlike many river-runners who skirt the hydraulics (holes, standing waves), the Belgians aimed for them. One of the older kayakers told me he had waited his whole life to run the Colorado River and he intended to run it, not avoid it."*

"I think the Canyon was a place for Sue to go back and get recharged. Sue did her first trip in the Canyon in the late seventies when she got out of school and worked for the Arizona Department of Tourism. I took her on her second trip in January '81. Sue and I would do about a trip a year. A lot of times, we would do trips where we were doing kayak support. I would be rowing a raft and there would be a lot of kayakers.

The long horizontal of a kayaker surfing a hole—it's not a panoramic camera; she did that crop. Her goal with a lot of these was trying to make pictures that were different, and she was really intrigued with the blurred idea and slow shutter speed."

—JOHN RUNNING

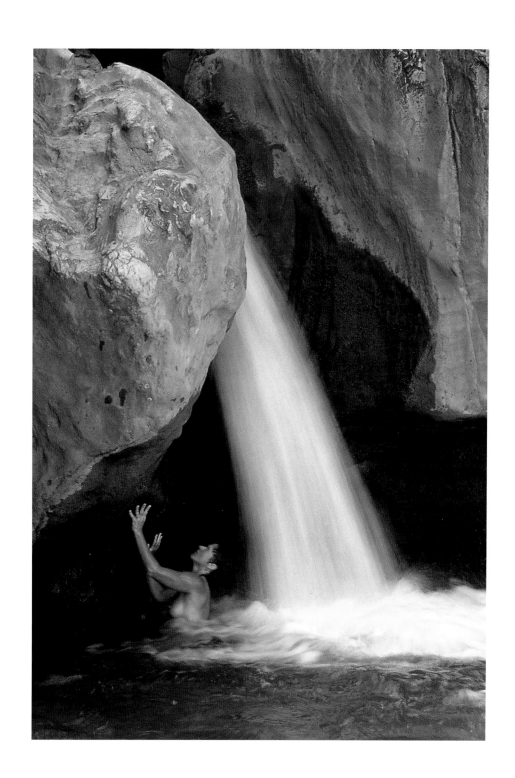

SUE BENNETT

Woman under waterfall

"IF THERE STILL IS A SLIDE FILE at Grand Canyon National Park, I'm sure the rangers are using some of my pictures today. I had the dream job—and that was almost thirty years ago." After working as a park ranger at Wind Cave National Park in South Dakota, Tom Bean's Park Service contacts landed him his first job as a photographer: a two-month stint at Grand Canyon taking pictures for the park.

Bean learned to photograph in the prairie that surrounds Wind Cave, "not one of the celebrated monumental landscapes." His model was David Cavagnaro, whose books *Living Water* (with Ernest Braun) and *This Living Earth* from the 1970s showed Bean how to take lovely pictures "down in the grass," how to "make photographs that didn't include some jaw-dropping vertical expanse of rock and snow and ice."

As a ranger, he moved on to Alaska, where he found his spiritual home at Glacier Bay—a monumental landscape but a relatively unexplored place where he could feel he wasn't following in the path of a hundred other photographers. When Bean became a full-time photographer, however, he came back to Flagstaff (which seemed "like a real town") and married a Grand Canyon ranger, writer Susan Lamb. He retains that love of content and earth science that he has carried with him since photographing for park interpretive programs: "I've tried to take pictures that will be beautiful, interesting to look at, compelling—but that also will explain things."

Tom Bean is from Iowa, and he holds on to an unpretentious commitment to Everyman in his work. He values his ability to "tell the story, to

TOM BEAN

*Big Nature and
Small People*

show the experience, to allow people to project themselves into the picture and not have to imagine that only a mountain climber or risk taker would go there."

This approach frees him from frustration: if "the big view and the perfect light don't work out. I can go take pictures of people getting on the mules. There's just a bunch of things that interest me. An awful lot of my pictures have people in them—a small person in the picture somewhere. It's Big Nature and small people, regardless of whether it's the Grand Canyon or the Great Plains."

Bean shares the professionals' commitment to "agenda-driven" fieldwork. For years, he went up to the Grand Canyon for a few days each year, "looking for rainbows" during the summer monsoons, and in winter, to catch the Canyon in fresh snow. Photographers plot their days in search of exceptional light. "We know enough about lighting and cloud movement that we can think ahead. If you didn't know better, you'd go, 'Oh, it's raining, it's a terrible day.' But if you are experienced with the patterns of weather here, you go, 'This could be exceptional.'" It's a gamble, but "I'd much rather be here on a day like this than if it was just another sunny day in June at the Grand Canyon."

With a certain amount of wonder, Tom Bean admits that he is photographing more people than landscape these days. "It's just as interesting as the first time I showed up at the Grand Canyon to take pictures. When you first pick up a camera, *anything* is new and exciting. But you keep looking for new things to interpret. Out on the Navajo Reservation where I've been working," once again, "I feel I'm showing up for the first time."

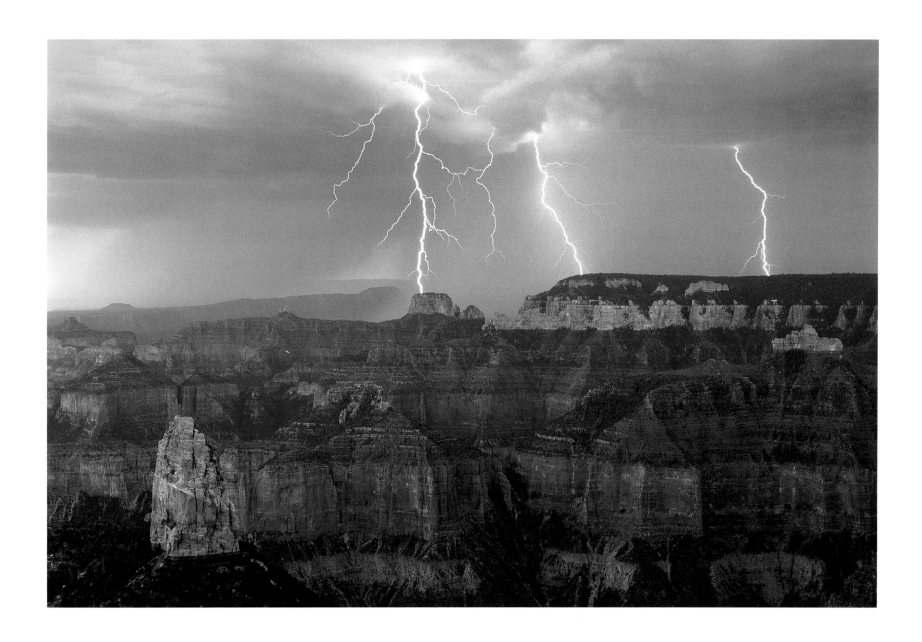

TOM BEAN

Lightning storm over Grand Canyon
from Point Imperial, North Rim

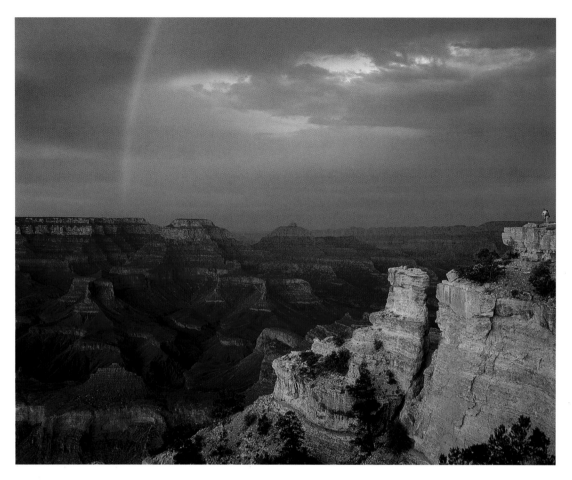

TOM BEAN

Rainbow over Grand Canyon at Yaki Point on South Rim

◉ *I could see that the clouds were building in that classic monsoon pattern. I was looking for rainbows, looking for storms moving around the Canyon late in the afternoon as the sun was near the horizon.*

I was going to drive to the horizon that offered the best place to be—on the west side of a rainstorm, with the sun shining on the storm. It turned out that Yaki Point was just the point. I got out there in a driving rainstorm and just knew the sun was going to come out and make this rainbow. Because I had all my camera gear, I thought, 'This is definitely something you want to get on the bigger format,' so I shot it on 2 1/4. As soon as the sun came out—I think it was still raining—I ran over and started taking pictures.

And then I heard this clip clop clip clop *and behind me in the parking lot, somebody said, 'It's a bighorn sheep!' And I thought, 'I've never seen a bighorn sheep except down at the river, once.' I thought, 'Okay, mule deer. Some pathetic person doesn't know the difference.' But* this *is the best rainbow I've ever seen at the Grand Canyon. So I'm clicking away, and at some point, I turn around, and, damn—it's two bighorn sheep walking through the parking lot.*

Then I was torn between them. The best sighting of bighorn sheep that I've ever had—they are in the parking lot, but maybe, maybe if they were to move out by the rim, you could have the rainbow, the sheep, the Canyon—you'd have it all!

How often does that happen? Can't we space these opportunities out just a little bit?

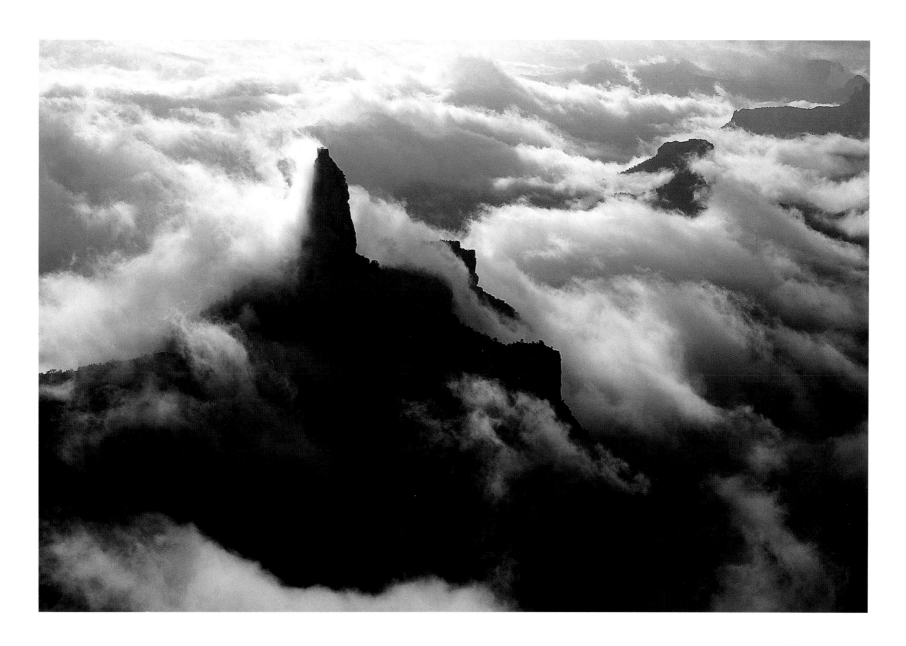

TOM BEAN

Morning clouds at Point Imperial, North Rim

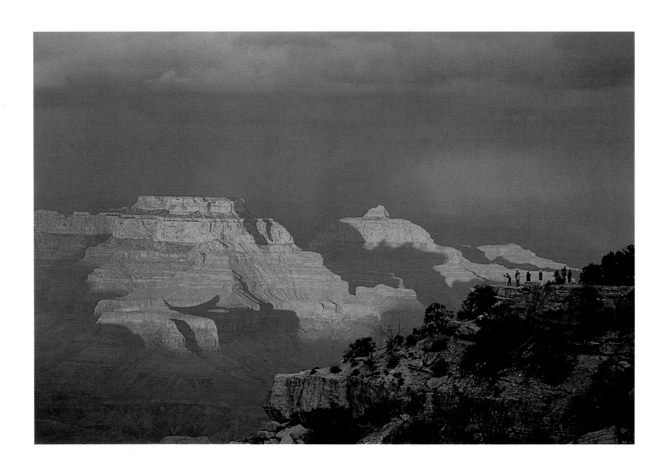

TOM BEAN

People on rim at Powell Memorial, South Rim

❂ *This looks more like a "typical" Tom Bean picture. It's a 35 mm, but it's got little silhouetted figures. They are standing on the rim below Powell Point. And I'm over at Hopi Point—a long ways away. I was photographing for* National Geographic *when I took that picture, and it's really one of my favorite ones from the shoot. It's brilliant colors, dramatic light, but then there's these unidentifiable people dwarfed by the whole thing looking out at the Canyon. It was the title page in a book that* Geographic *did on the Grand Canyon.*

What made it successful? The dramatic light. The rich colors.

There's bright light but also deep bluish shadows. There is that high-contrast, low-angle light. And it's a telephoto shot so everything is kind of telescoped together, and then there are these people there.

If you took the people out of the picture, you wouldn't have a sense of scale, you wouldn't have a sense of involvement. And the fact that you can't tell anything about the people is probably important, too. Because anyone can project themselves into it, and not have to imagine that only a mountain climber or some sort of risk taker would get there.

TOM BEAN

Deep snow, Mather Point at sunrise, South Rim

✺ *I would wait until there was a good snowstorm in Flagstaff. The idea would be to get up to the Canyon just as the storm was ending. Ideally, by the following morning at sunrise, everything would still be covered with snow. It takes about one day when the sun comes out for all the snow to fall off the trees, so that kind of fresh snow on things doesn't last very long.*

I know Larry Ulrich was there at the same time. I think Carr Clifton was shooting at the same time. It wasn't like we all met each other in the parking lot. Somehow, I knew that Larry and Donna were going to be up there. They probably called me and told me. We used to run into each other all the time. We knew each other's cars, even.

I think I saw Larry's or Carr's pictures of the same sunrise; I like theirs better!

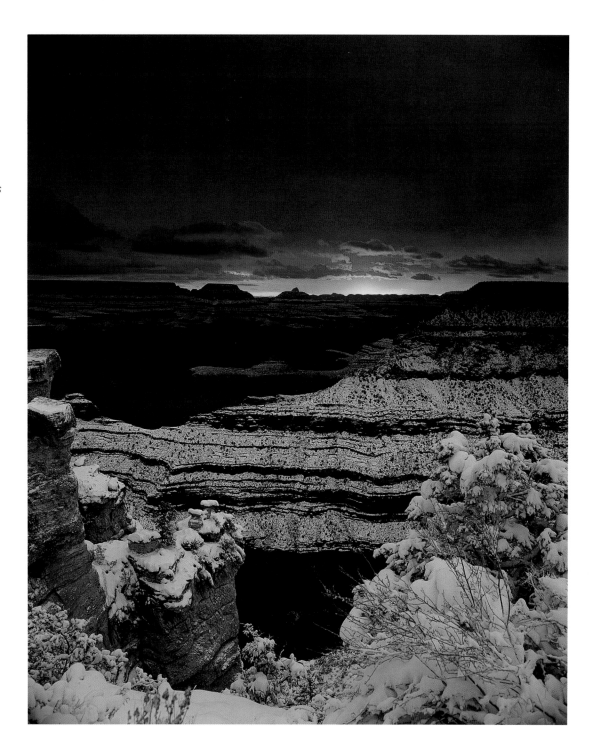

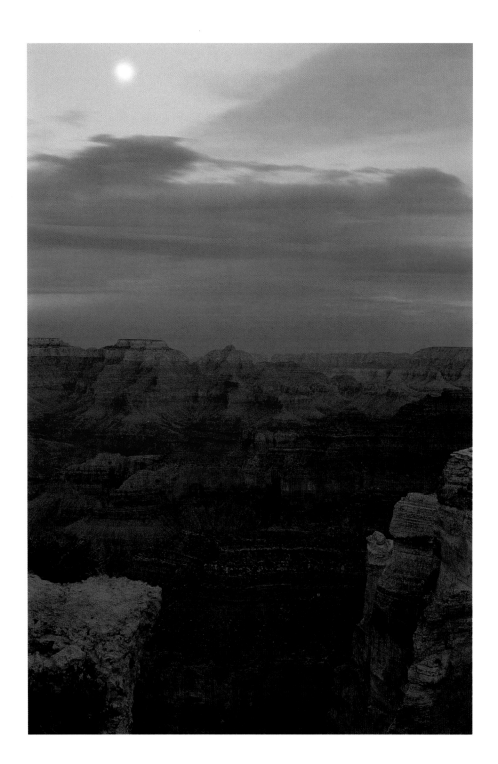

SOA

Enchanted Light

TWENTY-FIVE YEARS AGO, on their first date, Alfredo Conde and Sherri Curtis went photographing in downtown Fort Worth. That afternoon began their collaboration (they photograph together; Conde speaks for the partnership) but says little about their aesthetics, which are considerably more global than downtown Texas. The two spent years traveling in Asia, where they learned to slow down, to "slowly tame the animal of the ticking of the clock."

They returned to the United States from Central America in 1989, planning to bicycle from California to Alaska, but gear problems sidetracked them. They decided instead to go hiking for two months in the Grand Canyon.

That trip began with a story. When they traveled in India, Curtis and Conde first saw the Taj Mahal by the light of the full moon. They wanted to return to the Grand Canyon in the same mindful way, so they had friends blindfold them and guide them to a busy viewpoint "ritualistically." Just before the blindfolds came off, Conde remembers, a child came running up to the rim "screaming at his parents, 'Is that a painting?' And so when they took off the blindfolds, for me and Sherri, all of a sudden the Canyon became a painting." Ever since, they have felt, "photography is painting with light."

At the end of their two months, Curtis and Conde signed on to work at Phantom Ranch. They spent the next six years there, learning to photograph the Canyon "from the bottom up" as they "lived their dream." The first year, they left the inner canyon after six months only because they had to cash their checks before they expired. "We came as pilgrims" to this place of "luminosity, magnificence, and magic" and never left.

SHERRI CURTIS *and* ALFREDO CONDE

Stalking the Light

They carry three cameras, a medium-format camera for black-and-white and two 35 mm cameras loaded with color transparency film. They "stalk the light" far into the backcountry, "waiting for the moment, the revelation of the ethereal." "We sit for seven, eight, nine, ten hours in one spot—*in one spot!* We sit there and we just look and look and *look* and meditate and look. When the Canyon finally reveals itself, we are there to push the button. You have to be both very patient and very fast. We always try to photograph images that carry that feeling, that emotion, that spirit of the magnificent and instantaneous. Hopefully then we can share this vision with a world that's bombarded with imagery of anxiety and pain."

They sign their work SOA, Sherri and Alfredo. "We share the weight, too! The collaboration is in the setting and the sitting there. Once you start shooting, you don't know who has the finger on which trigger."

Curtis and Conde have published more than ninety postcards of the Canyon. Their fine prints were exhibited for years at El Tovar. Today, they live near Prescott, but the Canyon is their "mother's milk. It's natural, it's nutritious, it's warm, it's compassionate." It also "has places where we say, 'this has to be like the Moon, this has to be like Mars, this has to be like Jupiter.' Everything is there inside the Canyon. And so that was our commitment—that primordial emotion, to give people beauty."

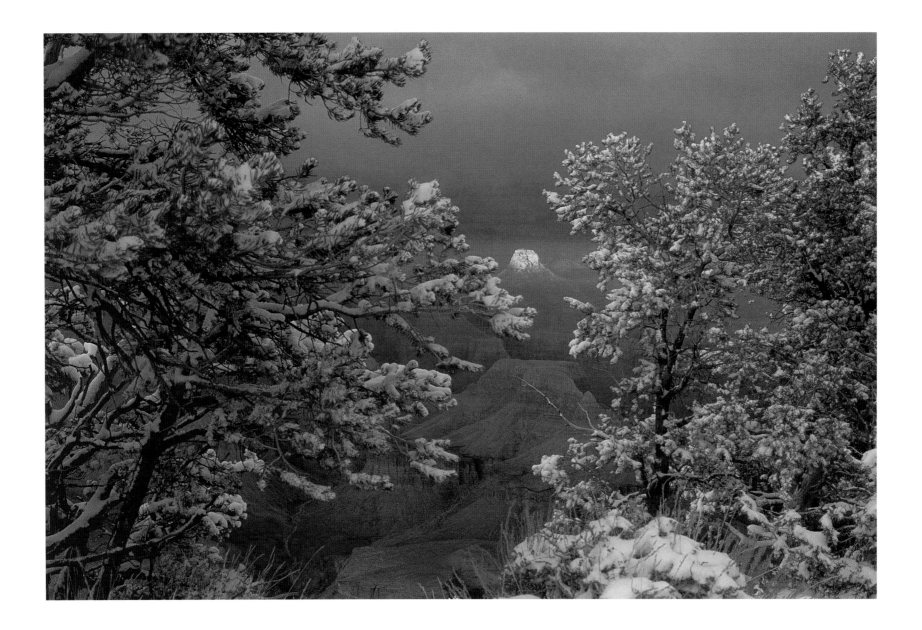

SOA
Waterfall

[*OPPOSITE*]
Buddha Temple

✳ *We've always felt that the Canyon is very gentle, very very kind. It's a great teacher, it's a great common denominator.*

You photograph according to your mood. That is always changing. We are confronted at every turn with the revelation of the ethereal only lasting a second. As photographers, to capture it on film is our only wealth.

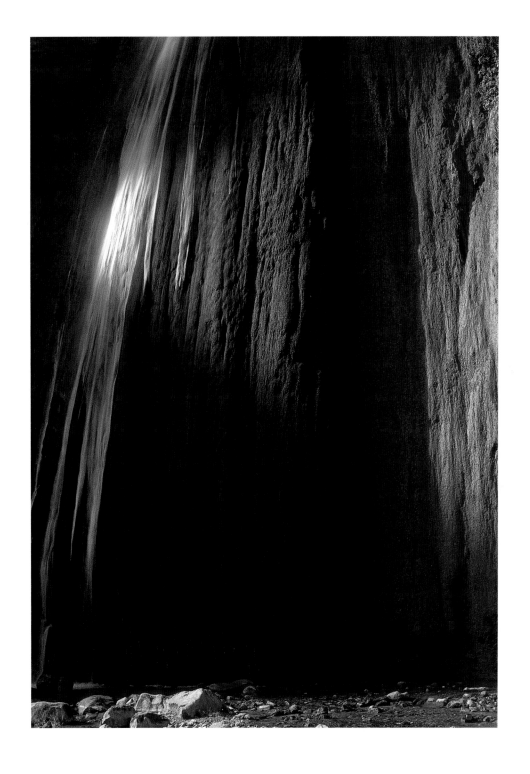

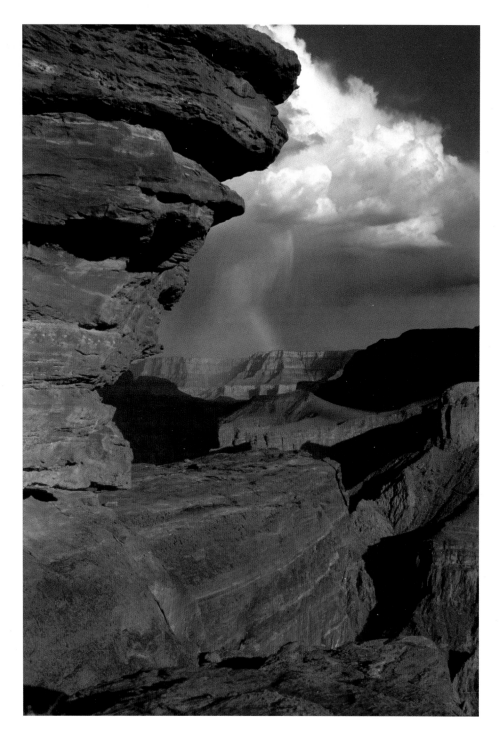

SOA

Rainbow

✦ *Our images tell the story of life, nature, movement, and light. They tell how nothing in this world stands still, they tell us about the ever-changing dynamics of nature. They tell us that we live in a world where nothing repeats itself, where there is only the eternal now.*

[OPPOSITE]
The Grand Canyon

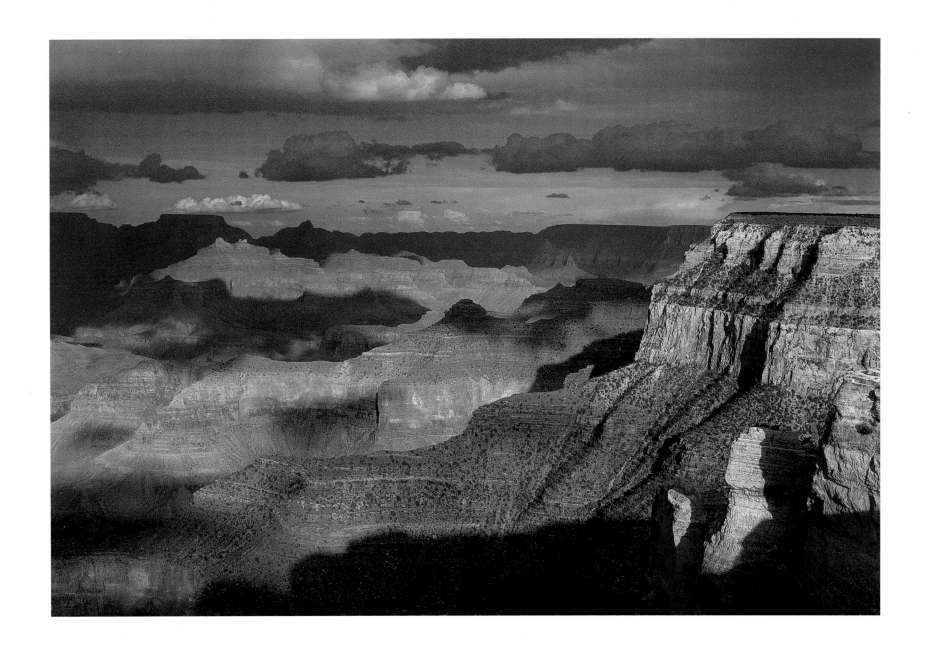

LIZ HYMANS ADMITS TO HAVING a "flamboyant personality." As one of the first women guides in Grand Canyon, she needed to combine that fire with competence. She is known for her adventure photography as well as landscapes, but she doesn't court physical risk. "Two of my qualifications for working as a river guide are that I'm scared of water and I'm scared of heights! And so, you take special care and caution. I never did flip a boat down there. And I never did fall off a cliff." She applies the same energy to "marching all over down there, hauling huge piles of heavy camera equipment."

But, first, she had to overcome her "moral opposition to photography. I thought that if you had to artificially preserve your memories, that your mind was weak, you weren't experiencing things fully." But as she began her twenty years on the river, "I came back and told people about it, and I realized I wasn't getting through, so I picked up the camera in 1974 as a communication tool."

LIZ HYMANS

Hungry Eyes

Born in Holland, Hymans grew up mostly in Colorado and came to the Grand Canyon as a river-runner and cross-country ski guide. After more than one hundred trips through the Canyon, she remains "under the spell of enchantment," in love with this place—"one of my sanctuaries." Along the way, she fell in love with panoramic photography and served as president of the International Association of Panoramic Photographers.

"A telephoto shows a part of the picture. And with a wide angle shot, there is just too much in there. What I love about the panorama is that it shows intimate details of foreground stuff to give a strong sense of place—of being there—and at the same time, it shows the whole scene, the broad perspective of it. And spreading out the elements across the width of a panorama gives it a much greater sense of depth."

Another reason Hymans loves the panoramic: she has

"hungry eyes. I like a long clear view. I like to see a lot in my scenery. Florida and Kansas are just too damn flat."

She teaches workshops, and she has coined a batch of aphorisms for photographers to carry along in their dry bags. "No one buys or prints excuses."

"Go beyond 'Wow, click.' Stand five places before you shoot the picture. (You'll start learning the difference between a decent foreground and an overwhelming foreground and leading lines that go nowhere versus leading lines that deliver. But you have to try different viewpoints before you shoot.)"

That moving around may involve shifting just a few inches, or it may mean "dropping over the rim and hiking a quarter of a mile to where you get a fresh perspective. The Canyon is so hopelessly overphotographed, you have to wait for special light. Work hard to get the best-ever photograph of a place. Ask yourself, 'what is it about that photo that I'm not going to like when I get home?'" And then fix it.

Liz Hymans revels in the trips she shared with Robert Webb's rephotography team. She matched historic panoramas, helped with "photo wrangling," and had the chance to photograph in the "nooks and crannies," to "linger in places that were scruffy and nondescript and see special things that you wouldn't have seen while visiting only the major attractions."

When Hymans started as a guide, reluctant employers wondered why a "little girl" wanted to work so hard and suggested marrying a boatman. She told them, "I didn't want to marry the boatman, I wanted to *be* the boatman."

She also believes "you cannot produce a good body of work on a place unless you know it." Now, after more than thirty years, she knows the Grand Canyon.

LIZ HYMANS

Sacred Datura

The datura—that was a lucky one. One day at the put-in for the river trip at Lees Ferry, I just looked down and I saw this flower unfurling and I thought, ahhh! That's beautiful. And I went and got my camera and shot it, without a tripod even—which I should have had. And just got it. One shot!

There wasn't too much thinking. I didn't move around a whole lot. I just looked straight down on it and got it. That's what I wanted. At other times, I've walked around datura, thinking how to best photograph. I've lain down on the ground and had the sun shining through the flower with a sun star sticking out the corner, and done other photographs of datura, too. But this particular flower, as it unfurled, had a swirl to it; a lot of them, the flower parts stick out in more of a straight line. It was just 'Wow! Click!'

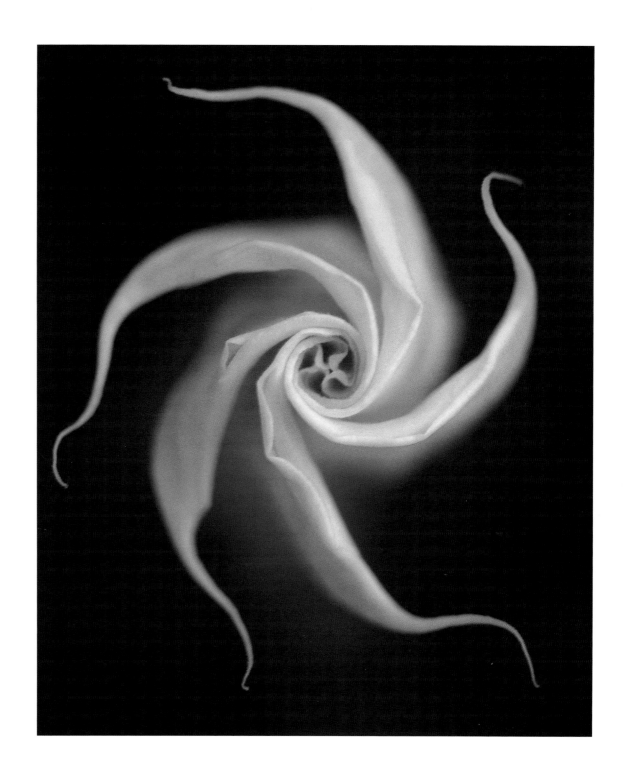

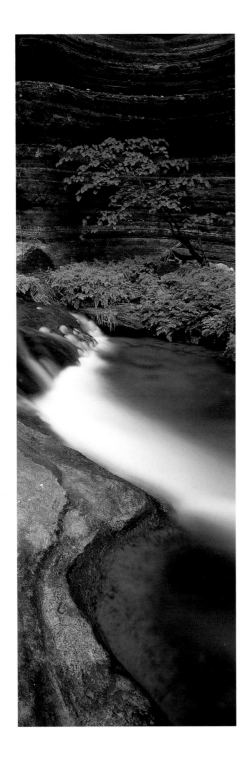

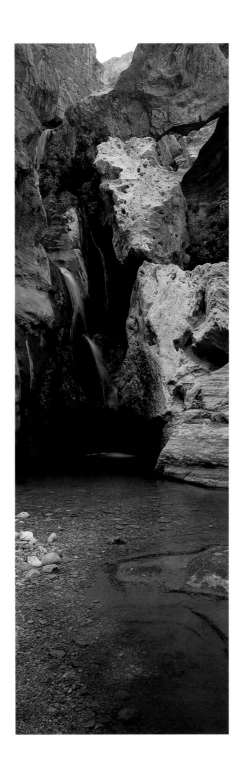

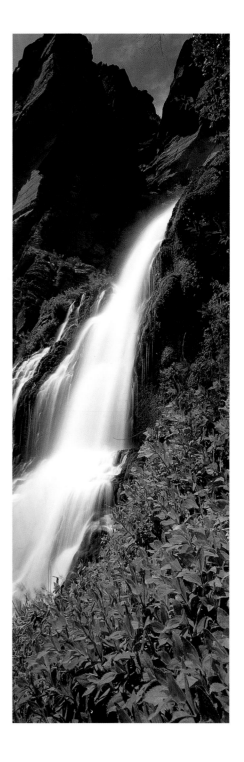

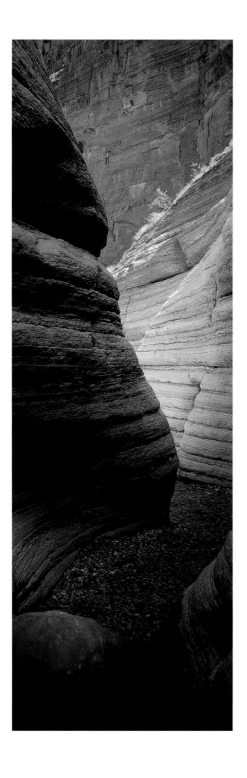

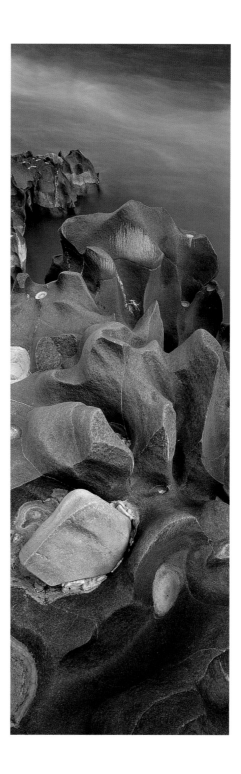

LIZ HYMANS

[*FAR LEFT*]

Matkatamiba

[*LEFT*]

Sculptured Schist

✷ *I love the schist—those beautiful fluted shapes. I have spent many hours—and sometimes days on special trips where I was able to take a day to myself—photographing that schist. It's very hard to get a really successful photograph of it that gets it, that grabs you the same way the schist does. I need a tripod in the middle of the river, and it's hard to put a tripod in the river. Depth of field—to get the whole thing sharp—you'd have to stand on a boat and basically macramé it to the Canyon to stabilize it! This one is good enough, but I can't quite get the superlative quality I want.*

[*OPPOSITE, LEFT*]

Deer Creek Narrows

[*OPPOSITE, MIDDLE*]

Elves Chasm

[*OPPOSITE, RIGHT*]

Thunder Falls

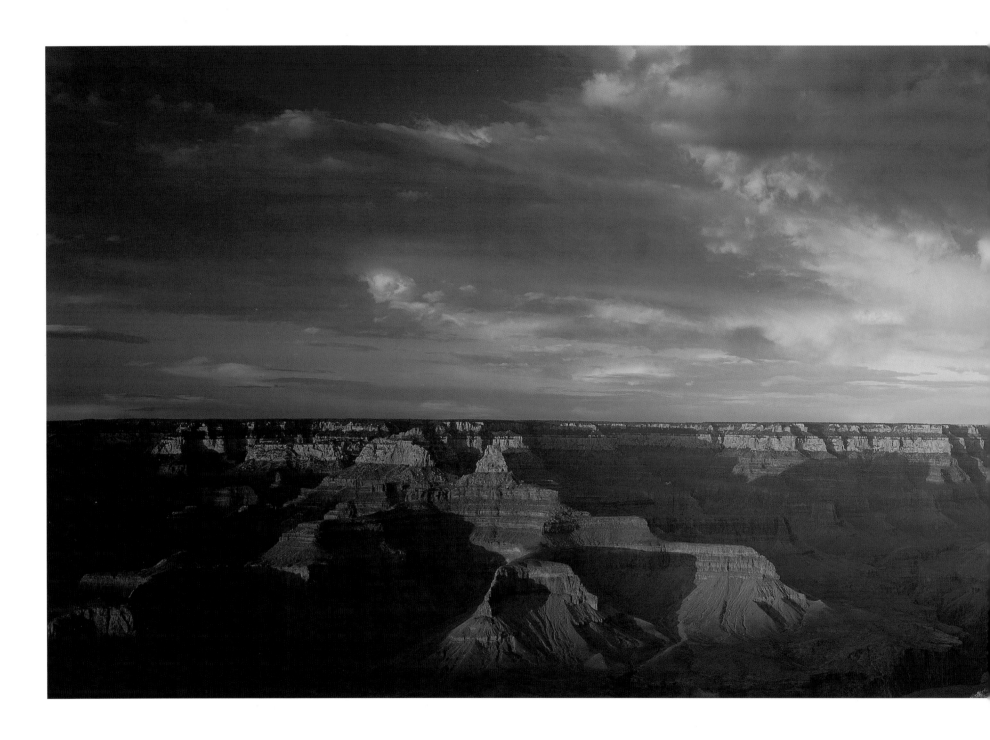

LIZ HYMANS

Sunset, Mather Point

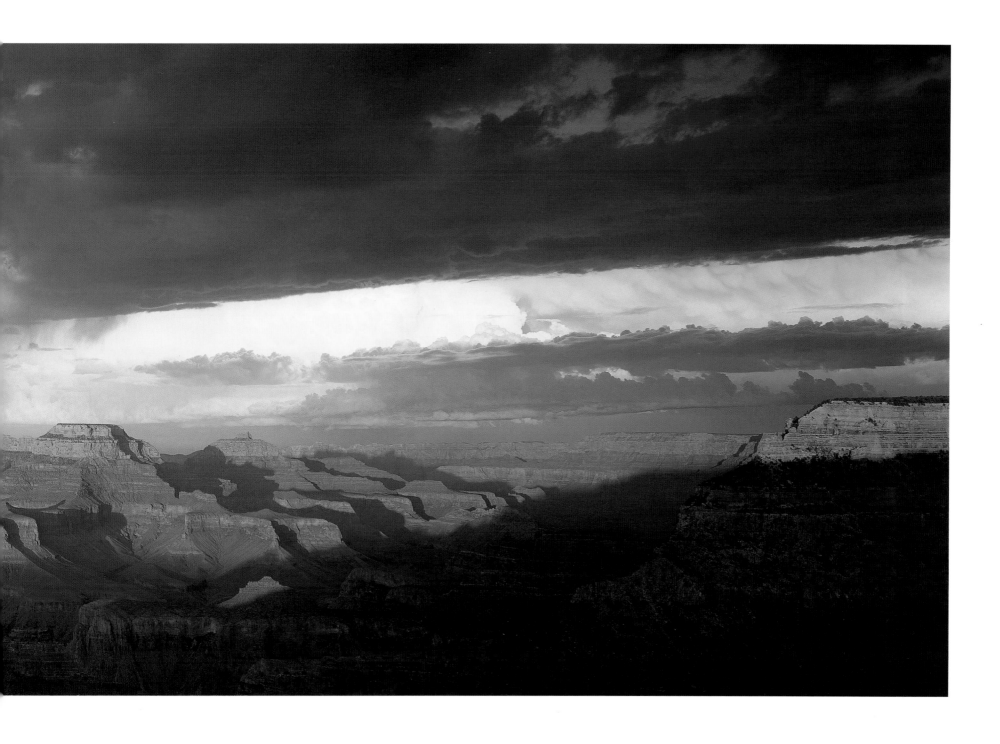

THE FIRST TIME TOM TILL EXPERIENCED Grand Canyon light, he was a college student but not yet a photographer. "We hiked down on a backpack trip, and a storm hit, lighting up the temples and the snow and the South Rim. I was already obsessed with Canyon Country, but that was the first time that I'd seen light like that anywhere. I didn't say right then that I wanted to be a photographer, but that unbelievable stormlight had a profound effect on me. It's been a lifetime goal to recapture what I saw at the Grand Canyon as a nineteen-year-old."

When the same sunset light lit up the cliffs around Moab on his drive home to Iowa, "that was all I needed to push me over the edge." He moved to Moab after graduating and began teaching high school English, journalism, and photography. In 1977, he bought his first view camera, and by the mid-eighties, quit teaching to photograph full-time. The Tom Till Gallery is now a fixture on Moab's Main Street, and he loves the feedback "from real people. The gallery would be the last thing I would ever give up."

His literary core didn't disappear, however. "My most successful pictures have some kind of a narrative—a simple story that could be related in a short poem."

In the Grand Canyon, Till initially thought the river would "do all the work—getting the camera into places that would be extremely difficult to get to by walking." He learned to row, searching out "magical photographs and magical subjects," even running the Grand Canyon in the great 1983 flood, when he was too terrified to take pictures. "It was so scary that I literally did not eat until after Crystal!"

He also realized, "after many years, that I was starting off trying to photograph in the most difficult conditions imaginable. On the river, when it's magic time, that amazing light is thousands of feet above you. Shooting other places was so

TOM TILL

That Amazing Light

much easier, because the light was right with you."

Tom Till admits to being "obsessive/compulsive." He photographs in the field up to three hundred days a year—in all fifty states and more than fifty countries. He has been down the river twenty times. He keeps a mental catalog of shots he wants to shoot. In the Canyon "I've gone to every overlook that you could possibly go to. I've hiked just about every official trail. You've got to do that to get the pictures, and that's a lot of physical work, especially with the 4x5, and an immense amount of time and an immense amount of exploration. And yet, the Grand Canyon is so big that you couldn't get everywhere in twenty lifetimes."

One winter, he "went to ridiculous extremes to get out to the North Rim. I spent several nights in a snowstorm, and then got out to one of the viewpoints and I was the only one there. I realized that nothing worked because it was all backlit—the light was terrible. Because it was wintertime, I was shooting right into the sun, shooting south, and I didn't get anything!"

Till treasures those "gifts that you could never have dreamed up. You are just given these moments and lighting and subjects." His other gift is his family, which he may treasure a little extra because he is on the road so much. "My daughter is a guide down there, now. And I think I am more proud of the fact that she has a Grand Canyon commercial license than I am that she graduated from a major university!"

Till still uses his view camera "exclusively." But, "I have been carrying around a forty pound pack for thirty years, and my knees hurt. That worries me some, but I just take an Advil and everything still seems to be okay."

TOM TILL

Deer Creek Falls and monkeyflowers

[*BELOW*]

Image taken from Lipan Point appears on a US Postage stamp; the photo was printed on the stamp backwards (photo is featured on the front cover of this book)

⚙ I had submitted it to the Post Office. We had signed contracts, but in this business, you never think anything is going to really happen until it happens. So I had no idea that it was actually going to be a stamp. They certainly didn't send me a proof. Nobody sends you a proof! I've had hundreds and hundreds and hundreds of pictures that have been published that have been flipped and probably 30 or so that have been published upside down. So it's not an uncommon occurrence.

This ended up being on CNN and in all the newspapers and then in all the magazines for stamp enthusiasts, where they said, 'This is the only interesting thing that's happened in stamps in the last three years.' Even though it's still for sale, it's worth a few cents more than sixty cents on the stamp market.

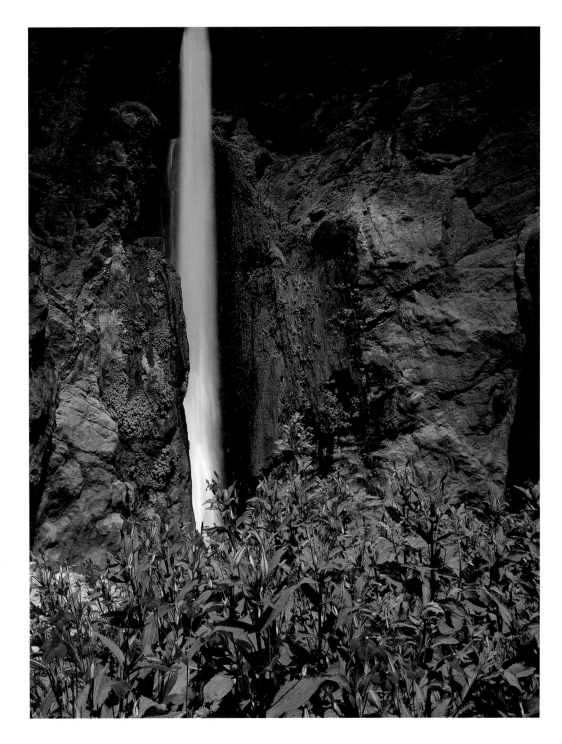

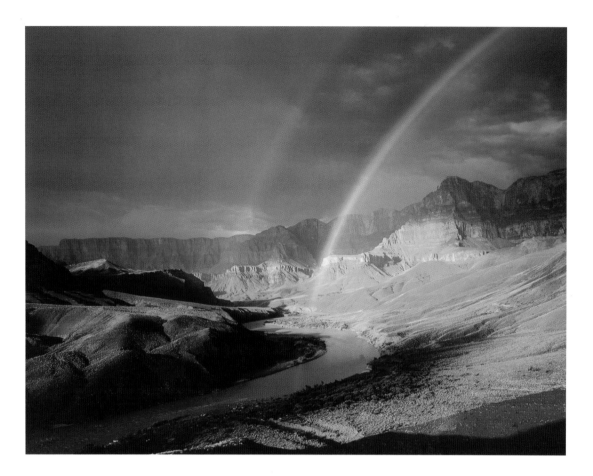

TOM TILL

Colorado River and rainbow seen from Hilltop Ruin

☼ *I wasn't really expecting to get a big scenic. I hiked up to Hilltop Ruin to photograph the ruin. It was pouring rain, and I spent a bunch of time in one of the little caves there just staying out of the rain. Then I got up to the top and was hoping for some light on the ruin to shoot with the North Rim or the South Rim, if I could.*

Instead, the sun broke through and the rainbow appeared and ended right in the river, which was kind of fortuitous—which goes to show that being there is vitally important, of course, but there is so much luck involved. You could go up there a hundred nights and it wouldn't do that. It was pretty lucky that I was there on the one night—on a river trip where the river is in control.

And it just so happened that I had quit teaching that year and was on a year's sabbatical to see if I could move from teaching to full-time photography. That picture sold a lot of times during that transition period, so it really helped me jump start my career. And of course it was on the cover of Blessed by Light. *I have a lot of affection for it—for the experience, and for the trip.*

I thought I had a nice shot, and I was carrying it in a rocket box. And I actually flipped while I was rowing Crystal Rapid. Fortunately, the film survived intact, and so did I.

[OPPOSITE]
Grand Canyon sunset, South Rim

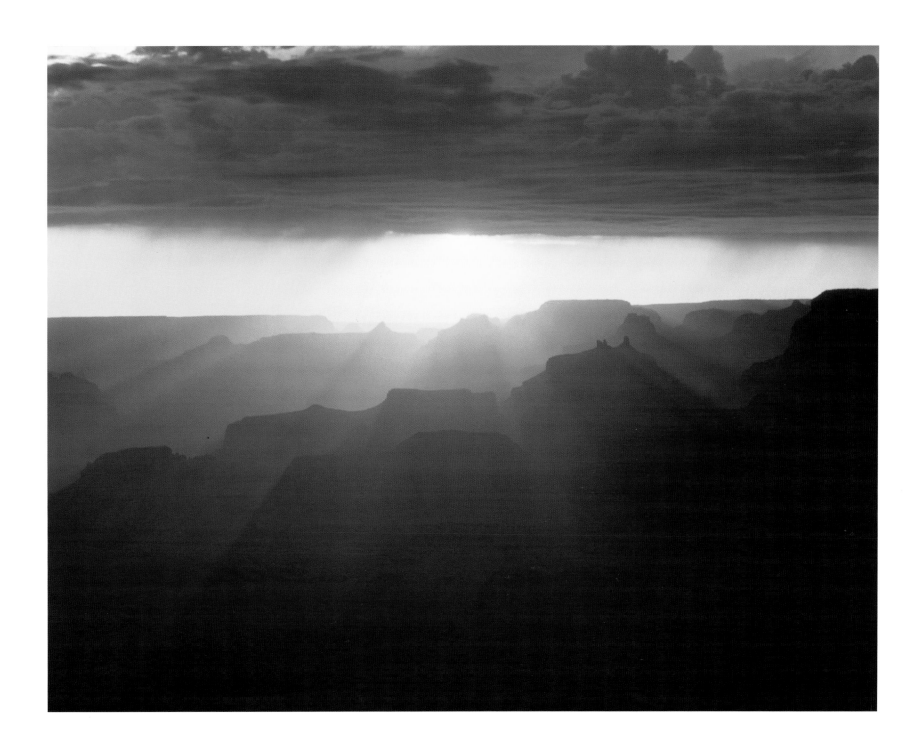

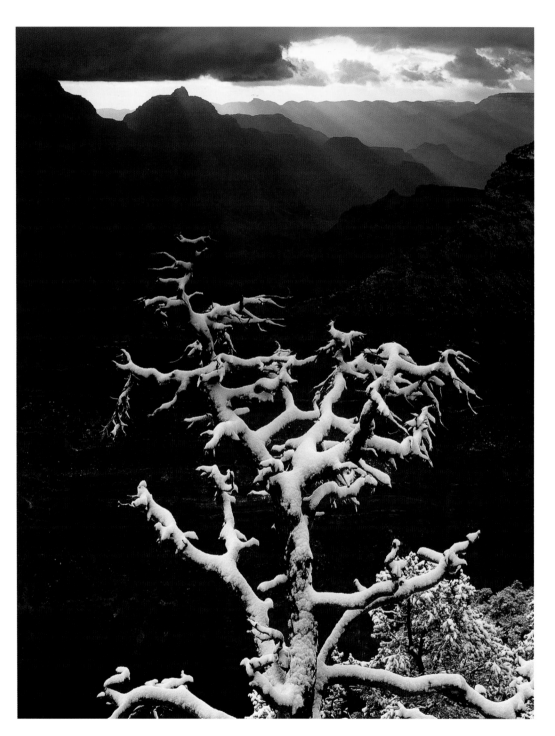

TOM TILL

Mather Point sunrise, piñon pine

[OPPOSITE]

Heavy snow and alpen glow at Mather Point

○ *I always try to go a couple times a winter. By using modern day weather forecasting, I like to be there when the storm is leaving, because the air is the cleanest then, the snow the freshest. I like that just-fallen look, which you can lose within hours after the sun comes out and the snow stops.*

This shot was taken just last January (2005). I went down and there was hardly anyone there. I spent two nights waiting for the storm to go and then it snowed all night. I think there was about two feet. I got up in the morning and thought, 'You know, they might close the place because there was so much snow.' I was camped just outside the park.

So I got up at like three in the morning. The gate was still open, so I went in and waited for sunrise. They did close the gate, so I was the only one there except for the people who had stayed at El Tovar or who were in the campground. They closed both the East and West Rim drives, so you couldn't go out there anywhere. So the only place I could get to was Mather Point. Even those roads were kind of iffy.

But it was great with all that snow, being the only person on the rim. That just doesn't happen very often. Off to the east is the more deserty part of the world, so sometimes you can get a short sunrise break through the clouds there because it's coming up over the desert. That's what happened in that shot. It lasted just seconds.

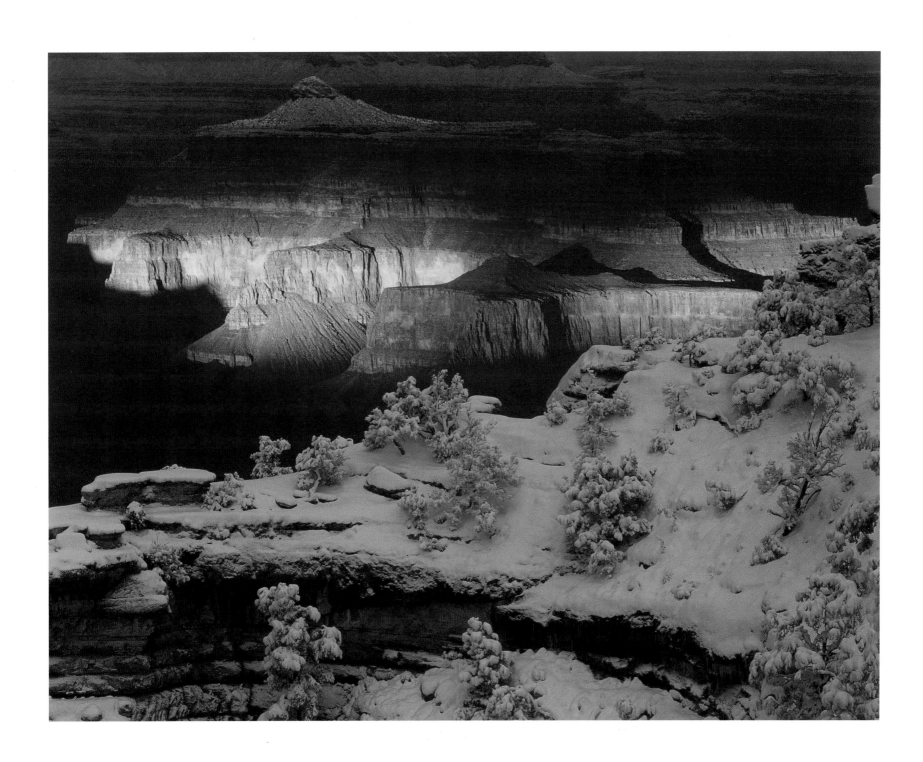

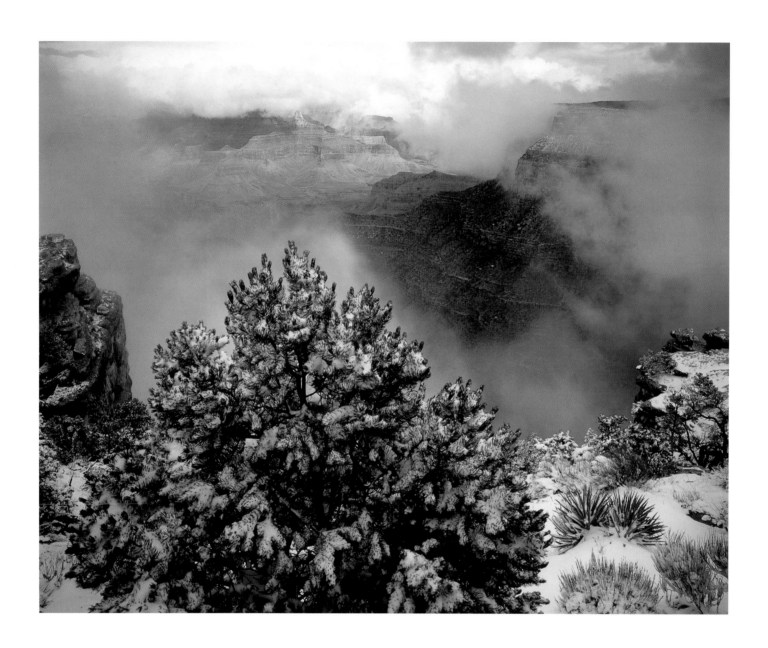

LARRY ULRICH

Piñon pine on Maricopa Point, South Rim

LARRY ULRICH'S FATHER GREW UP IN ALASKA, and Ulrich absorbed from him that bracing frontier confidence and self-reliance. He loves the "thrill" of wild places, a love imprinted deeply as a kid on backpacking trips with his father in the Sierra Nevada. He began his career selling prints at West Coast street fairs and craft shows. He remains a stubbornly independent photographer: "I haven't done many assignments because I am just not adaptable; I don't like the idea of shooting other people's vision."

And, like a frontiersman, he revels in challenge. "I've got over thirty years invested in this idea of photography," he says. And he is not about to let the shift to a digital world leave him and his thousands of 4x5 transparencies behind. So "I am reinventing my business. I've drum scanned and digitally mastered four thousand of my originals. I've been working sixty, eighty hours a week for over two years." He made the first all-digital submission to *Arizona Highways*. "I'm recreating my own creativity with the computer."

As much as he loves the power of Photoshop to saturate a quiet old transparency just enough to make it look "like it was shot yesterday on Velvia," Ulrich would rather be in the Grand Canyon. When he and Donna, his wife and photo partner, worked on an Arizona book in 1987, they signed up for their first twenty-one day dory trip. "We were reluctant. We had never been boaters, and it didn't seem a very efficient use of time to get a couple of pictures." And then, of course, "the magic of the place changed our lives."

They have been down the river four times now, always in dories. As Park Service restrictions have made it harder to follow the light on the rim, the Ulrichs have "invested our time in Grand Canyon on the river. There we can be spontaneous and free—and feel like we are in the wilderness. And it's not only just being there, it's going down the river with family and friends and seeing the magic on the faces of

LARRY ULRICH

The Thrill of the New

these people you love."

They shoot with one camera, and Larry is the technician. "But we've got two sets of eyes, and Donna has an incredible color sense." "The view camera is so cumbersome and labor intensive" that working as a team "has saved a lot of shots over the years. One thing we lust after is that thrill of capturing those elusive moments. We work the big camera together so efficiently that we are almost as fast as a 35 shooter."

The Ulrichs first saw the Grand Canyon in 1982. They hadn't ventured out much from their northern California home in their "beloved redwoods," but photographer friends talked them into their first trip to the desert. They came for a "magnificent spring," made their "first foray into the social scene of photography," meeting many other photographers out for the flowers. When the weather turned, they heard "it was going to snow down to four thousand feet up at Grand Canyon." So up they went.

"I'm not much of a wide-angle photographer. I love using telephotos; I wanted to focus on the intimacy instead of the expansiveness, and so the Grand Canyon was a treasure chest of visual opportunities for me." Ulrich also has devoted himself to macro wildflower photography. "Getting your face down in little tiny flowers and reinventing unbelievable beauty down there—it's a whole new world, an untapped resource."

In his early days, Ulrich was "ravenous" about being a "fanatic student." He "devoured" the Sierra Club books featuring Eliot Porter, Philip Hyde, and Richard Kauffman. "It was the most wonderful thing to know all the pictures that David Muench or Philip Hyde had taken at Grand Canyon, and to go look for a new angle. That's what drove me. To never copy anybody else. To look for the new. That's the thrill of it."

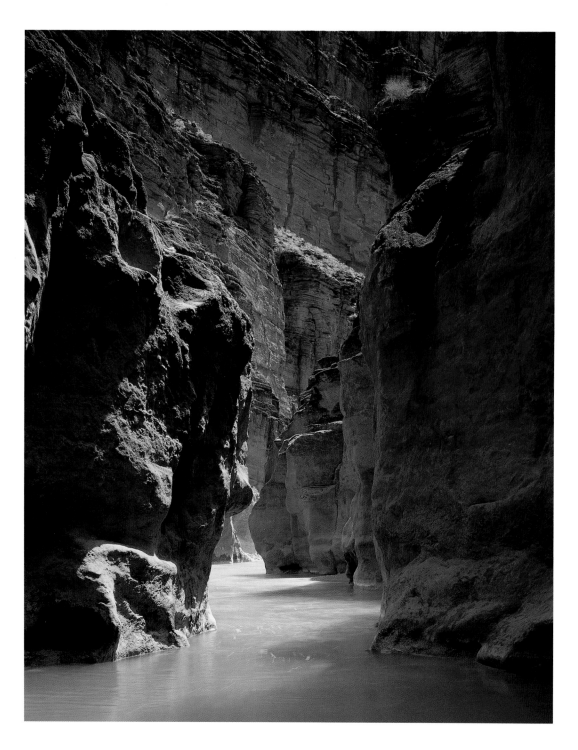

LARRY ULRICH

Havasu Creek

✿ *On our* first *trip through Grand Canyon, you could take the dories right up Havasu Creek. The travertine was pristine. This picture was never possible unless you could do it from a boat. But being a 4x5 shooter, that wasn't possible.*

This was done on my second trip through Grand Canyon, in 1993. There was a debris bar built up at the mouth of Havasu Canyon from the big flood, and it was the only time I could take that picture.

There was a dangling striped rope hanging in the middle of the picture on the left wall. I was sitting there with a couple of my boatman buddies, and I said, 'God, I'd sure love it if I could get that rope out of my picture.' And one guy says, 'Well, I'm a rock climber.' And so these two guys got up that cliff, took the rope and put it on the other side of that wall, so it wasn't in the picture. This was back before Photoshop; I probably wouldn't have taken the picture back then if it hadn't been for these guys getting the rope out of it. So that was a collaborative image!

[OPPOSITE]

Cardinal monkeyflower and box elder, Havasu Creek

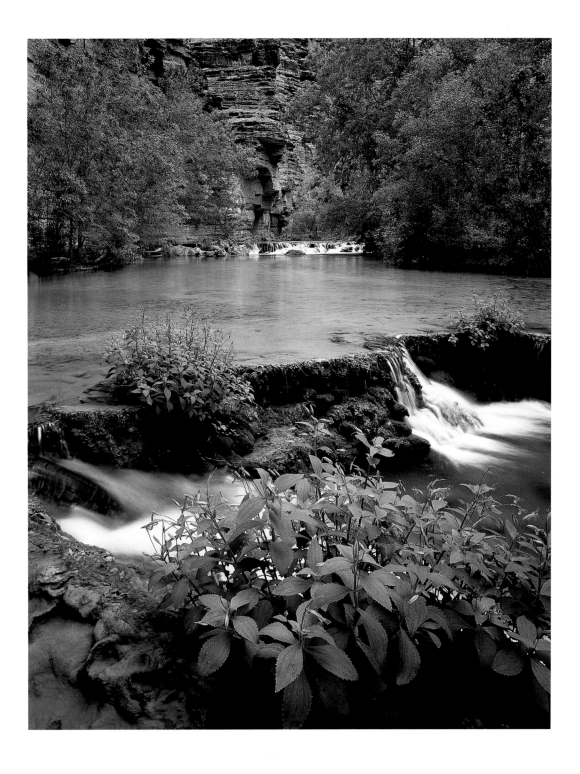

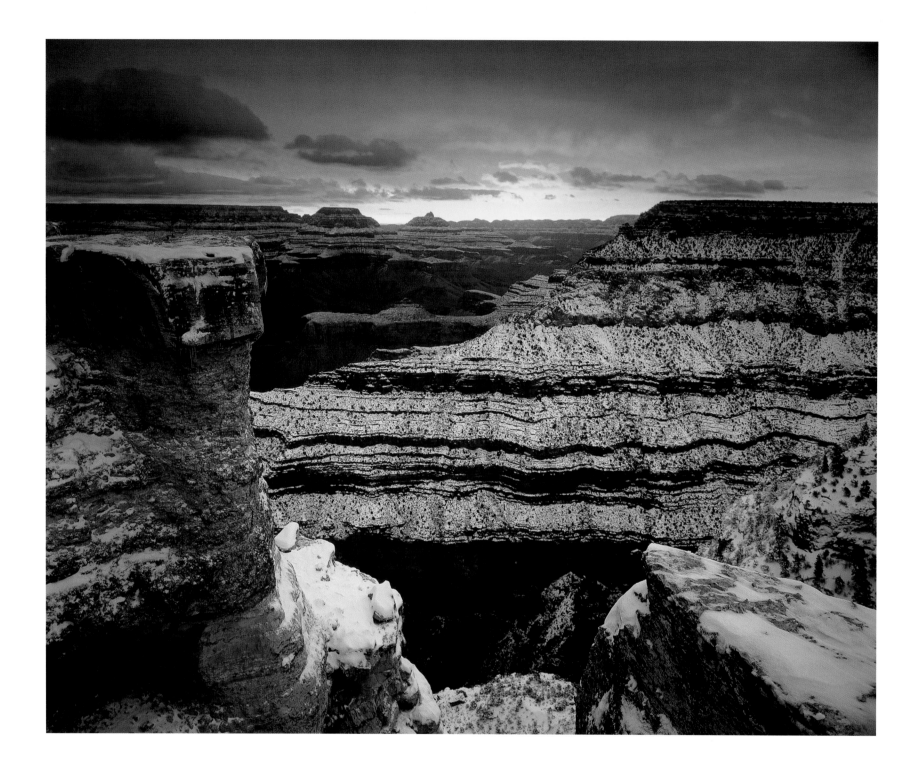

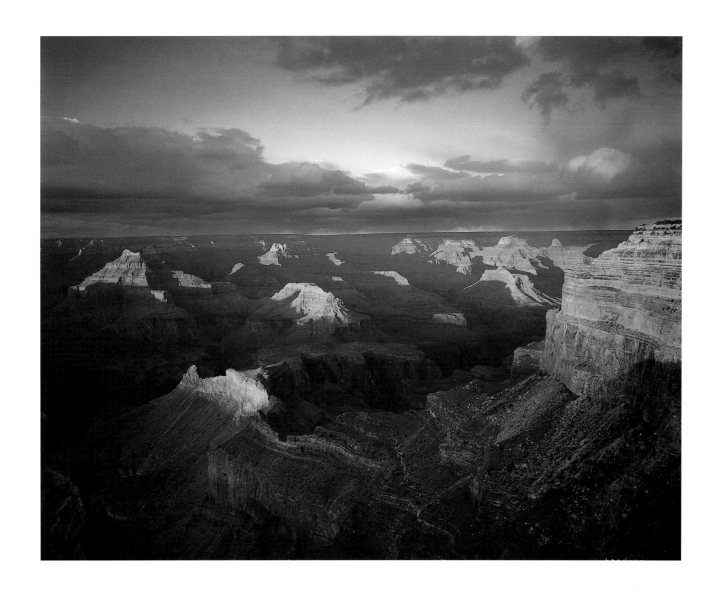

LARRY ULRICH

Grand Canyon from Mohave Point

[*OPPOSITE*]

Sunrise over Grand Canyon from Mather Point

PHOTOGRAPHY HAS "stitched together" much of Michael Collier's life. In 1975, the threads came together in the Grand Canyon. After growing up in Phoenix and hiking into the Canyon with his father in early adolescence, he found himself an undergraduate student in geology at Northern Arizona University in Flagstaff. He could have gone off to an arts institute for a degree in photography, but he thought it would be far better to "get a degree in something I might be photographing."

Collier is a person of remarkable intentionality. He analyzes his options; he makes choices. He wanted to photograph and study geology in Grand Canyon, so he learned to row: "I thought I should be on the water, to have access to places that I want to photograph." He wanted to photograph the Grand Canyon from the air, so he learned to fly: "I fly for the view, to photograph, but mostly I fly for the vision." He finished a master's degree in geology at Stanford along the way, and rowed commercially in the Canyon for six years, racking up three years of living below the rim. "The Canyon was a terribly important place to me," he says.

"I'm incapable of looking at the Canyon without seeing it geologically. That's not a blinder, it's like a whole new set of colors that are integral to the Canyon that I can't deny or ignore—the color of geology."

Collier is incessantly balancing his passions. He knew that a freelance life of photography and writing had its drawbacks, so he went to medical school in the 1980s. Now, he practices family medicine one week in Williams, Arizona,

MICHAEL COLLIER

The Color of Geology

and the next, works in his studio in Flagstaff or in the field on his photographic and book projects—often collaborating with his wife, writer Rose Houk. He balances art and science both in his life and in the content of his photographs. Indeed, the American Geological Institute recognized his efforts with a 2005 award for increasing public understanding of geosciences—a prize previously won by Stephen Jay Gould and John McPhee.

Collier loves the "breathless moment" of capturing the image—with the 35 mm Nikons he used on the river, the medium format cameras he uses from the air, or the Arca Swiss view camera he has fallen in love with recently. "Every time you go somewhere, there is going to be a surprise. Your job is to keep your eyes open and realize—*that* was the surprise." He has 120,000 images on file: "I'm glad they are there; they're friends. But what I really like is when they are useful, when they are in books, explaining things."

He has realized that when people see his pictures, "somebody who has not been to the Grand Canyon will look through and past my pictures, and they are creating a whole world that they alone can see. Each person brings their own

sense of color, their own sense of the bigness of the world, and they are going to see through that picture to something that *they* create on the other side of it.

"I don't have to bring the Grand Canyon home. I don't have to bring it *all* back. I just get to make pictures."

MICHAEL COLLIER

Aerial view of Paria River carrying sand to the clear
Colorado River at Lees Ferry

⊚ *When I was doing my senior project for Northern Arizona University,*
I remember trying to get a picture of a brachiopod. I was balanced on
my toes kind of hunched down in a squatting position, to photograph
this brachiopod in the Redwall along the Hermit Trail. The trouble was,
I was hanging over a six hundred-foot cliff, and sure enough I started
to fall backwards. I was going—there was six hundred feet of space
between me and the ground. The only thing I could do was fling my
arms up and catch this nubbin of rock. My Nikon was on a strap, and
I so vividly remember the arc that it took—I have it in slow motion in
my head, but it was a very fast arc as it smashed against the rocks.
I didn't fall. I have taken risks.

In boating, I sometimes ran the right side of 25-Mile or the wrong side
of Hance or other interesting routes. In flying I don't go out of my way
to take risks, but I'm happy to push the envelope sometimes.

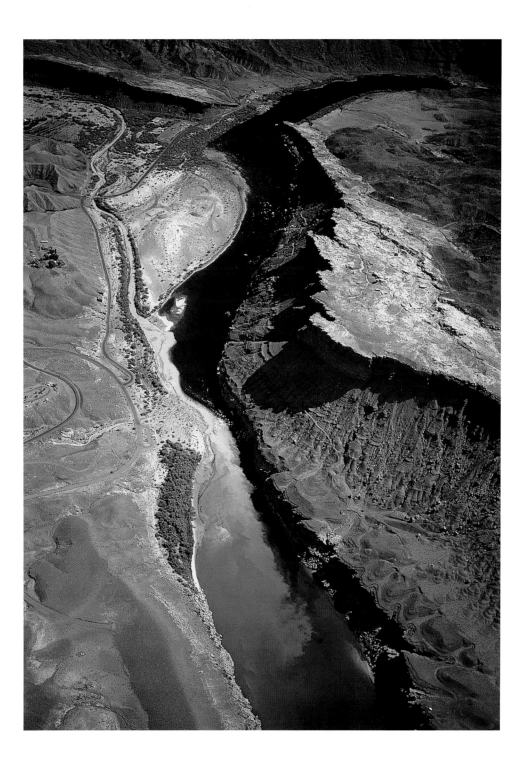

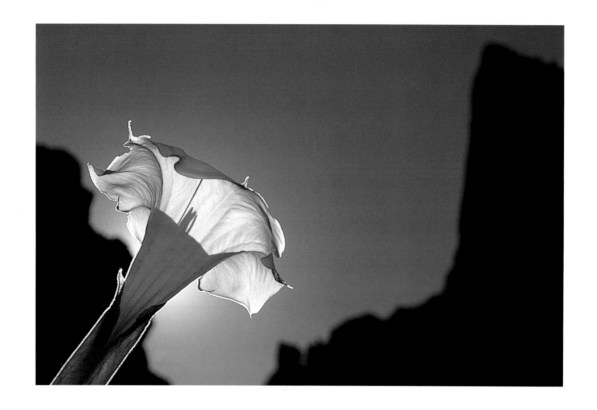

MICHAEL COLLIER

Datura in Havasu Canyon

[*OPPOSITE*]

Aerial view of sand blowing into Paria River above
confluence with Colorado River, Lees Ferry

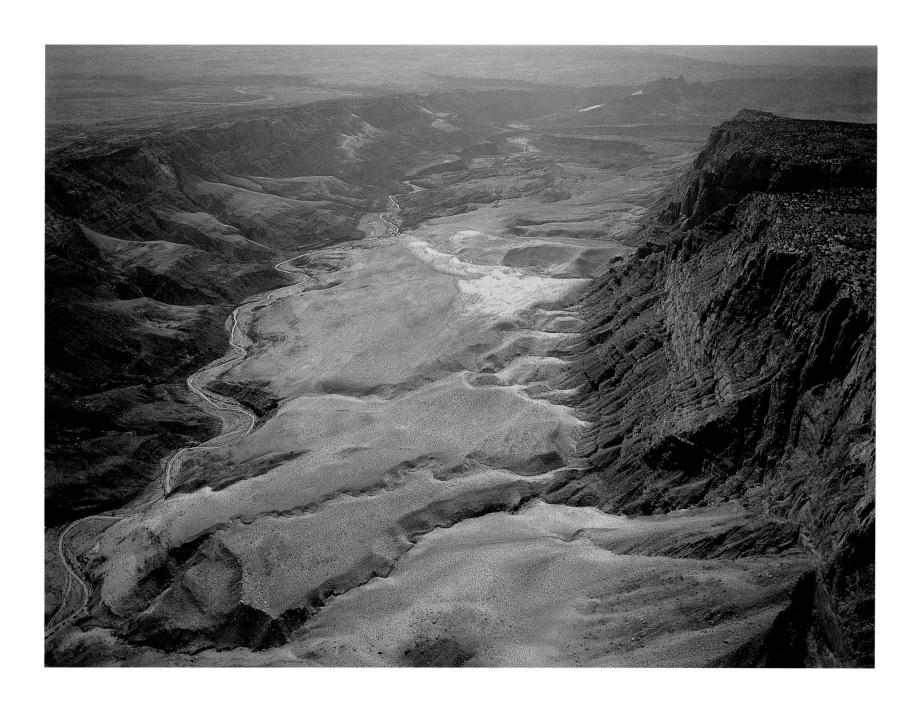

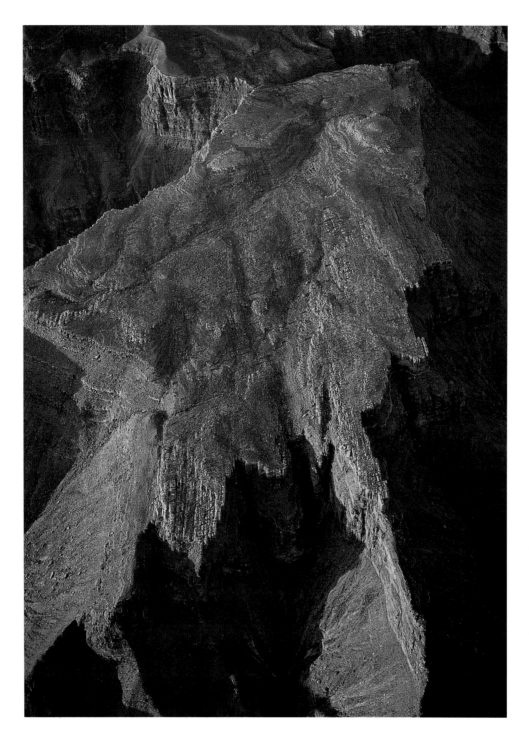

MICHAEL COLLIER

Aerial view of Esplanade Sandstone
in western Grand Canyon

[*OPPOSITE*]
Aerial view of western Grand
Canyon near 205-Mile Canyon

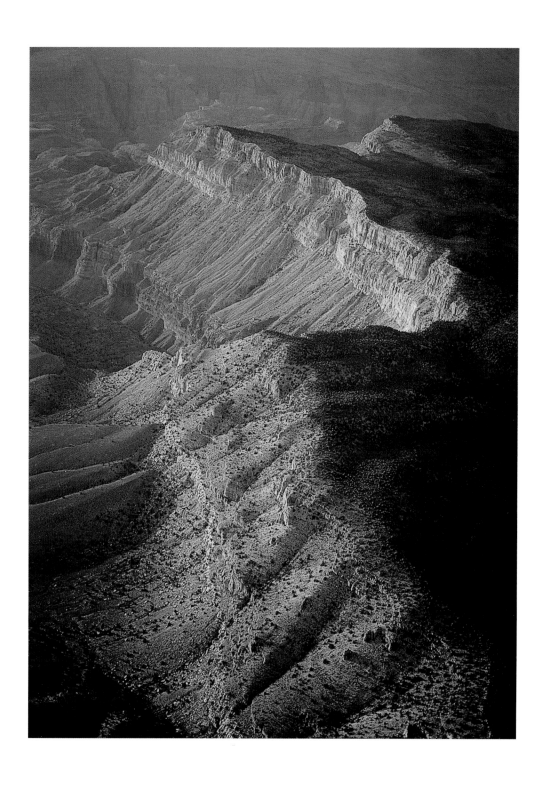

STEVE TRIMBLE has lived in the Four Corners states throughout his life, rooting his home and his work in the southwestern landscape. He started in Colorado, where his geologist father led the family on pilgrimages to national parks, with running commentary. After college, he moved on to park ranger jobs in Utah and graduate school in ecology in Arizona before arriving in Flagstaff in the late seventies. Today, he splits his time between his home in Salt Lake City and at a retreat in Torrey, deep in the slickrock country of southern Utah.

Along the way, Trimble took pictures. He *always* took pictures—as a means of "looking for relationship—with the world, with people, with myself." Trimble brings back stories from his time in the wilderness. Beginning with "those little thirty-two-page general interpretive book-lets" for the national parks and evening slide shows in the campgrounds, his writing and photography eventually demanded bigger books. Thirty years and twenty books later, his work in the Southwest often includes Grand Canyon.

His approach to photography is embedded in his search for the heart of a place. "If the light is spectacular, I'm thrilled to photograph. But when the light is dull, or if I oversleep and miss sunrise, I have this whole other thing I can do: I can take out my journal and think like a writer.

"I could never choose between writing and photography. I love them both, for different reasons. Writing engages my brain—it takes everything I can muster—over a long, long period of concentrated work. Taking pictures is a release, an outlet for reacting directly to the land and to people, a way to reap the instant emotional gratification that writing cannot grant."

STEPHEN TRIMBLE

Paying Attention

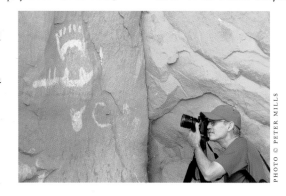

PHOTO © PETER MILLS

Trimble sees the Grand Canyon as a challenge: "I love approaching an icon like the Canyon and looking for a new way to capture the soul of the place. I stand on the rim and look for interactions with foreground, with sky, with clouds. I look for *relationship*."

"Or I look down at my feet and the natural world transforms into an endless series of patterns. I peer into blossoms, through backlit leaves, or scan the textures of lichen and schist, shifting the composition, framing a graphic—one graphic among a hundred that could be framed."

The key is *paying attention*. Trimble credits his ecology professor at Colorado College with teaching him "how to think like a naturalist," to pay attention as he walks through the world, "to listen for bird calls, watch for raptors on fencelines, learn the difference between Douglas-fir and limber pine, notice blue grama grass and aspen leaves and acorns."

The small details that draw him help to make sense of an enormous place like the Canyon. When Trimble took his children to Toroweap, they spent their time playing in mud at the edges of potholes. His best-selling Grand Canyon image isn't a rim view; it's a lizard perched next to fossil tracks on a slab of stone.

Trimble spends a lot of time in southern Utah these days, but he is "always aware of the Grand Canyon hovering out there. Every little stream in the Canyon Country is headed for the Colorado; the whole Southwest comes to a climax at the Grand Canyon. I love its power. I see the swell of the Kaibab Plateau off to the south, and I know that giant gash in the earth is always just over the horizon. I try never to forget that."

STEPHEN TRIMBLE

Havasu Falls

⊙ *I lived in Flagstaff while I became an adult—turning thirty and having an emotional time making my passage. Before the big flash flood, Havasu was so beautiful and so sensuous, it matched my response to this landscape, which was a little overwrought.*

I visited Havasu several times, hiking down from the rim and hiking up from the river. I went with friends; I went alone. I hiked out by moonlight and through storms. Lodged in my brain were the best photos that I'd seen of the falls with their astonishing blue-green water, along with fragments of Edward Abbey's and Wallace Stegner's descriptions of the place. I came as a romantic, an apprentice, eager to create my own photos and to write my own words.

This place was so astonishing—and the challenge for me as a photographer was to find a way to take pictures that captured my feelings, that captured the place, and that didn't look like every other photographer's work. In this picture, I chose the soft time after sunset, when I thought my beloved Kodachrome might be able to match the delicacy of the light. Part of that was "reciprocity failure," the film's color going a little haywire at long exposures. I hoped those intensifying colors would match the mood.

And they did.

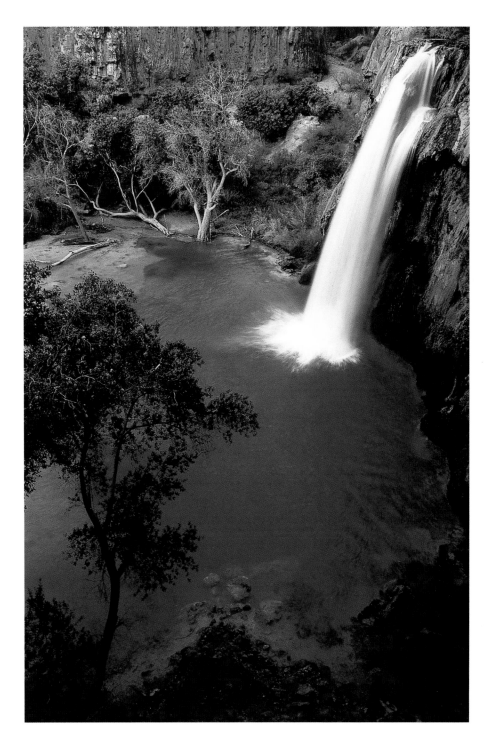

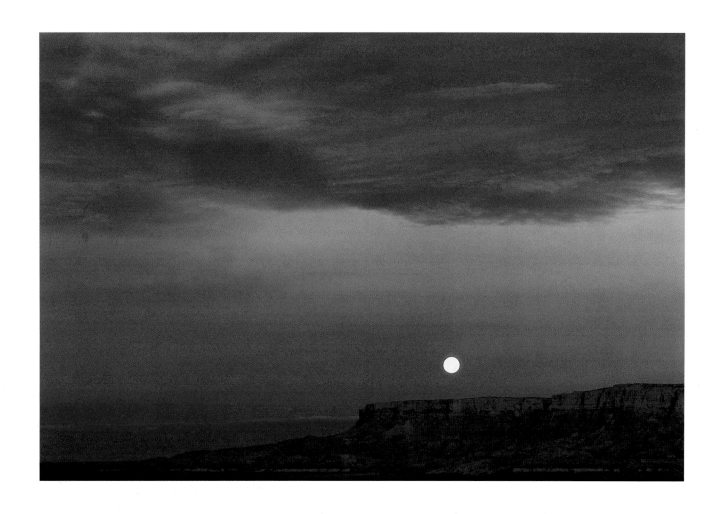

STEPHEN TRIMBLE

Moonset, looking past Marble Gorge to Vermilion Cliffs

[OPPOSITE]

Cataract Canyon rims, Havasupai Reservation

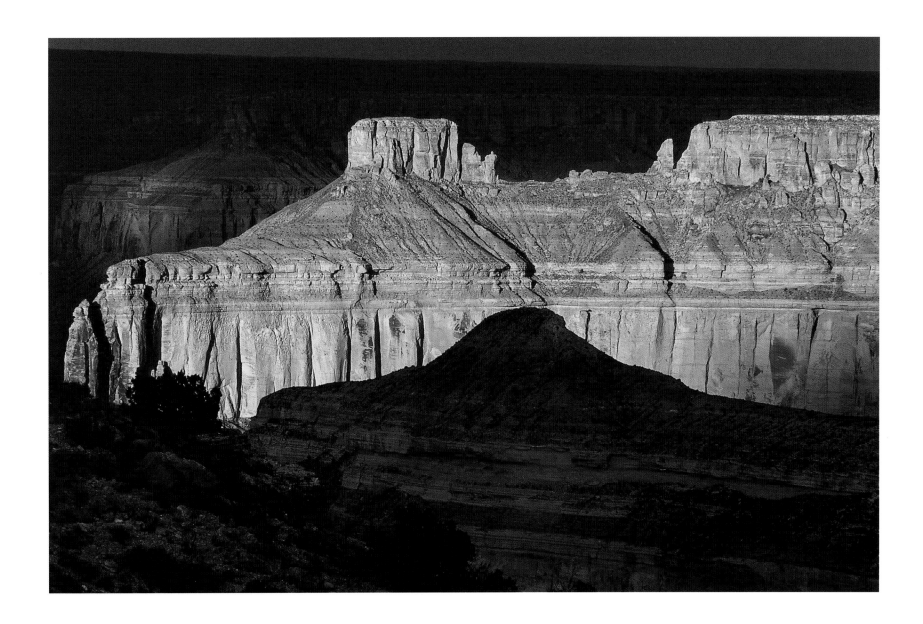

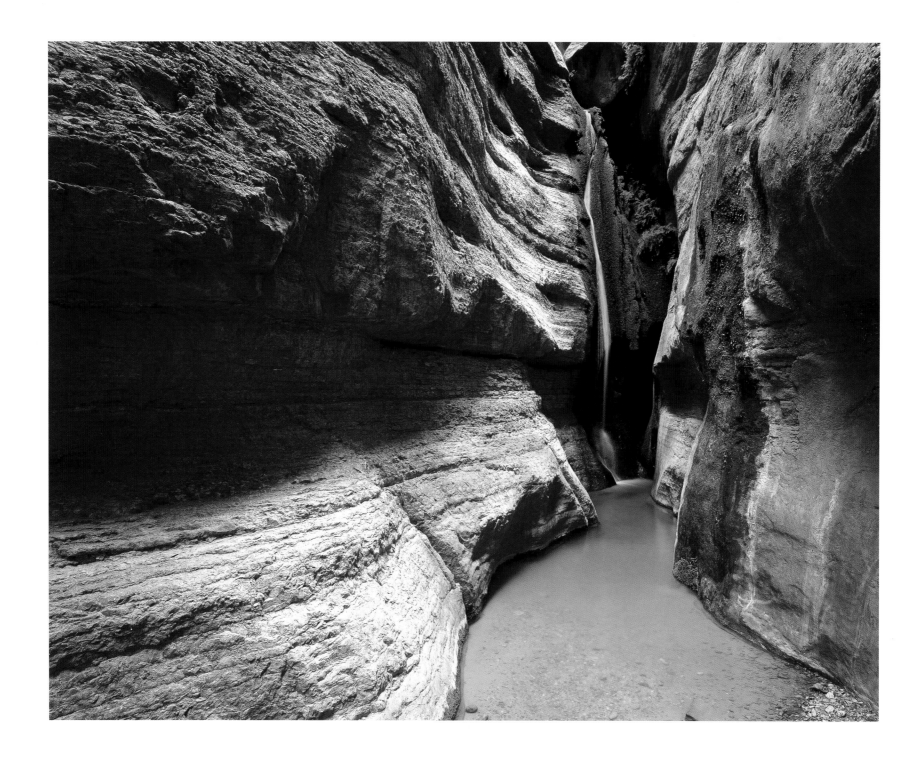

LIKE SO MANY OTHER ASPIRING PHOTOGRAPHERS, publishing in *Arizona Highways* was Randy Prentice's "ultimate goal." For years, he pored over each issue. When he bought a good 35 mm camera in 1983 to photograph his family, it was only a year before he moved to a 4x5 for its "stunning image quality." Prentice began to "live and breathe photography," taking classes, reading books, "looking at everybody's photos." One year more, and "I was trying to start a career in photography, and the Grand Canyon seemed like a good place to start." He stumbled on Toroweap on that first trip, and, for him, that remote perch remains "enchanted"—his favorite place.

Publishing with *Highways*, both in the magazine and in books, now forms his "mainstay." He and his friend, Jack Dykinga, chat about photography and equipment on a regular basis, usually over lunch, and they go to the field together, "to some pretty cool places. It's always nice to have company when you are out there, as long as we don't step on each other's toes."

Prentice admits to inertia. He finds it hard, sometimes, to pack his camper and get out the door and into the field. "But once I get out there, I turn into this photographic machine. I snap a couple of pictures, working with shapes, trying to be graphic and simple and striking, and then I start getting high from it again."

Photographing "the Big Hole, you have so many options. The scenery is kind of all the same and yet it's constantly changing. There is a photo out there for any lens you have. You can zoom in on little buttes and emphasize those with telephotos. With the wide, you can get that grand sky with clouds in it, with the Canyon below. And on the river, every time, I go to a different place. I'm just scratching the surface on exploring down there."

Prentice favors those new places. "If I get a really good shot, I tend not to go back to the same scene again. I find that it's sometimes painful to go back and try to make a better shot. You come back with something that's inferior." He occasionally breaks this rule. "What draws me back? I've been doing a Grand Canyon calendar for ten years, so there is always a reason for me to go up there, to keep coming up with fresh images."

Something of a renaissance man, Prentice developed a widely-used stock photography software system. He also plays blues guitar, and his creative confusion fits right in to the observations many have made about the reciprocity of photography and music. "I'll be dropping off to sleep, and I'll be thinking of a song or I'll be thinking of an image, and they'll merge in my head. It will start out one thing and end up another."

Randy Prentice understands the patience demanded by weather and craft—anticipating lightning storms, looking for shadows, working with sidelight, waiting out the middle-of-the-day "ugly light. If you don't have the light, there is no photo there. I've had to wait five days for winter storms to clear. I'll stay a couple of nights in my camper, then get a hotel room, then stay a couple more nights in my camper." Finally, the storm cleared.

"I got one shot—but it was a good shot."

RANDY PRENTICE

High on Photography

[*OPPOSITE*]

RANDY PRENTICE

Maidenhair fern and moss flourish on a waterfall located deep in Saddle Canyon near the Colorado River in Marble Canyon

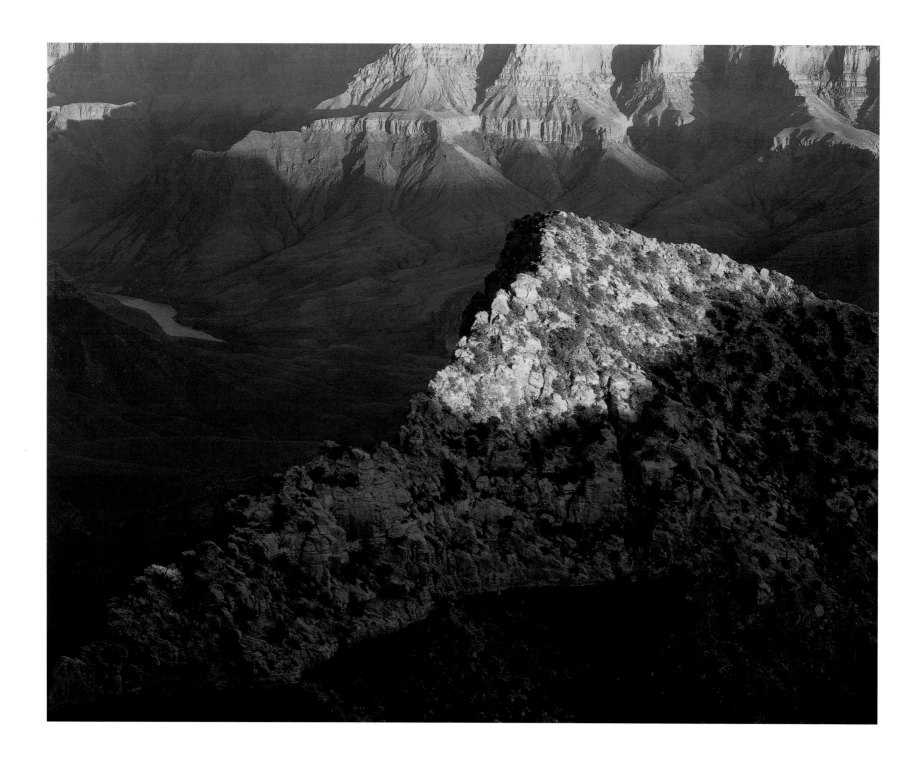

RANDY PRENTICE

Early morning light illuminates the cottonwood trees
surrounding Havasu Falls

⚙ I'd been in Havasu once before, in 1986. I got some fabulous
photos of the falls and the travertine terraces. But of course
since then, they were washed out. So that pretty much rendered
my photos useless—except for historical purposes.

In 2000, I was working on a book for Arizona Highways on rivers.
Peter Ensenberger (the photo editor down there) and I rode some
horses down with all our gear.

The thing about Havasu is trying to find a new angle, a new shot,
because it's been photographed to death. So I just stood up at
the top and figured I'd wait for the light to start streaming in. I
had no idea how it was going to look. I just waited, and I saw it
hitting those cottonwood trees, and I waited until they were all lit
up—and I took the photo. That was something I'd never seen
before in quite that way.

It's just being in a place and waiting. I probably waited forty
minutes or so as the trees came up and started to light up.

[OPPOSITE]
Light illuminates Freya Castle with Colorado River
viewed from Cape Royal

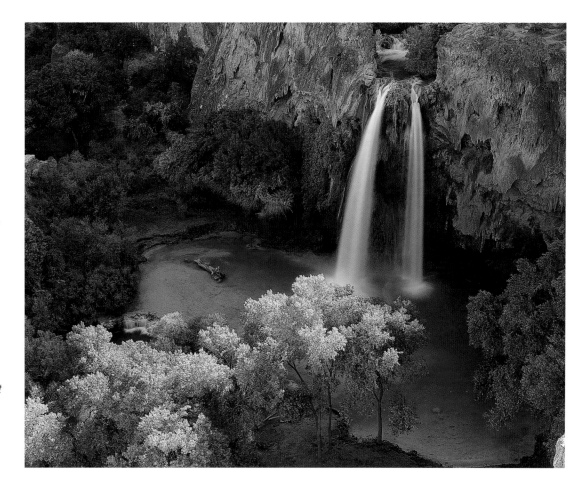

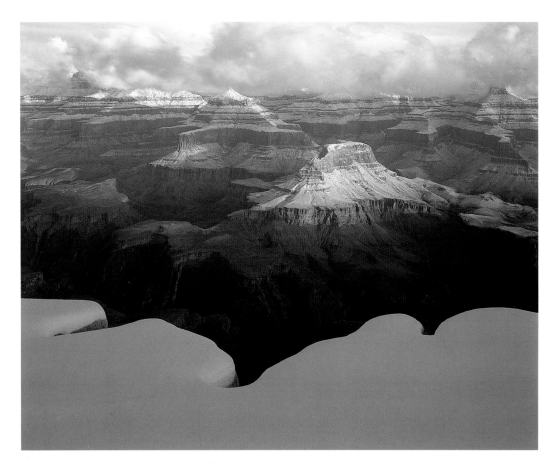

RANDY PRENTICE

Snow-blanketed edge of Yavapai Point on South Rim looking toward Cheops Pyramid and Isis Temple

◉ *I like to go up there in the winter. I've probably got as many winter shots, snow shots, as I do anything shot in the summer or fall. Because I just love the snow. It's so beautiful, especially when it's pristine and it's new. This shot was at Mather Point. I was actually sort of forced to go there because the West Rim was closed and the East Rim Road was closed. Because it was a fairly heavy snow, I had nowhere else to go.*

That edge of the Canyon looks like a jigsaw puzzle piece. Nobody had stepped on it yet. I thought that was graphically interesting. To me it would supply that extra element in the photograph that would make it different and unique.

I start with the basic photographic rules, and then I'll go from there. What it comes down to is what looks right to me when I look in the ground glass. A photographer has an instinct for that. It can't be learned. Everybody has different tools for what they can do. For me, working with the organizing shapes seems to come fairly natural.

I'm just trying to communicate something about what I feel about the picture. I think my compositions are pretty simple. Trying to be graphic and getting something across—like that jigsaw pattern on the snow— I figure if it has an effect on me, it will probably have an effect on somebody else and move you in some way. It's just a matter of getting that effect across in the photo.

[OPPOSITE]
Rainbow and sheets of rain at dusk over Freya Castle and Vishnu Temple

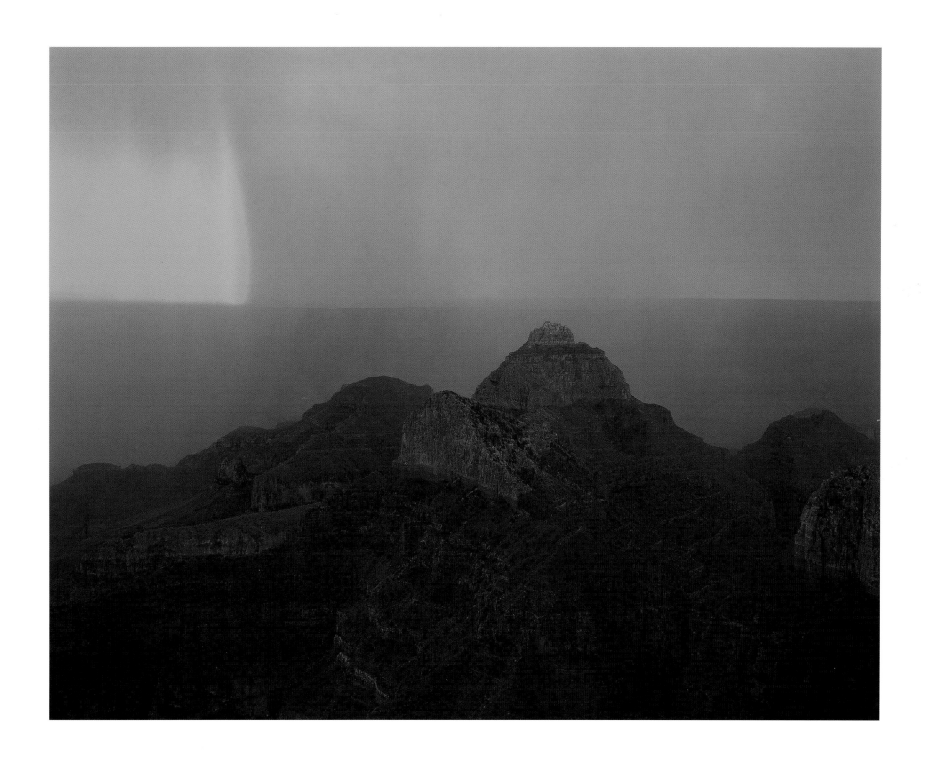

WHEN TOM BROWNOLD LEFT PRESCOTT COLLEGE, he carried a tripod-mounted 8x10 view camera over his shoulder. He learned from the masters, Frederick Sommer and Jay Dusard, fine art photographers who taught at Prescott for years. Sommer's horizonless, crystalline, black-and-white landscape patterns ("surrealist wallpaper," in one critic's pithy brief), influenced a generation—and Brownold speaks of both Dusard and Sommer with affection and reverence.

Brownold went on to study at the Apeiron Workshops in rural Millerton, New York, where "every week some god would come and visit the disciples on the farm. People like Minor White and Fred Sommer and Aaron Siskind. We'd sit at their feet, and they would look at our day's assignment and just rip us to shreds."

Brownold moved to Flagstaff around 1980 and began photographing and guiding in the Grand Canyon. His took his beloved 8x10 on several raft trips, creating a lightproof film-changing chamber by piling massive amounts of tarps on the top of a tent to block the ambient light. But he "realized that nobody really cared what size film you were shooting. They just wanted to see a pretty picture." Besides, he loved the fact that, with 35 mm, "you get thirty-six pictures to a sheet of film."

Gradually, he shifted to smaller formats, eventually migrating all the way to 35 mm digital and the "infinite tools in my powerful Macintosh computer." He applies the lessons

TOM BROWNOLD

Learning from the Gods

of the 8x10 to his commercial photography—the discipline, the sense of quality in optics and prints. But "there aren't many connoisseurs out there." His big view camera hasn't come out of its storage box in a year.

On the river, "I just shot when I saw something of interest. You start at your navel and work your way out. If it's a stormy cloud landscape—fantastic! If it was a spotted toad on a watery ledge, that was equally fantastic. Put it on film and contemplate it later—because, by the way, I've got to make dinner."

Brownold pays attention to the editorial content on an assignment, but he prefers more spontaneity, to break the rules, to "just go out and try to put light, color, and gesture together." He likens photographic technique to the lifelong knowledge of how to ride a bicycle: "Technique is forgotten, and at the same time, as you push the shutter, remembered."

He concentrates on the "fleeting moment that can be captured in the blink of an eye. Blink, and by golly you've got it. If it's wrong, well by golly you can do one of two things. You can wait there forever to see if it happens again, or you can accept the consequence and move on. That's life.

"The Grand Canyon is a work of art in and of itself. It's an iconic location, which is every reason to go continually renew my relationship with it. Sometimes, I am fortunate enough to connect the dots correctly and capture more than I expect. That's the beauty of the medium."

⊙ We were floating just above 36 Mile when the Canyon got dark and rain started falling in drops the size of lead shot—and spaced so as to present a path between those drops. We were at the end of our day and looking for camp. By the time we rounded the corner the spacing got a lot tighter.

I always marvel at how the river changes from Lake water green to Desert river brown. The noise of the rain on the water, the water on the cliffs, the waterfalls cascading down and then the huge slabs of Redwall Limestone falling to the next level—and us cheering it all on loudly with every crash, bang and splash—was amplified by our delight at being warm and dry on a cold rainy evening turning to night.

Then we noticed a mist coming off the cliff, and then that mist, too, turned into a minor ribbon waterfall. Tiny pebbles started hitting the sand with dull thuds, and our delight in the spectacle became one of guarded tension. Notice that there is a little trickle of water running toward the boats: that was our concern. After all we were a six-person trip with five boats, and we needed everybody healthy, our provisions intact with our boats.

We spent all the next day under our ledge because it was still coming down in sheets—but we were warm and dry. Some of the commercial guides call this camp George and Martha's camp because of the silhouettes on the skyline. We just called it "Home" for the next twenty-four hours.

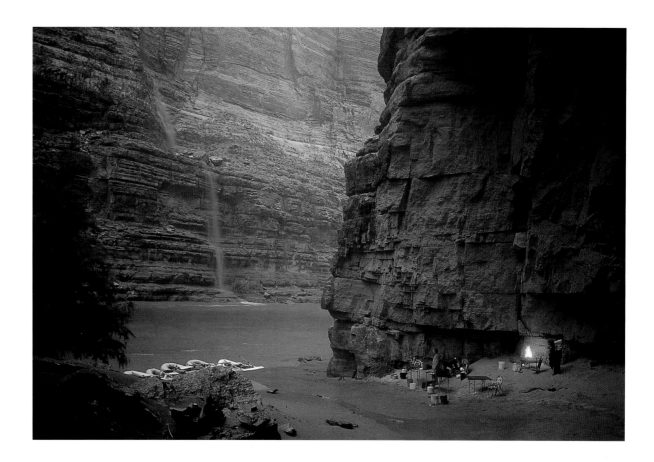

TOM BROWNOLD

Dry Camp in Marble Canyon

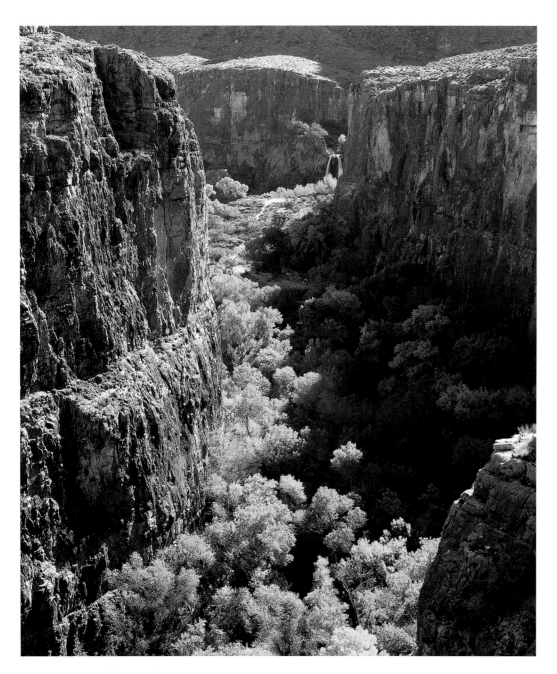

TOM BROWNOLD

Campground in Havasu Canyon

[*OPPOSITE*]

North Rim from Mather Point

✿ *I was on my way from Flagstaff to Marble Canyon for the Grand Canyon river guides meeting and decided to take a detour. It was on an exquisitely cold March evening. I needed to contemplate, and Grand Canyon is a good place to contemplate.*

This picture was taken at Mather Point, and I was surrounded by a bunch of Eurasians and foreign languages. It was bitter cold, and it was a beautiful evening. Light snowstorm clearing. . . it's totally serendipitous. That's the way my photography has always been. Serendipitous. It's the right place, time, moment—and equipment. How do I make this happen with some frequency? I leave often. You've got to go to be there.

This particular image is a medium-format image made with a Mamiya RB67. The reason I used that camera is that it's the closest thing I can come to the 8x10 and still not take up too much more space than is required.

The Australians bought this image a lot in the stock market. That was interesting—same colors. This photograph was taken from a view-point that's visited by millions of people a year, but it's a very rare occasion that you can even see a half a mile, let alone the inner gorge and the North Rim. We have so sullied the view in Grand Canyon that to get a clear view of the Canyon is becoming a rare commodity.

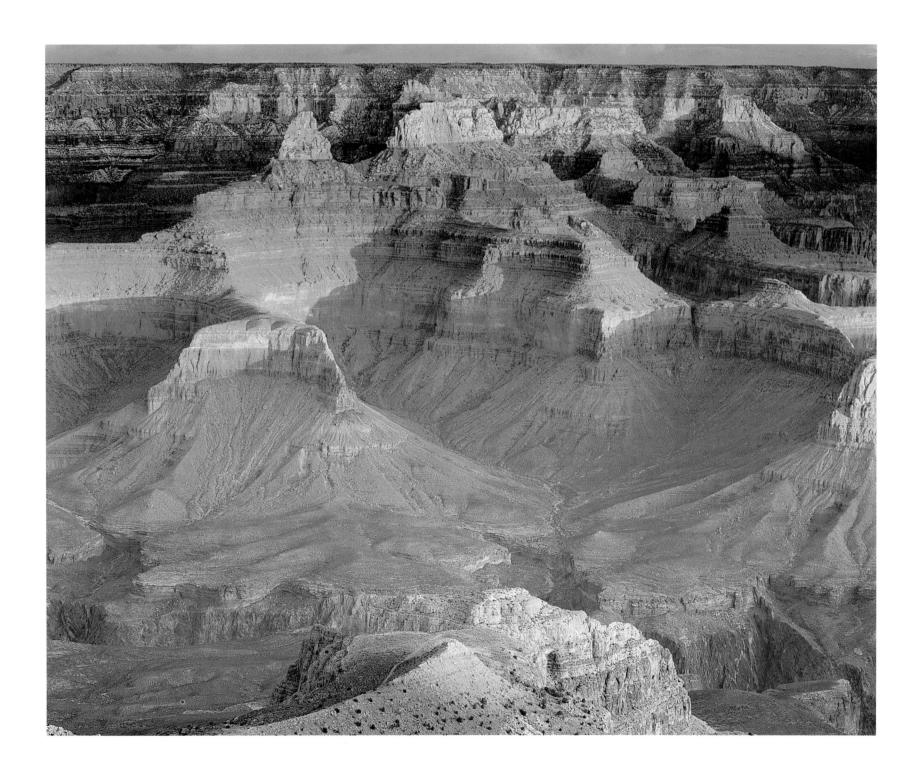

GEORGE HUEY GREW UP IN MANHATTAN taking pictures of parks and squirrels as a middle-schooler and printing them in a storeroom-turned-darkroom in his family's apartment. He pored over Nancy Newhall's landmark Sierra Club book, *This is the American Earth*, moved by the text and resonating with the photographs—certain that someday he would move West. His first chance was college, and he went just about as far away from New York as he could, to Prescott College in Arizona.

Soon after his arrival, Huey decided to go to the Grand Canyon with friends. "I'm not even sure we made the distinction between the North Rim and the South Rim, but somehow we found ourselves at the North Rim." The greenhorns gassed up at Jacob Lake and drove south, only to find the gate locked. So, "being young and somewhat fit and foolish," they walked the forty-five miles to the rim, taking two days. Huey's first glimpse past The Transept and into the Canyon "was breathtaking, like it is for everybody."

Four years later, after mentoring from legendary Prescott photography teacher Jay Dusard—and through him, from Dusard's mentor, Frederick Sommer—Huey set off into the world with a BFA in photography. A college friend running the Grand Canyon Natural History Association gave him his first assignment, sending George and his 4x5 to photograph the lovely old buildings at Phantom Ranch in black-and-white for a park booklet. (The designer of that booklet, Christina Watkins, would become his wife when he met her years later. They recently sold their house in Arizona to live on a sailboat, photographing the Atlantic Coast between Maine and the Caribbean.)

Huey began to teach himself how to shoot in color. He became an admirer of Larry Ulrich, who introduced him to the mini-4x5 Arca camera he has used for the past ten years, with the tilts and swings of a view camera, a back that loads medium format roll film, while still light enough "to carry as far as I can carry it."

Huey photographs from the rim, but he finds the trails take him beyond "the standard views we all see." He and Christina worked on a trail guide for the North Bass Trail in the early 1990s and (because of schedule constraints) hiked the steep unmaintained trail in August, when the heat was so intense they couldn't sleep. They tried climbing into Shinumo Creek at midnight to cool off.

Nonetheless, Huey "still finds looking for photographs the most exciting thing that I do."

He is careful to preserve the fragile magic of that search, just as he favors fleeting and subtle light rather than the easy, intense spectacle. "The Canyon is so operatic—everything is so over the top there—and there is all that atmosphere between the North Rim and South Rim; it's a formal visual challenge to compose a photograph. But if I spend enough time, I'll begin to see in a photographic way that suits my style."

Huey values "looking away from the horizon and looking down towards my feet for smaller elements that, when combined in a series of images, can tell a much bigger story." He worries that if he is too conscious of what he is doing, if he analyzes too much, "that I'll lose whatever I have. If I ever feel I'm getting stuck and I'm really not able to find a photograph, I'll leave all my equipment behind and just go walking—walking and looking. And for me, somehow not having that camera pack on my back will give me some visual insights that carrying the camera around with me precludes. The whole process is non-verbal, and I try to keep it that way. While I'm looking, I'm trying not to look—not to look too hard."

GEORGE H.H. HUEY

Trying Not to Look

[*OPPOSITE*]

GEORGE H.H. HUEY
Greenland Lake with summer rain,
Kaibab Plateau, North Rim

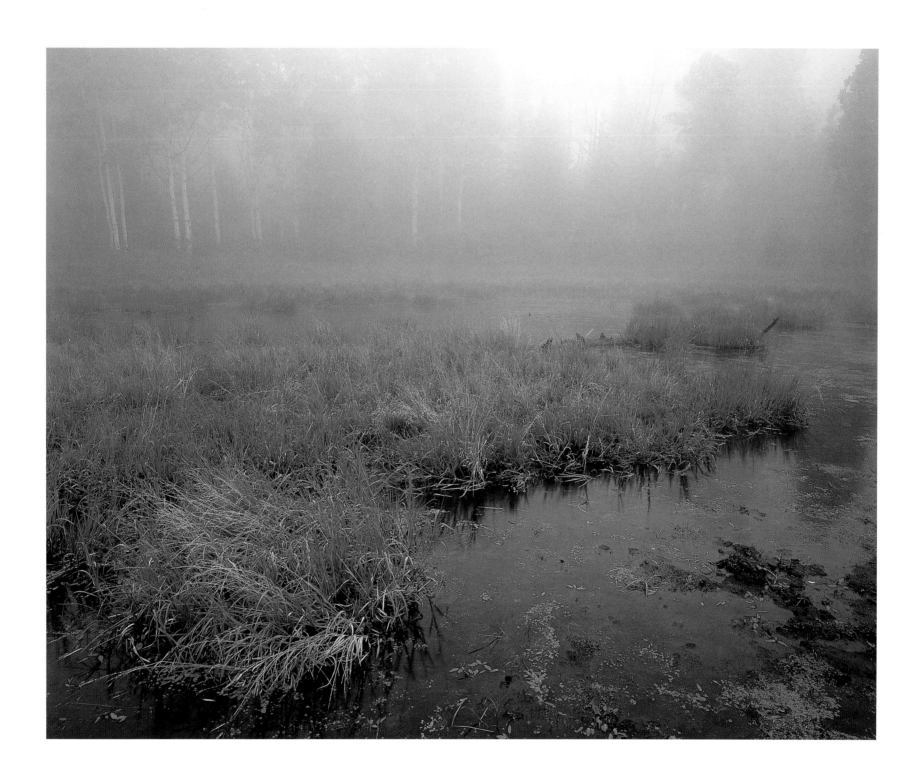

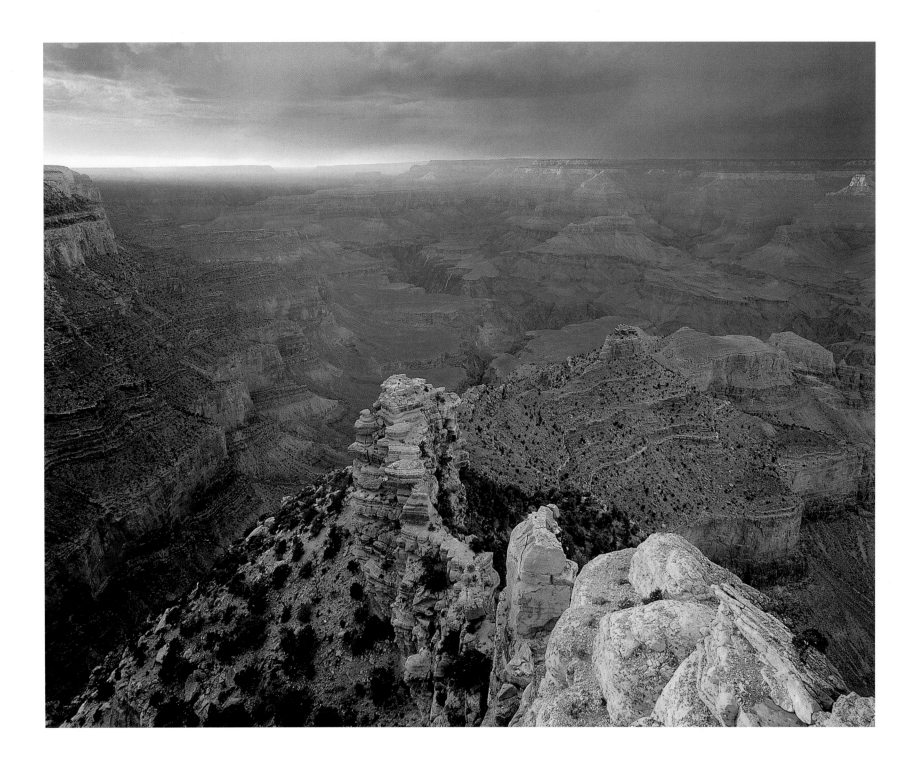

GEORGE H.H. HUEY

Hiker at Yaki Point, sunset

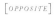 *I have always found the Canyon one of the most challenging places to photograph, which on the surface makes little sense. It is unquestionably dramatic and certainly scenic by anyone's perspective. Yet, trying to translate that breathtaking landscape into a two-dimensional image has often been frustrating. Perhaps the root of the problem is the pure vastness of the Canyon, and finding a way to express that and define it on film.*

"Form" is the inherent dilemma in making images of the Canyon—how to show more than the deep, wide, empty space that makes it so distinctive. One solution would include people, an animal, or boats on the river while another is to use a telephoto lens to compress that space, as I did one evening on the South Rim— using a telephoto lens on a medium format camera in a scene that included a hiker on a precarious perch of Kaibab Limestone. Finding the location was easy; convincing the hiker to move close to the edge was much harder!

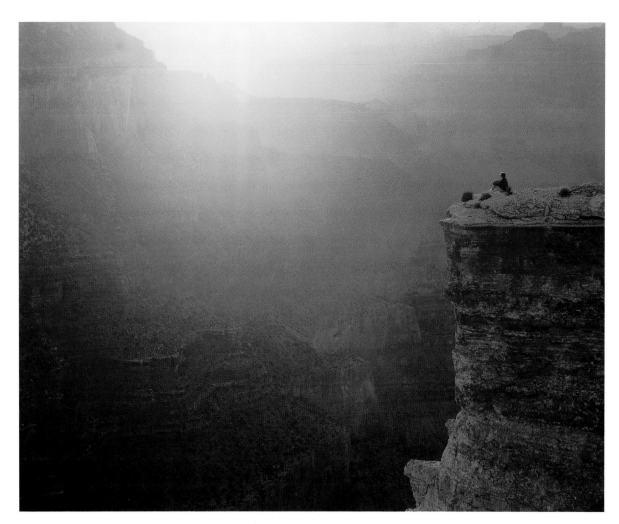

[OPPOSITE]

View from Yaki Point at sunset from South Rim with storm over North Rim at right

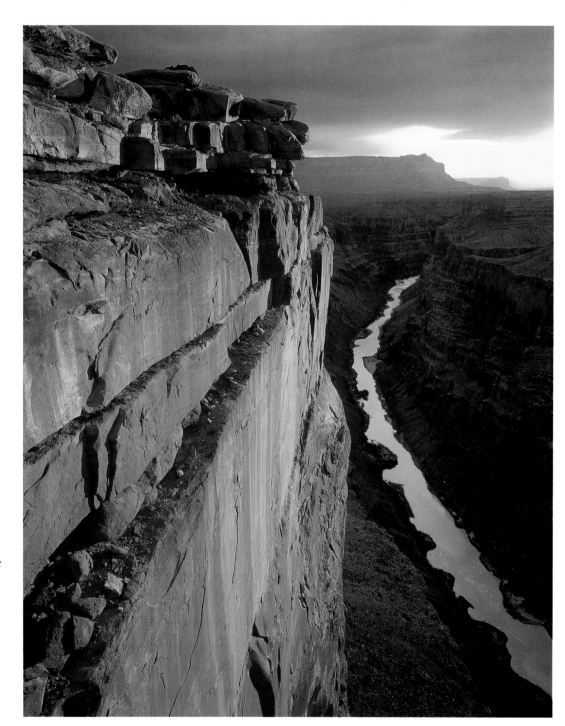

GEORGE H.H. HUEY

Colorado River, three thousand feet below, seen from Toroweap overlook at sunrise

[OPPOSITE]

View from South Rim, near Mather Point, at summer sunset

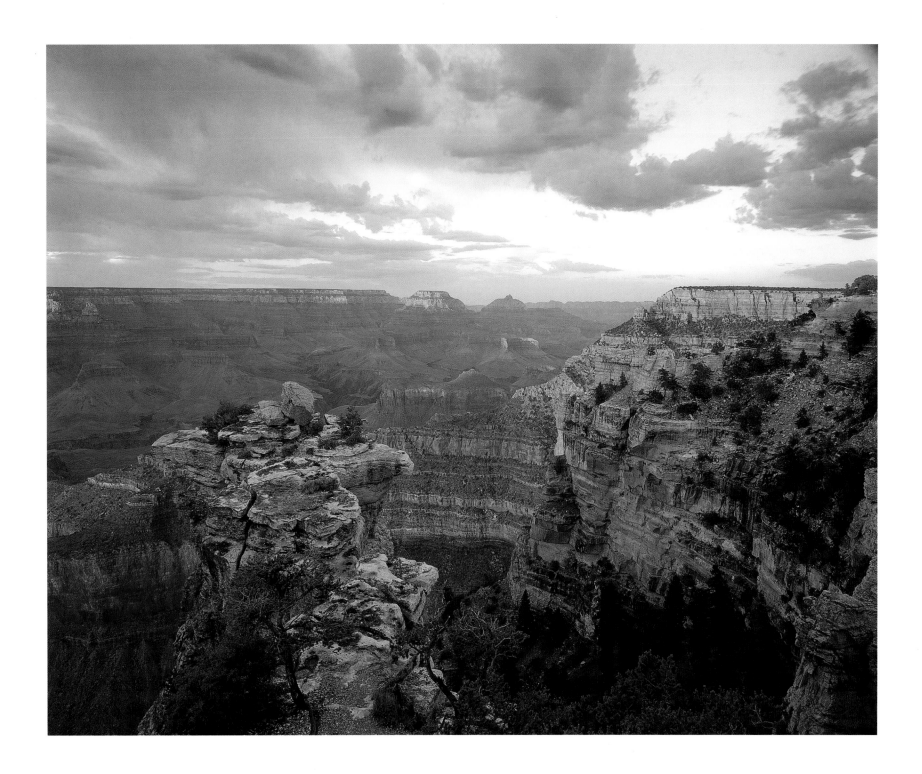

DUGALD BREMNER'S 1997 DEATH in a kayak accident on Silver Creek, above the South Fork of California's American River, rocked the boating and photographic community and left friends grieving around the world. By all accounts he was a witty, charismatic, talented, charming man. His adventure photography career was accelerating—with an assignment for *National Geographic* in print and another arriving the day before his death.

Born in Edinburgh, Scotland, and raised in Texas, Bremner first came to the Grand Canyon from Prescott College in the late 1970s. By 1985, he had served his apprenticeship and was working as a river guide. The next year—at the urging of his friend, Flagstaff photographer David Edwards—he began to take pictures. After three years assisting John Running and Sue Bennett, Bremner went solo and rented the downtown Flagstaff studio next to Edwards, quickly developing his own graphic style and his own list of clients, including North Face and *Outside* magazine.

DUGALD
BREMNER

Relentless Pursuit

His partner for the last three years of his life, Kate Thompson, remembers how much Bremner loved the graphic strength of Jay Maisel's work. "He wanted to bring that same graphic quality into the challenges of shooting crazy expeditions. Since he was a climbing and whitewater guide, he could really get ahead of the action."

Dave Edwards speaks of the same qualities: "You have to know what you are photographing, and Dugald was good at everything! He was just an astonishing athlete—a good mountain climber, kayaker, skier, rafter, doryman, rock climber. When he did adventure photography for advertising, he knew what to shoot. His images were new. He was good at improvising equipment, as well—it's kind of a boatman thing. When things don't work you have to fix them."

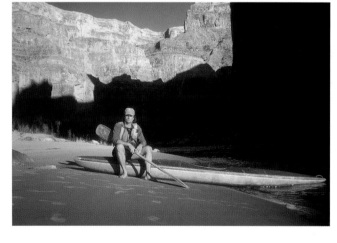

Edwards respected Bremner's steadiness in emergencies. "Good guides never crack. They don't lose their temper, they're always there." Not every guide can pull this off, but Bremner did. Edwards also admired Bremner's photographic drive. "He learned relentless pursuit. He kept going back again and again and again. He checked his equipment over and over and over again. Those qualities come from mountain climbing, they come from willpower, they come from being a Scot."

Bremner's Grand Canyon photographs were distinctive—still-lifes of an oar in the water; unusual vantage points reached because he was a good climber; technically innovative remote-control shots from his dory in rapids in low light. Kate Thompson emphasizes how much he loved those unusual angles. "He looked for movement, using a strobe or blur-panning a shot. He really struggled to capture the emotion of nature, the emotion of the moment, and the graphic quality of light."

She has replayed his accident a million times. "He definitely liked to take risks, but calculated risks. He was feeling on the top of his game that day. He knew what he was doing—and this was a freak accident." Bremner decided to run a waterfall, but stalled on a piece of bedrock where a subsurface current sucked him into a crevice.

Along with the memory of a man cherished by his friends and family, Dugald Bremner's pictures survive—strong photographs made by a man who did his best to live up to the lessons he learned from photographing on expeditions. Thompson quoted Bremner's list of aspirations from his journal: "To find inner harmony. To lead an exciting life. To have a sense of accomplishment. And to always cultivate wisdom."

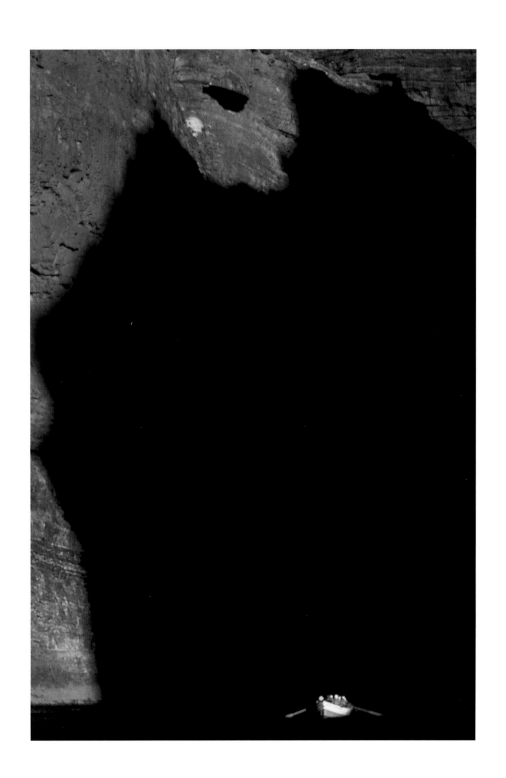

DUGALD BREMNER

Boats on water, Marble Canyon

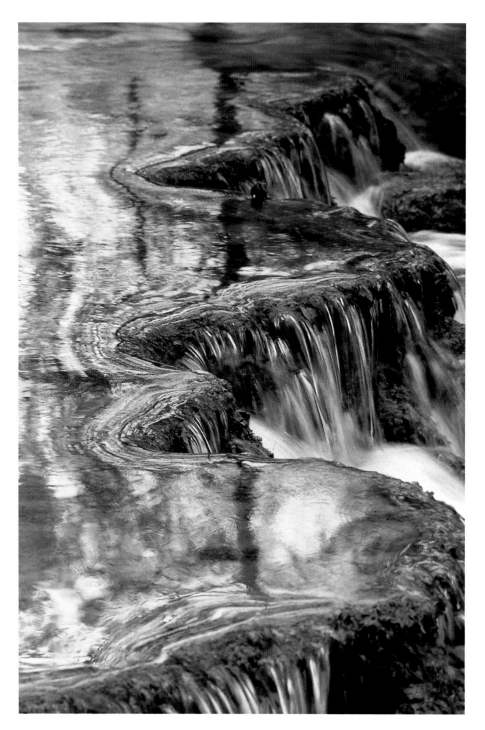

DUGALD BREMNER

Travertine Terraces, Havasu Creek

[OPPOSITE]

Rafting Lava Falls

✿ *Dugald was always intrigued by "the good old days," when the water ran muddy all the time before the dam. It took him to a lifetime piece of ongoing work called the Legends Project, photographing our forefathers and mothers—the explorers before us that are still living legends. He has a whole series of them. In his journals he was always talking about what those days were like, the pre-dam days. And so muddy water was a very spiritual thing for him. I think he took this shot of the raft entering the notorious V-wave in Lava Falls in the late eighties. Such muddy water, just being buried in it is one of the moments he lived for.*

I believe Dugald was experimenting with slow shutter speeds and panning shots. What the water is doing here is wonderful. And the action captured is classic. —KATE THOMPSON

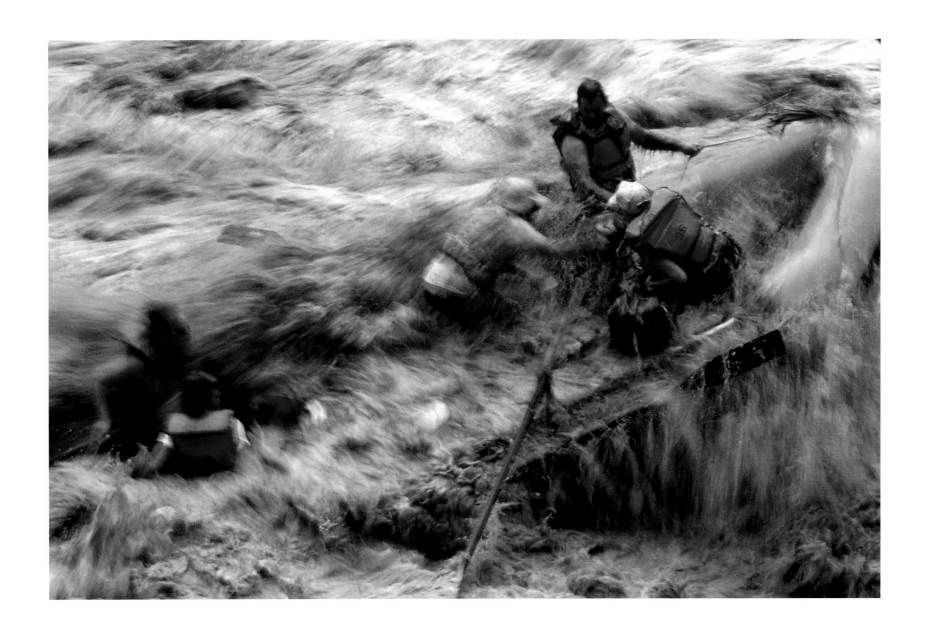

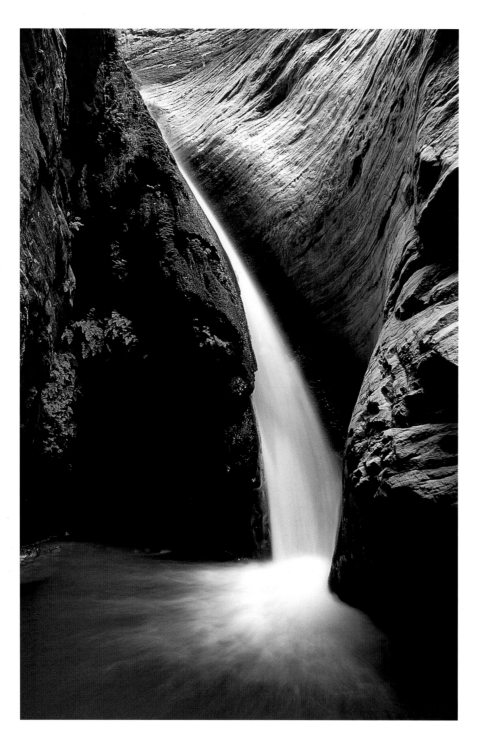

DUGALD BREMNER
Stone Creek Falls

[*OPPOSITE*]
Granite Falls

✿ Looking upstream from Granite Falls after a clearing storm—
Dugald made repeat photos of this place, spanning the mid-eighties
through mid-nineties. He really studied this place. He would go to
certain locations at sunset every time he camped here. In his journals,
this is one of the places he'd write about, particularly the quality of
his runs and how to perfect them in the future. He took pictures of the
rapid with all the different rocks showing, because in a dory you want
to know where the rocks are in every possible run. The shutter speeds
are slow and I think just the composition of this area was what really
intrigued him. —KATE THOMPSON

Whenever I go to Granite Rapids, I always think of the picture that he
shot there (on a photography charter trip with National Geographic
photographers Nick Nichols and Sam Abell in 1992). I always think of
that and the light. When I've taken photo charters down there, I've
always stopped and mentioned that one of my friends shot a very
beautiful image there. And also I think of him at a couple of side
canyons, National Canyon, where he went climbing and has some real-
ly beautiful work.

He had a great spirit of adventure. —DAVID EDWARDS

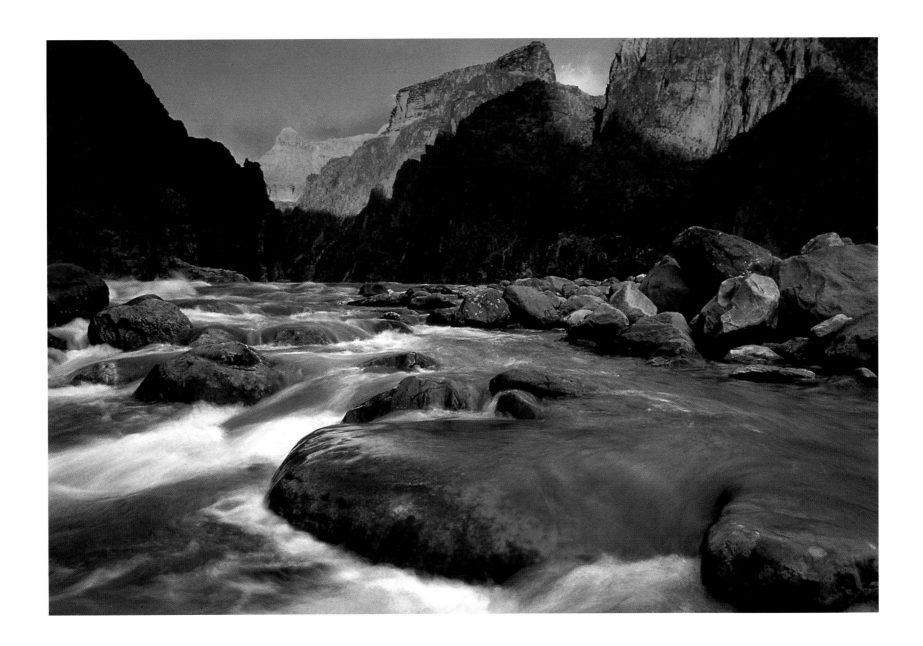

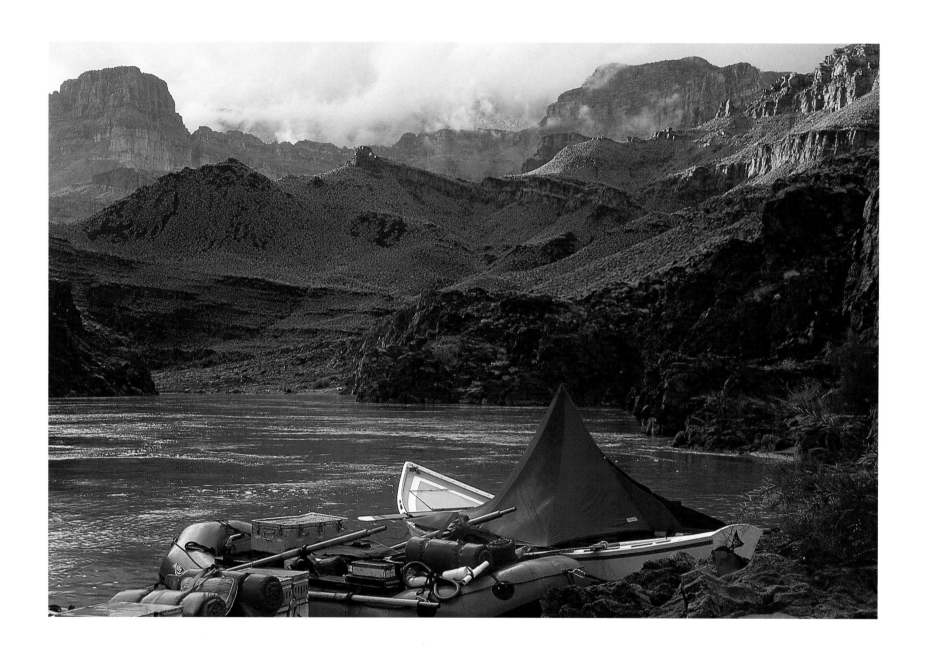

KATE THOMPSON

Camping along the Colorado River

KATE THOMPSON KEEPS RETURNING to the Grand Canyon in new guises. First, she came as a commercial river guide. Then, as a soil scientist for beach erosion surveys and United States Geological Survey archaeological projects, doing multiple trips in all seasons. Finally, she came as a photographer.

Her work in photography began in the mid-1990s through her then-boyfriend, the adventure photographer Dugald Bremner. She started as Bremner's assistant, and then, when Dugald died in 1997, Thompson "had an investment in his work emotionally and careerwise." She took over the marketing of his images and rooted herself in the nourishing Flagstaff photographic community, working with John Running and Sue Bennett and David Edwards, all three encouraging and coaching her. But it was really Dugald Bremner's images that informed her photographic eye. "By virtue of endless, endless hours of editing day after day, night after night on the light table, looking through those images for years, I was basically mentoring myself through his work."

By the year 2000, Thompson had the courage to drop her science projects and become a full-time photographer. She moved from Flagstaff to Dolores, Colorado, where she values "the sleepy little cowtown" away from the distractions of busy downtown life.

She has moved from one male-dominated field to the next, from guiding on the Colorado River in Grand Canyon, to geology, to photography. For Thompson, the Canyon is "a very extreme environment with big water. When the wind blows, it blows hard. When it rains, it rains hard. But I see so much feminine aspect in Grand Canyon—the sinuosity and the eroticism of the rock. I think it's a woman's place."

KATE THOMPSON

Savoring Life

Kate Thompson revels in the fact that she photographs like a woman—just as she "rows like a girl"—getting away with tiny strokes, feeling the water and the boat in all their subtlety. "I have a softer touch. When I'm taking pictures, I'm really savoring life intensely down to 1/100th of a second. I take pictures for myself, and having a camera in my hand makes me realize the gratitude of being in the place."

She deals with the vastness and endless choices of photography in the Canyon by giving herself assignments, like shooting with only a wide-angle for an evening. And sometimes she needs a break from this overwhelming place: "I just put down the camera and take pictures with my eyes." On the rim, she looks for "which intimate butte is becoming illuminated right now."

And, always, she returns to the river—generally for a couple of trips each year. Her first assignment for *Arizona Highways* naturally involved the river. She photographed historic wooden boats running the river once again. But by the time she nailed down the assignment, the trip was full, so she had to "arrange backpacker permits in all these different obscure places so I could go down and join the trip and then

hike out and then come back and join the trip and hike out." She did this four times.

In the story, writer and boatman Brad Dimmock talked himself through Granite Falls at the oars of a wooden boat: "Anticipate. Act. React." His mantra works just as well for Kate Thompson photographing his run from shore—a remarkably active role "in this extreme environment." "The image arrived, and to have these surprises come out is the most wondrous thing. I thought, my god, the universe is providing for me at this rare moment."

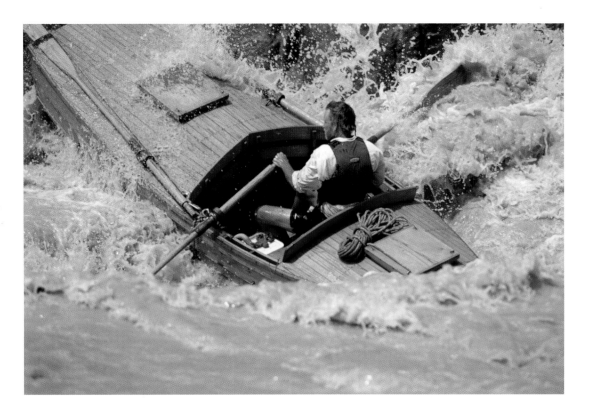

KATE THOMPSON

Holmstrom boat in Granite Rapids

⊙ *I hiked into Granite Falls for the* Arizona Highways *shoot about wooden boats—a seven or eight hour hike that started super-early in the morning, at first light. I arrived pretty early in the afternoon to beat the heat and planned on camping there with the river trip. I was exhausted and dehydrated so when they pulled up about a half hour after I arrived, I was napping in the shade.*

I awoke to, 'Kate, we're here, we're ready to run.' There is this adrenaline to go, to go, go, go. 'We're nervous, the water levels are high, and we're scared, and we're running.'

I ran down to the water's edge at the middle of the rapid with my Nikon F5 camera, my backup F-100 camera, and the long lens. Literally, as the first boat is dropping in, I'm slapping on my lens and dialing in settings as it is going through. And cursing myself because this is the photo that I envisioned. Granite Falls is a magnificent place to shoot, and I knew what to expect there. I think I got something, but I'm not sure. I'm checking my settings again and the boat I really wanted to shoot is next, the Holmstrom boat, which is a lapstrake, all-wooden boat, really beautiful. And my F5 for some reason died.

For all my personal and passionate reasons for wanting to shoot this, it all comes down to this moment. I just threw my camera down in frustration. Immediately, I pulled out my F100, slapped on the lens, slammed it on program and went with what the camera decided to do for me. But something came together in that 1/100th of a second. And I got the shot that I wanted that made the magazine.

[OPPOSITE]

MARC MUENCH

Colorado River

The exhibit of Grand Canyon photographers hung at the Kolb Studio in 2006 featured twenty-two of the contemporary photographers profiled in *Lasting Light*. Grand Canyon photography embraces more fine photographers and pictures than can fit into the cozy space of the Kolb brothers' aerie, however.

Lasting Light closes with a sampling of images beyond these exhibiting photographers—from longtime Canyon photographers such as David Edwards and Larry Lindahl to Raechel Running and March Muench, inheritors of family tradition, and innovative Gen-Xers such as Kyle George and Jay Showers.

THE CONTEMPORARIES~ *Extending the View*

DAVID EDWARDS (B. 1940)

CHRISTINE KEITH (B. 1953)

PAUL LEATHERBURY (B. 1956)

GEOFF GOURLEY (B. 1958)

LARRY LINDAHL (B. 1958)

MIKE BUCHHEIT (B. 1964)

RAECHEL RUNNING (B. 1965)

MARC MUENCH (B. 1966)

JAY SHOWERS (B. 1968)

KYLE GEORGE (B. 1979)

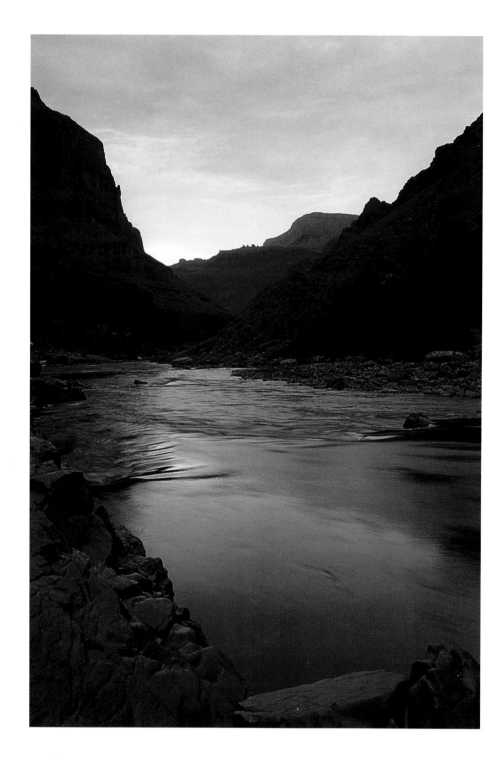

DAVE EDWARDS
Grand Canyon dawn, mile 132

[*OPPOSITE*]
Conquistador Isle

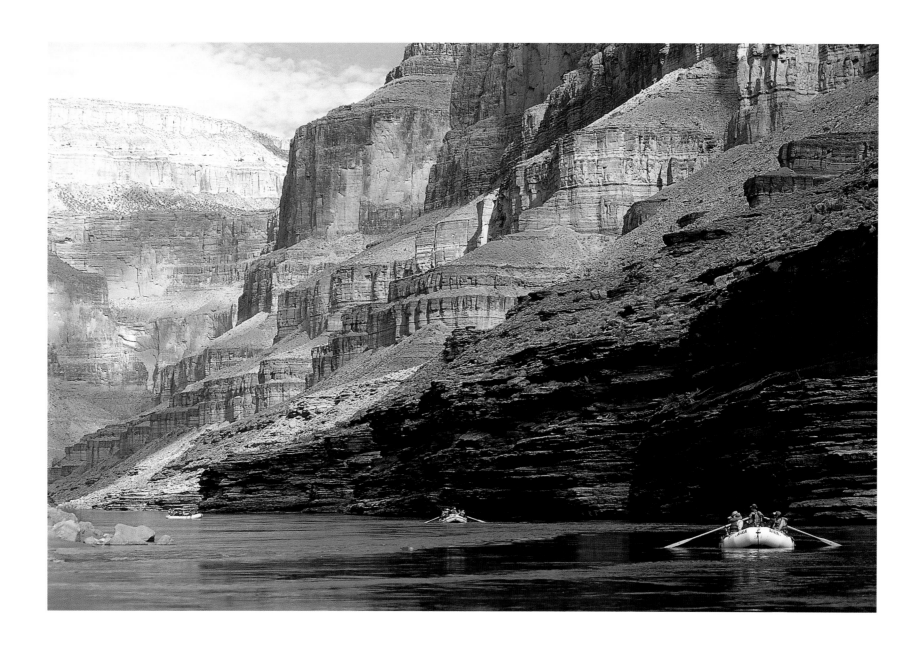

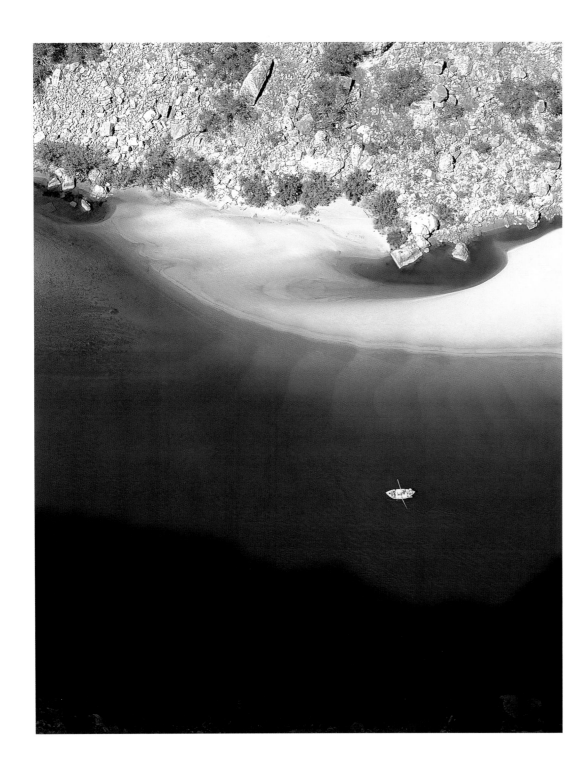

LARRY LINDAHL
Underwater pattern, dory below
Eminence Beach overlook

[*OPPOSITE*]
Desert View Watchtower and
Colorado River, sunrise

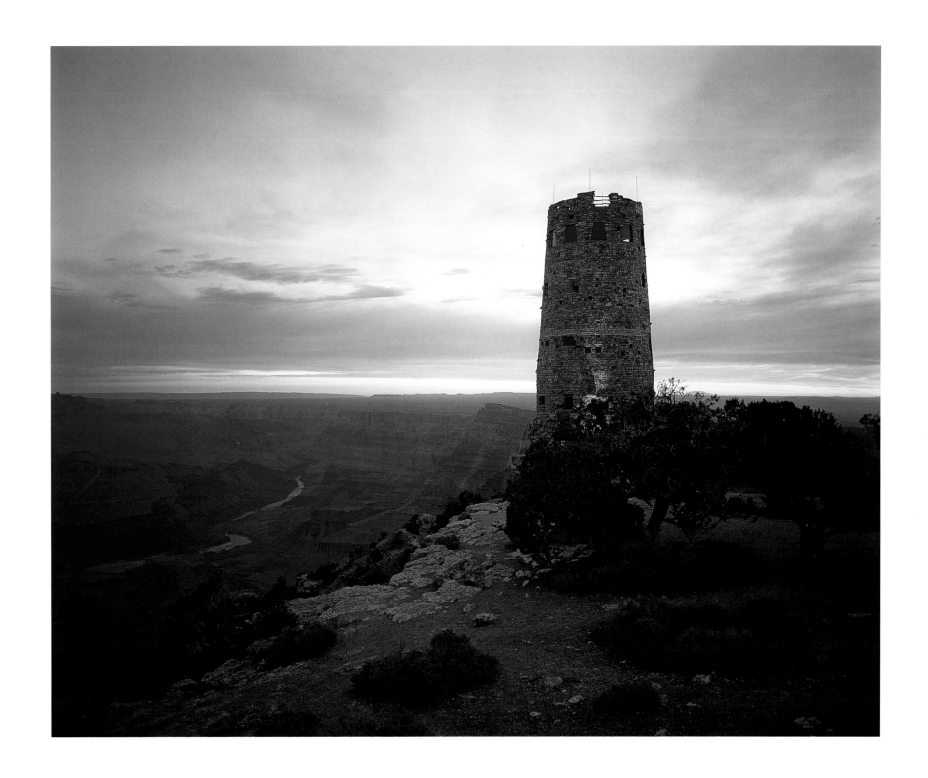

CHRISTINE KEITH

Mixed conifer old growth, Swamp Ridge,
North Rim

[*OPPOSITE*]
Silhouetted mixed conifer old growth, sunrise
at Grand Canyon's East Rim

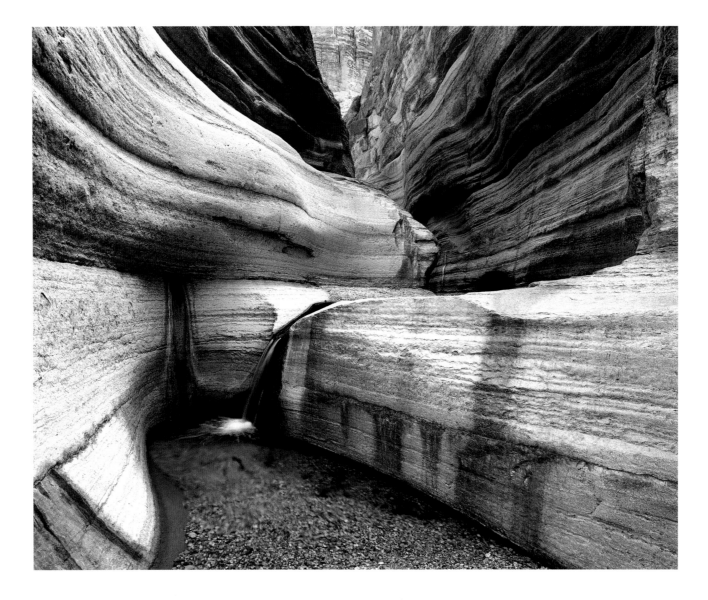

MARC MUENCH

National Canyon

[*OPPOSITE*]

Marble Canyon at Nankoweap

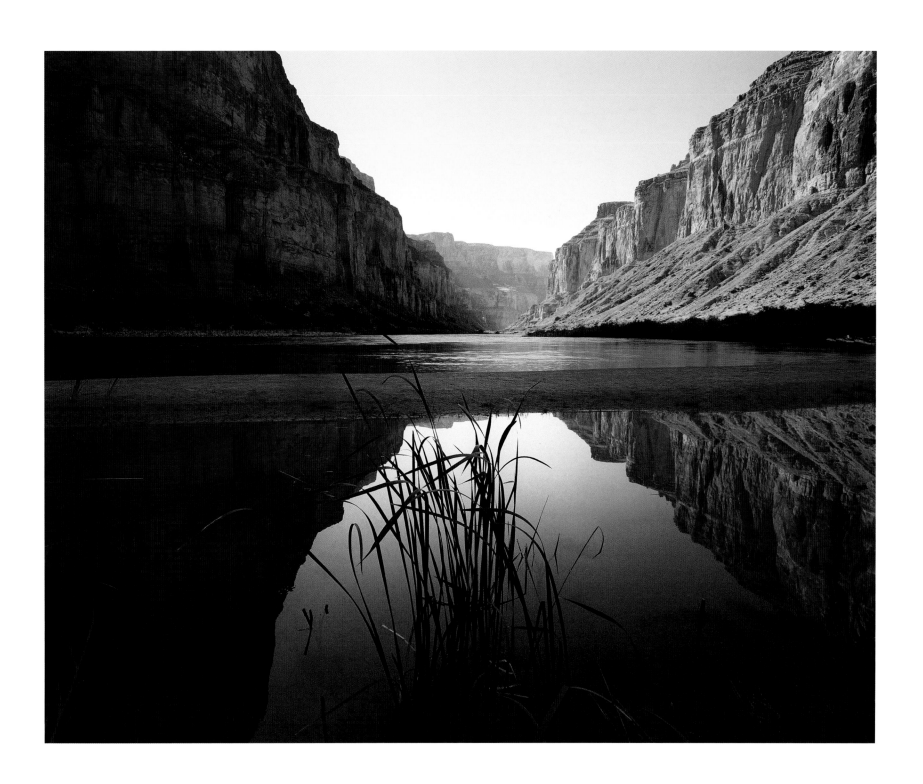

GEOFF GOURLEY

Dory, Deer Creek

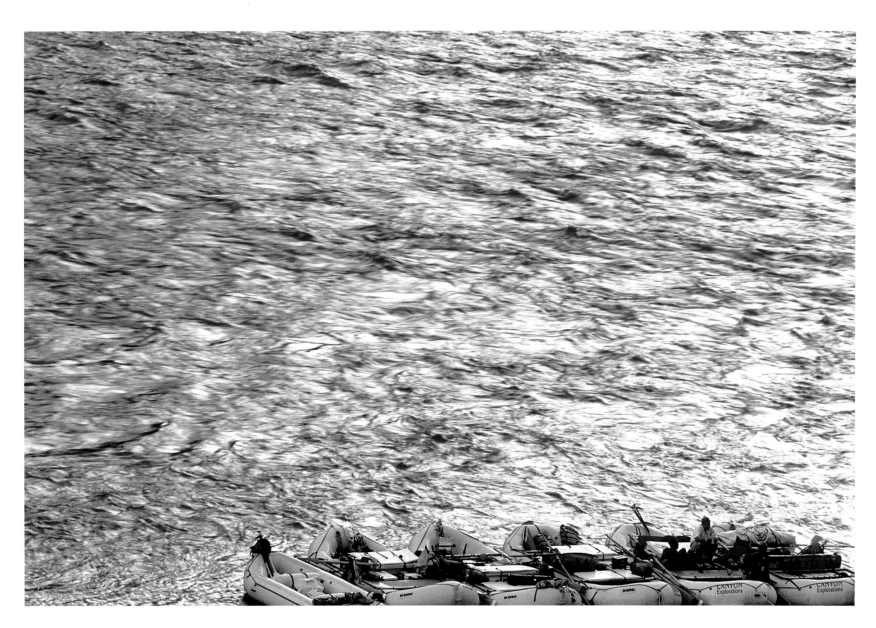

GEOFF GOURLEY

Riverboats

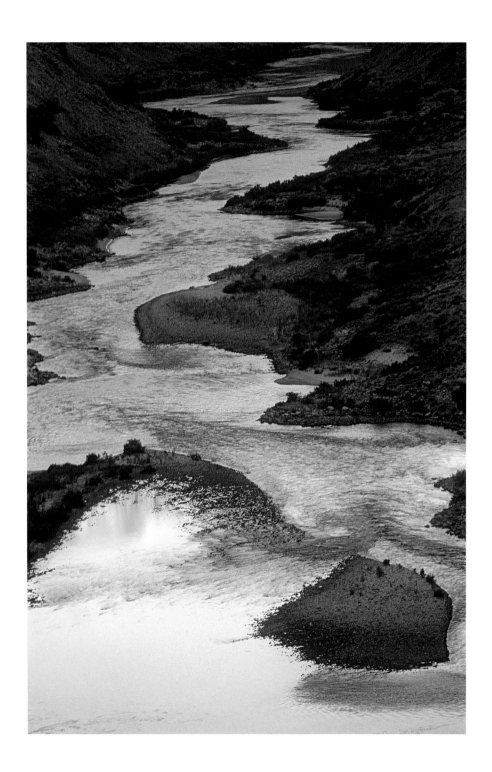

GEOFF GOURLEY

Nankoweap downstream

[*OPPOSITE*]

Parashant

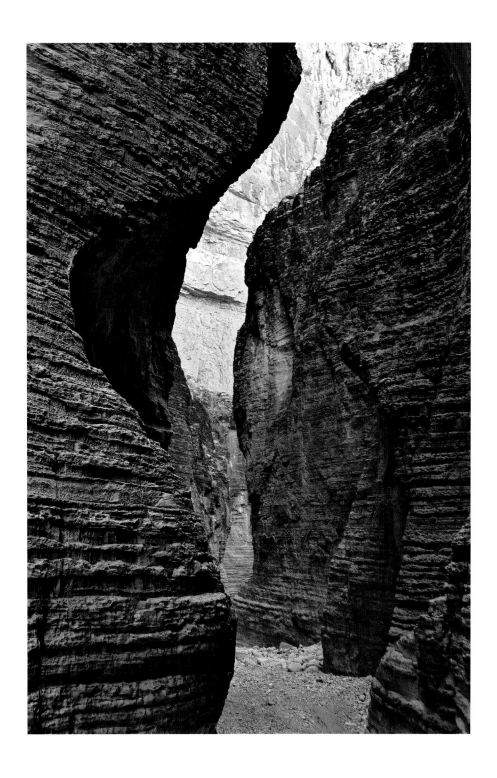

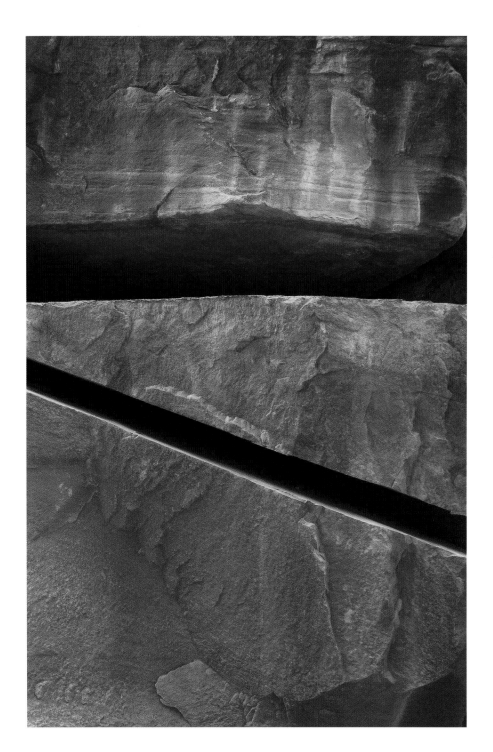

RAECHEL RUNNING

Crack in rock, North Canyon

[OPPOSITE]

Lava Chuar

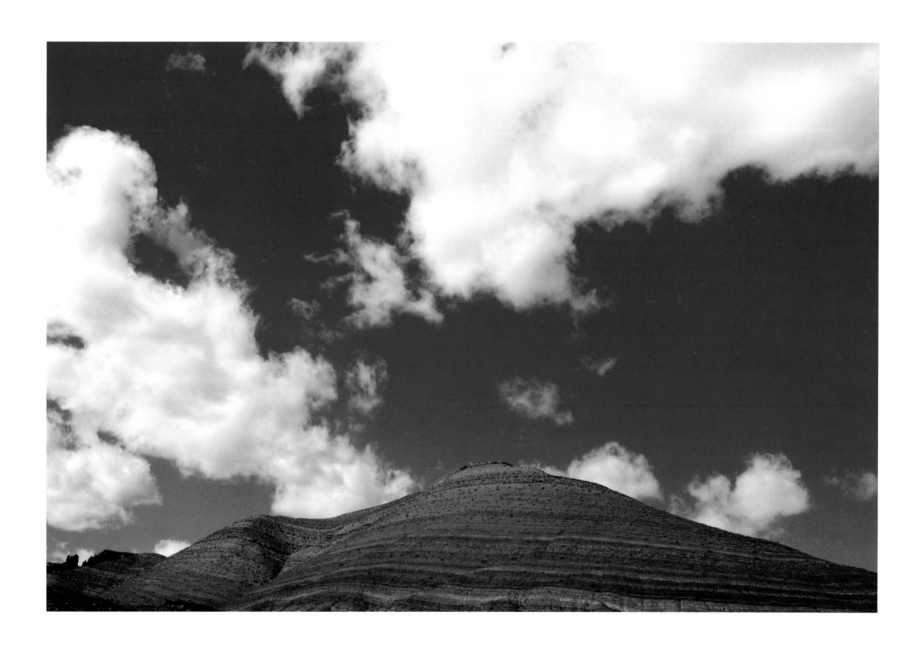

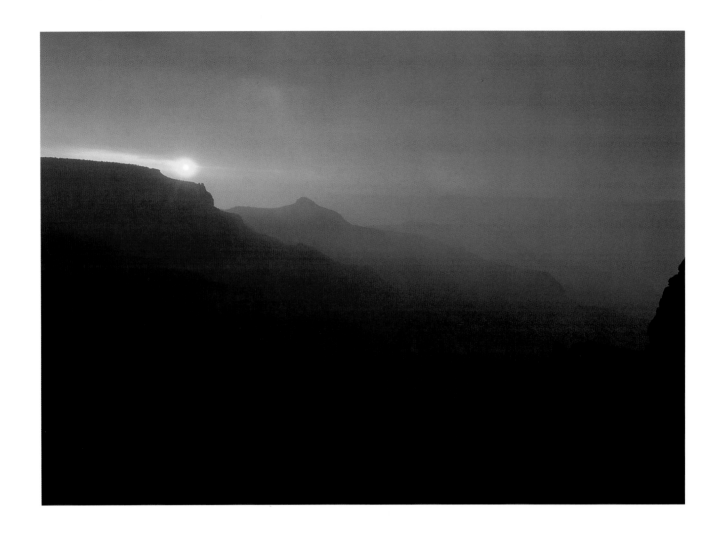

KYLE GEORGE

Morning storm from Cape Royal

[OPPOSITE]

Night exposure of Nankoweap

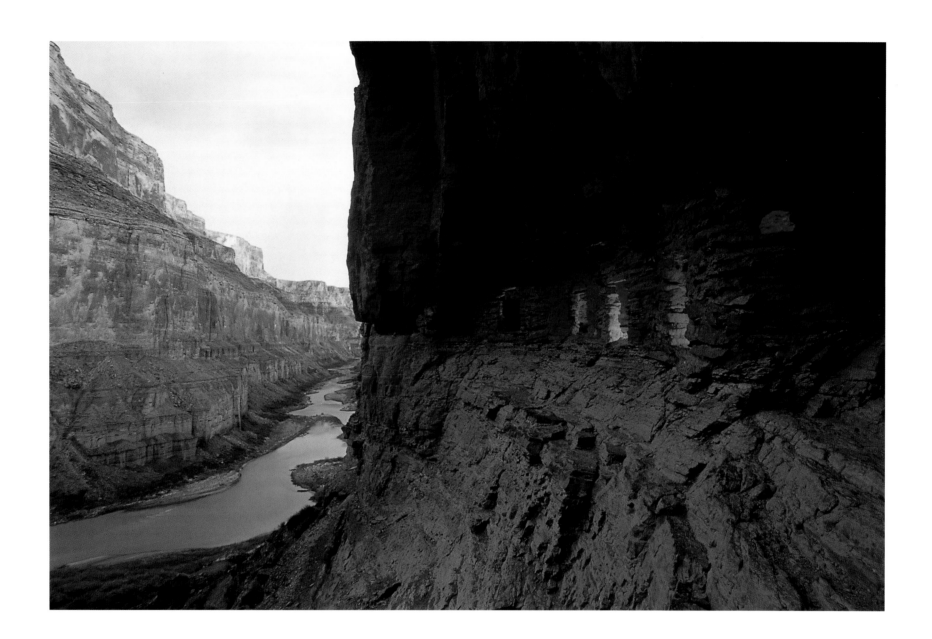

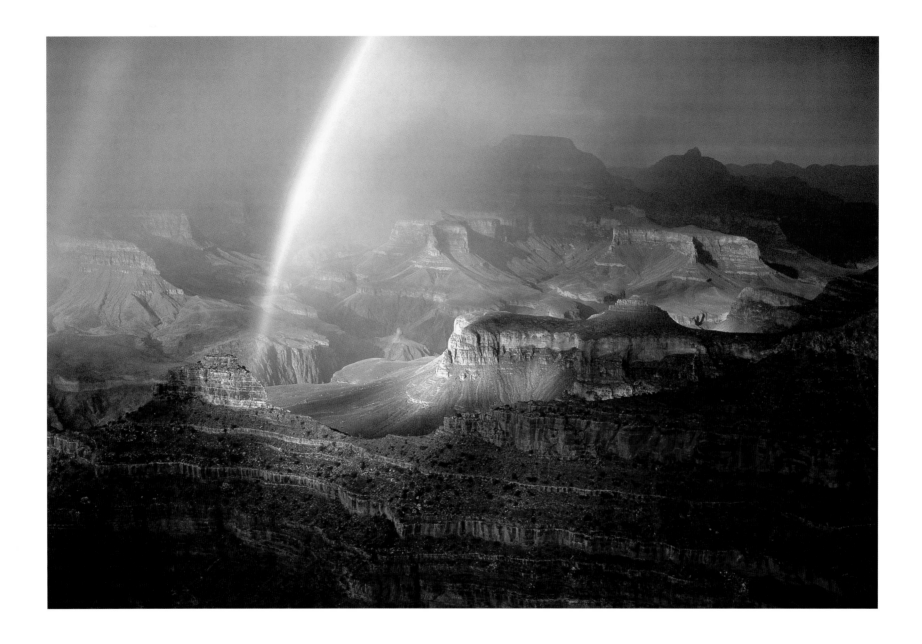

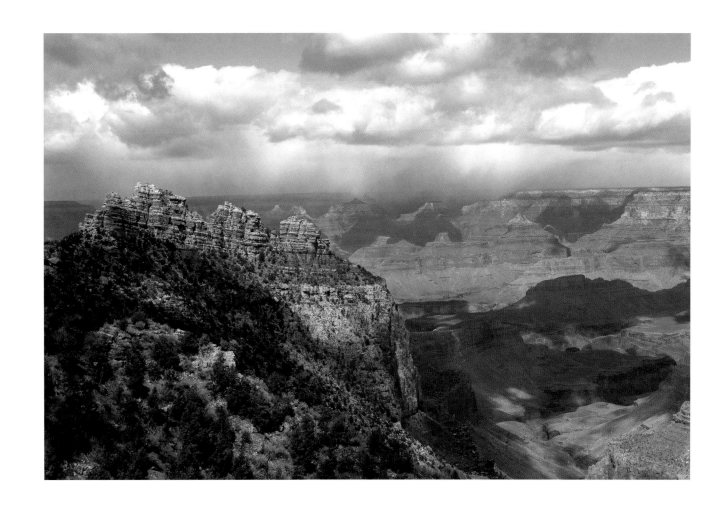

MIKE BUCHHEIT

Sinking Ship

[OPPOSITE]

O'Neill Butte Rainbow

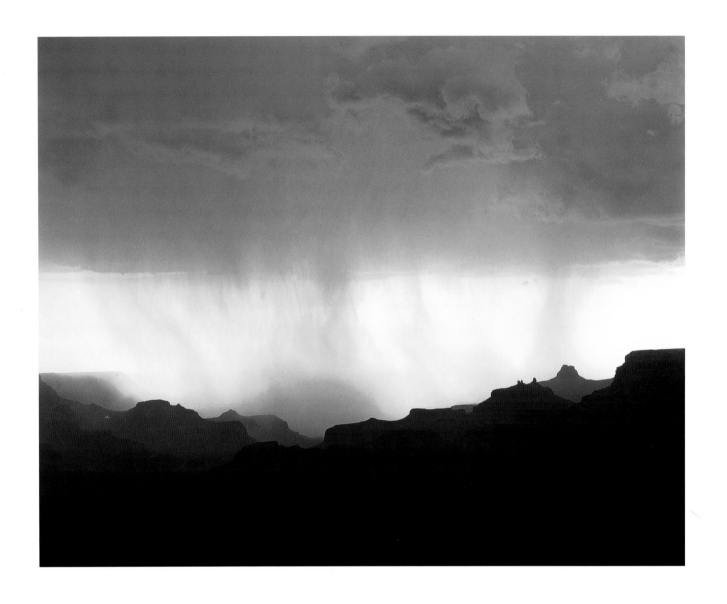

PAUL LEATHERBURY

Storm clouds and rain west of Desert View

[OPPOSITE]

Multiple lightning strikes during a late summer thunderstorm

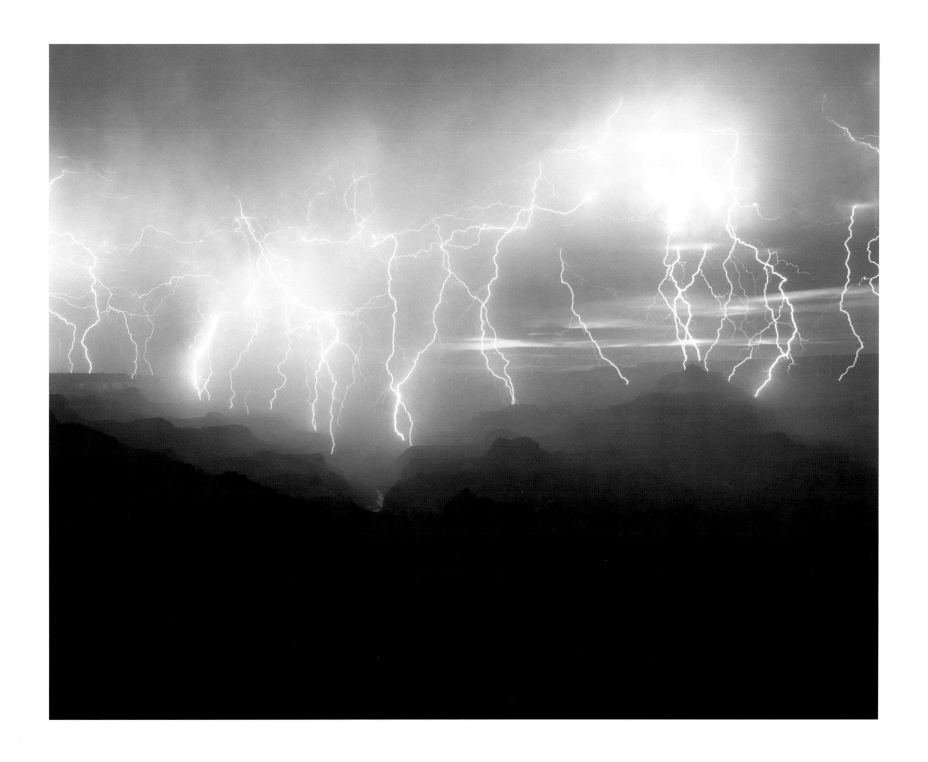

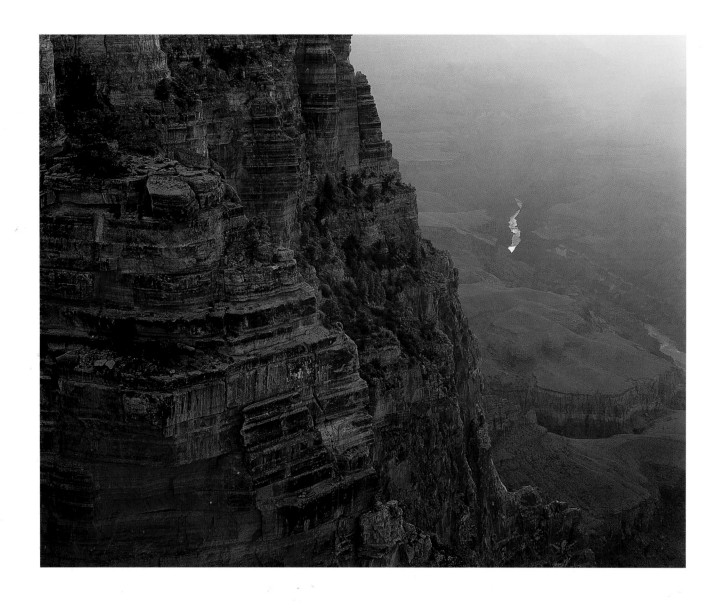

PAUL LEATHERBURY
*Late light and glowing cliffs
near Navajo Point*

[OPPOSITE]
Sunlight streaming over Unkar Rapids

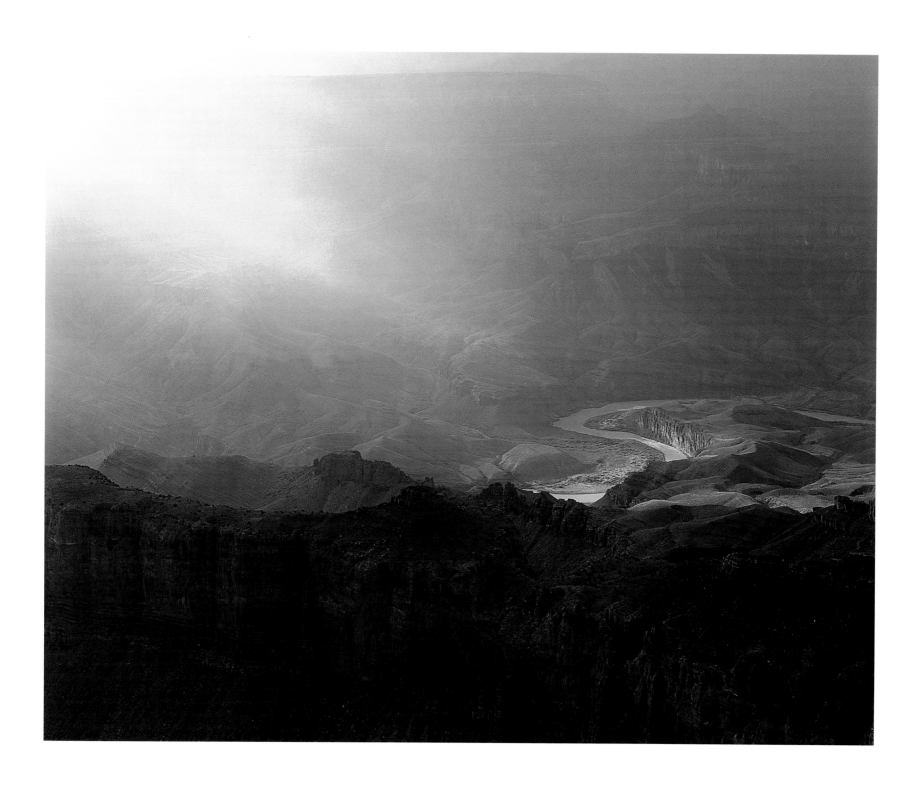

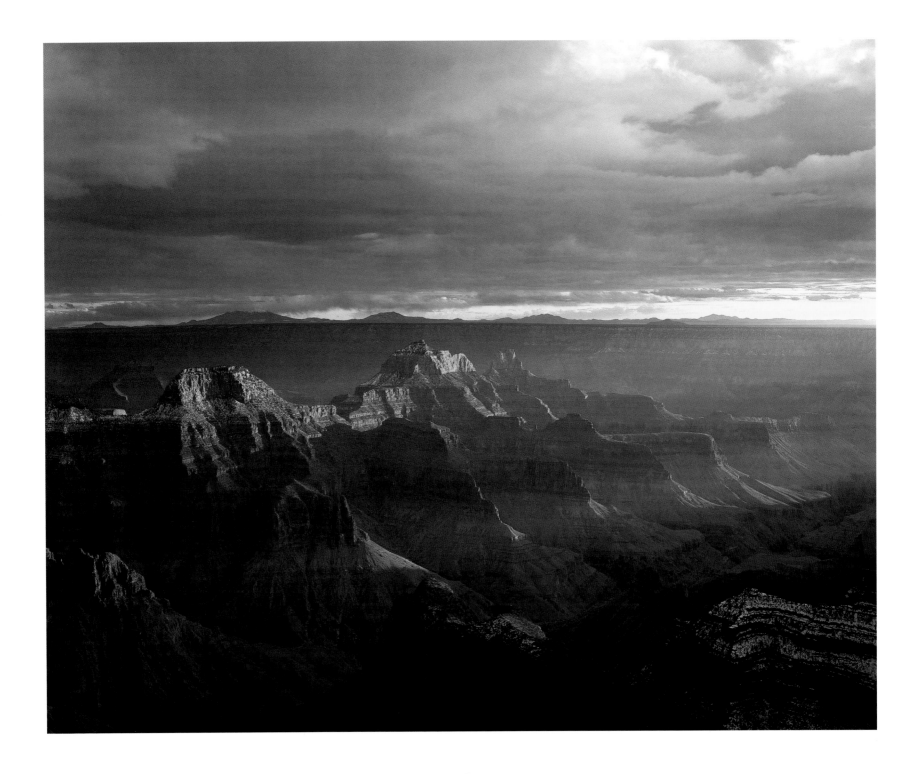

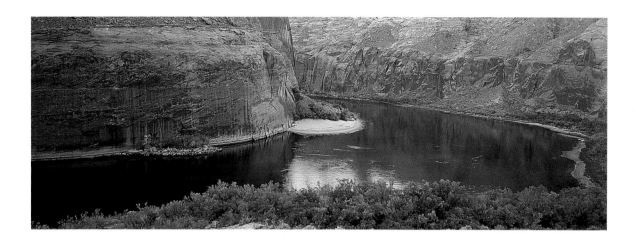

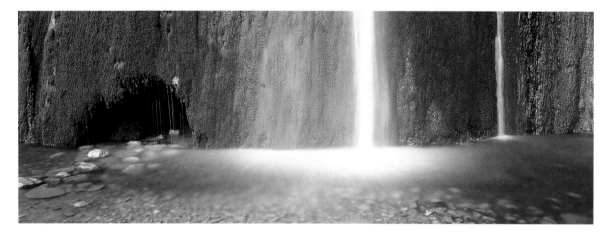

JAY SHOWERS

[*TOP*]

Mile 6 above Lees Ferry, Marble Canyon

[*MIDDLE*]

Ribbon Falls

[*BOTTOM*]

Deva, Brahma, Zoroaster Temples, view from North Rim Lodge

[*OPPOSITE*]

Deva, Brahma, Zoroaster Temples from North Rim Lodge in winter

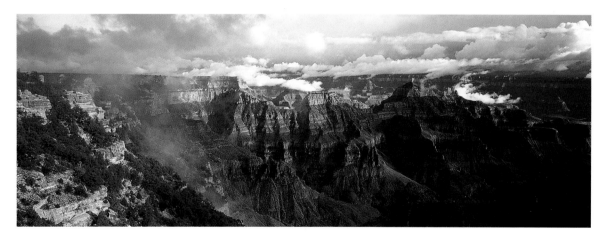

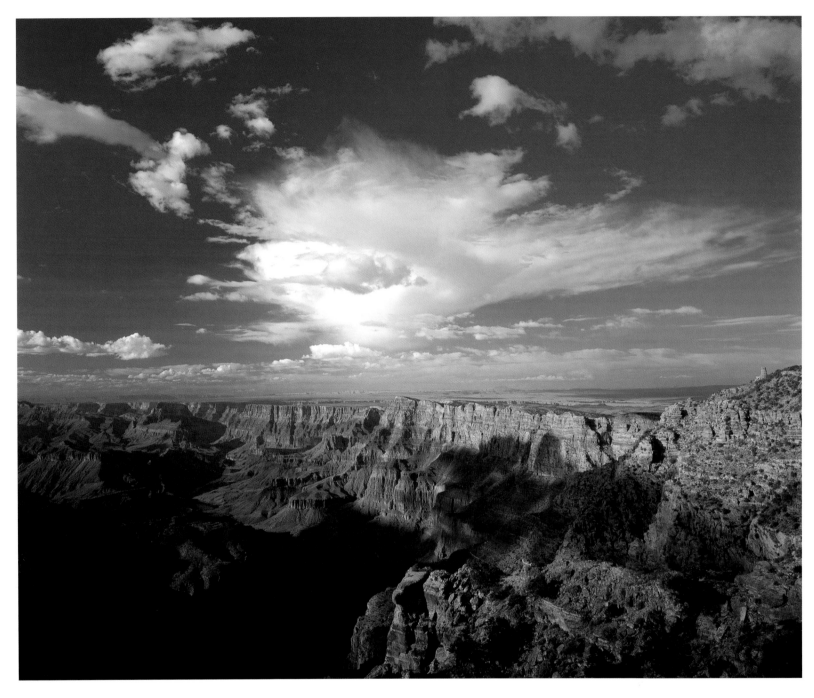

RANDY PRENTICE
Alto cumulus clouds hover over Comanche Point
and the Colorado River.

NOTES

page i: Epigraph: Estelle Jussim, *The Eternal Moment* (page 50).

NOTES TO THE INTRODUCTION

page 1: Epigraph: Wallace Stegner, "Coda: Wilderness Letter," in *The Sound of Mountain Water* (page 153).

page 1: I'm not the only writer to try to understand what the Grand Canyon means to a first-time visitor who has seen hundreds of pictures of the place. Walker Percy's essay, "The Loss of the Creature," in *Message in a Bottle* independently looks at a similar visitor stepping up to the Rim with a camera.

NOTES TO THE EARLY YEARS

page 7: Epigraph: Martha Sandweiss, *Print the Legend* (page 183).

page 7: Early history of photography comes from John Szarkowski, *Photography Until Now.*

page 8: Critics' comments on O'Sullivan: Szarkowski, *American Landscapes* (page 7). William Kittredge on O'Sullivan: from "We Are What We See: Photography and the Wheeler Survey Party" (page 63). O'Sullivan critique from Robert Adams, "Towards a Proper Silence: Nineteenth-Century Photographs of the American Landscape" (page 9).

page 8/10: Szarkowski on glass-plate cameras as muzzle-loaders: *Photography Until Now* (page 126).

page 10: Detailed quote about collodion process from Robert Cahn and Robert Glenn Ketchum, *American Photographers and the National Parks* (page 125).

page 11-13: Hillers quotes from Fowler, *"Photographed All the Best Scenery."*

page 13: quote from *Doing the Grand Canyon* by John T. McCutcheon from Sandra D'Emilio and Suzan Campbell, *Visions and Visionaries: The Art & Artists of the Santa Fe Railway* (page 123). "Aesthetics of erosion," from Stephen Pyne, *How the Canyon Became Grand* (page 77).

page 15: Background and quotes on Stanton from Robert Webb, *A Century of Change* and Smith & Crampton, *The Colorado River Survey.* Stanton's exasperation at first trying photography: Webb (page 15). Stanton on Moran: in

Crampton, *Land of Living Rock* (page 188).

page 16: Overexposure in Stanton's desert photos: Smith & Crampton *The Colorado River Survey* (page 277).

page 17: Hal Rothman quote: *Devil's Bargains* (page 50).

NOTES TO THE MIDDLE YEARS

page 27: Epigraph: Robert Glenn Ketchum, *American Photographers and the National Parks* (page 140).

page 27: Raymond Carlson quote: from the magazine's history "Arizona Highways: Gateway to an Inspiring Land" on the *Arizona Highways* Web site, www.arizonahighways.com.

page 32: Adams quotes about national parks from Cahn, *American Photographers and the National Parks* (page 133).

page 35: "synaesthetic:" *Ansel Adams: An Autobiography* (page 215).

page 39: Haas: quoted in *Ernst Haas Color Photography* (page 14).

page 40: Eliot Porter quotes and the phrase, "the color of wildness," come from the Amon Carter Museum Web site: http://www.cartermuseum.org/edu Other Porter quotes come from Paul Hill and Thomas Cooper, *Dialogue with Photography* (pages 188-199). Porter was a fine writer; "An Early View of the Southwest," his intro to *Eliot Porter's Southwest,* is charming.

NOTES TO THE CONTEMPORARIES

page 61: Epigraph: John Muir, *Steep Trails* (page 256).

page 62: Jose Knighton's "Eco-Porn and the Manipulation of Desire," first appeared in *Wild Earth* (Spring 1993): 76-78.

page 63: William Fox on Mark Klett's "Around Toroweap," *View Finder:* (page 195).

page 64: William Fox on Klett, *View Finder:* (page 214); quote from Mark Klett in "A View of the Grand Canyon in Homage to William Bell" (page 88).

page 65: "Bedrock Cathedral" is the name of a song on Paul Winter's album, *Canyon.*

page 66: Szarkowski quotes: *American Landscapes* (page 12).

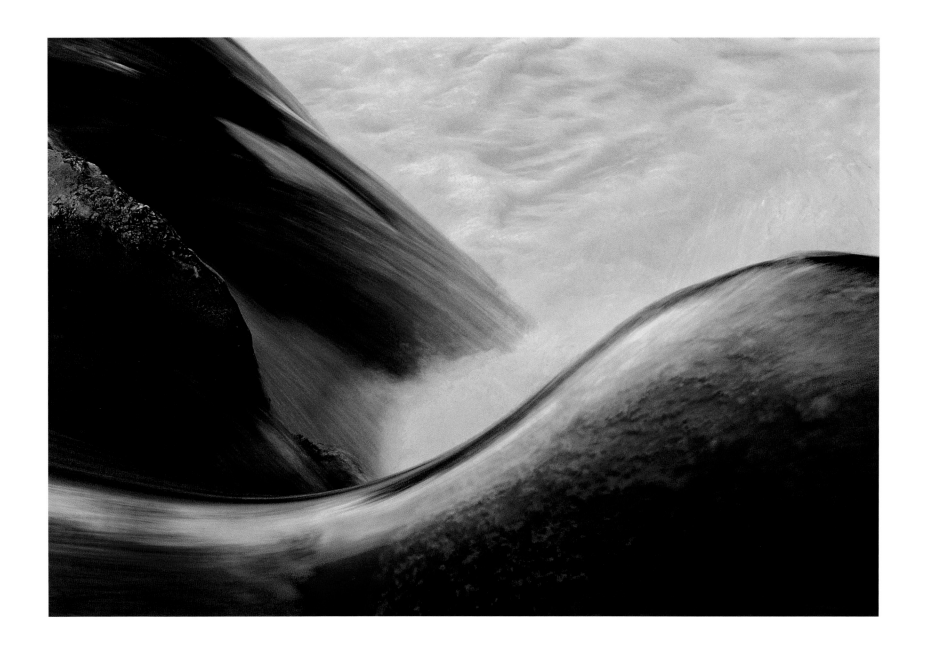

JOHN BLAUSTEIN
Havasu Creek water

BIBLIOGRAPHY

John Annerino, *The Photographer's Guide to the Grand Canyon: Where to Find Perfect Shots and How to Take Them* (The Countryman Press, Woodstock, Vermont, 2005).

Ansel Adams and Nancy Newhall, *This is the American Earth* (Sierra Club Books, San Francisco, 1960).

Ansel Adams: An Autobiography (New York Graphic Society Books/Little, Brown, Boston, 1985).

Robert Adams, "Towards a Proper Silence: Nineteenth-Century Photographs of the American Landscape," *Aperture*, Number 98: Spring 1985.

Tom Bean and Susan Lamb, *Grand Canyon: The Vault of Heaven* (Grand Canyon Association, 1998).

John Blaustein and Edward Abbey, *The Hidden Canyon: A River Journey* (Viking/Penguin, New York, 1977; Reprint by Chronicle Books, San Francisco, 1999).

Ernest Braun (journal and photographs), Roderick Nash (editor), *Grand Canyon of the Living Colorado* (Sierra Club Books, San Francisco, 1970).

Robert Cahn and Robert Glenn Ketchum, *American Photographers and the National Parks* (Viking Press/National Park Foundation, New York, 1981).

Michael Collier, *Water, Earth, and Sky: The Colorado River Basin* (University of Utah Press, Salt Lake City, 1999).

Michael Collier and Ann Zwinger, *Grand Canyon: Little Things in a Big Place* (University of Arizona Press, Tucson, 2006).

C. Gregory Crampton, *Land of Living Rock: The Grand Canyon and the High Plateaus: Arizona, Utah, and Nevada* (Alfred A. Knopf, New York, 1972).

Sandra D'Emilio and Suzan Campbell, *Visions & Visionaries: The Art & Artists of the Santa Fe Railway* (Gibbs Smith Publisher, Layton, Utah, 1991).

Clarence Dutton, *Tertiary History of the Grand Cañon District* (U.S. Geological Survey Monograph II, 1882).

Jack Dykinga, *Large Format Nature Photography* (Amphoto, New York, 2001).

Jack Dykinga's Arizona (Westcliffe Publishers, Denver, 2004).

Seymour L. Fishbein, *Grand Canyon Country: Its Majesty and Lore* (National Geographic Society, Washington D.C., 1993).

Don D. Fowler (editor), *"Photographed All the Best Scenery:" Jack Hillers's Diary of the Powell Expeditions, 1871-1875* (University of Utah Press, Salt Lake City, 1972).

William Fox, *View Finder: Mark Klett, Photography, and the Reinvention of Landscape* (University of New Mexico Press, Albuquerque, 2001).

Ernst Haas, *The Creation* (Viking, New York, 1971).

Ernst Haas and Robert Wallace, *The Grand Canyon* (The American Wilderness/TIME-LIFE Books, New York, 1972).

Ernst Haas Color Photography (Harry Abrams, New York, 1989).

Paul Hill & Thomas Cooper, *Dialogue with Photography* (Farrar Straus, New York, 1979).

George H. H. Huey and Nicky Leach, *The Guide to the National Parks of the Southwest* (Western Parks Association, Tucson, 1992).

Philip Hyde & Edward Abbey, *Slickrock: Endangered Canyons of the Southwest* (Sierra Club Books, San Francisco, 1971).

Philip Hyde, *Drylands: The Deserts of North America* (Harcourt Brace Jovanovich, San Diego, 1987).

Estelle Jussim, *The Eternal Moment: Essays on the Photographic Image* (Aperture, New York, 1989).

William Kittredge, "We Are What We See: Photography and the Wheeler Survey Party," in *Perpetual Mirage: Photographic Narratives of the Desert West* (Whitney Museum of Art, New York, 1996).

Mark Klett, "A View of the Grand Canyon in Homage to William Bell," in *Myth of the West* (Rizzoli, New York, 1990).

Ellsworth Kolb, *Through the Grand Canyon from Wyoming to Mexico* (Macmillan, New York, 1914; University of Arizona Press reprint, Tucson, 1990).

Gary Ladd and Craig Childs, *Grand Canyon: Time Below the Rim* (Arizona Highways Books, Phoenix, 1999).

Gary Ladd's Canyon Light: Grand Canyon & Lake Powell (Stephens Press, Las Vegas, 2003).

François Leydet, *Time and the River Flowing: Grand Canyon* (Sierra Club Books, San Francisco, 1964).

Charles Lummis, *Mesa, Cañon, and Pueblo* (Century Company, New York, 1925; University Press of the Pacific reprint, Honolulu, 2004).

Letitia Burns O'Connor, *The Grand Canyon,* with photos by Tom Bean, John Blaustein, Michael Collier, D.T. DeDomenico, Dana Levy, David Muench, Greg Propst, John Running, and Paul Vucetich (Beaux Arts Editions/Hugh Lauter Levin, Westport, Connecticut, 1992).

Walker Percy, "The Loss of the Creature," in *The Message in the Bottle* (Farrar Straus, New York, 1975).

Eliot Porter, *In Wildness is the Preservation of the World* (Sierra Club Books, San Francisco, 1962).

Eliot Porter and David Brower, *The Place No One Knew: Glen Canyon on the Colorado* (Sierra Club Books, San Francisco, 1963).

Eliot Porter and John Wesley Powell, *Down the Colorado* (E.P. Dutton, New York, 1969).

Eliot Porter's Southwest (Holt, Rinehart and Winston, New York, 1985).

Eliot Porter, foreword by Martha A. Sandweiss, *Eliot Porter* (New York Graphic Society Books/Little Brown, Boston, 1987).

John Wesley Powell, *The Exploration of the Colorado River and its Canyons* (Smithsonian Institution, Washington, D.C., 1875; Penguin reprint, 2003, introduction by Wallace Stegner).

Stephen J. Pyne, *How the Canyon Became Grand: A Short History* (Viking, New York, 1998).

Hal K. Rothman, *Devil's Bargains: Tourism in the Twentieth-Century American West* (University Press of Kansas, Lawrence, 1998).

Martha Sandweiss, *Print the Legend: Photography and the American West* (Yale University Press, New Haven & London, 2002).

Dwight L. Smith & C. Gregory Crampton (editors), *The Colorado River Survey: Robert B. Stanton and the Denver, Colorado Canyon & Pacific Railroad* (Howe Brothers, Salt Lake City & Chicago, 1987).

Wallace Stegner (editor), *This is Dinosaur* (Alfred A. Knopf, New York, 1955; Roberts Rinehart reprint, 1985).

Wallace Stegner, "Wilderness Letter," in *The Sound of Mountain Water* (E.P. Dutton, New York, 1980).

Hal G. Stephens & Eugene M. Shoemaker, *In the Footsteps of John Wesley Powell: An Album of Comparative Photographs of the Green and Colorado Rivers, 1871-72 and 1968* (Johnson Books, Boulder, 1987).

William C. Suran, *The Kolb Brothers of Grand Canyon* (Grand Canyon Association, 1991).

John Szarkowski, *American Landscapes* (Museum of Modern Art, New York, 1981).

John Szarkowski, *Photography Until Now* (Museum of Modern Art, New York, 1989).

Barry Thomson, *The Enchanted Light: Images of the Grand Canyon* (Museum of Northern Arizona Press, Flagstaff, 1979).

Tom Till, *Plateau Province* (Fable Valley Publishers, Moab, Utah, 2004).

Stephen Trimble (editor), "Visions of the Southwest," *Plateau Magazine,* Museum of Northern Arizona, 52: 3, 1980.

Stephen Trimble (editor), *Blessed by Light: Visions of the Colorado Plateau* (Gibbs Smith Publisher, Layton, Utah, 1986).

Stephen Trimble (text) and Dewitt Jones (photographs), *Canyon Country* (Graphic Arts Center, Portland, Oregon, 1986).

Larry Ulrich, *Arizona: Magnificent Wilderness* (Westcliffe Publishers, Denver, 1991).

Larry Ulrich and Susan Lamb, *Wildflowers of the Plateau and Canyon Country* (Treasure Chest Books, Tucson, 1997).

Robert H. Webb, *Grand Canyon: A Century of Change: Rephotography of the 1889-1890 Stanton Expedition* (University of Arizona Press, Tucson, 1996).

INDEX

NUMERALS IN *italic* INDICATE PHOTOGRAPHS.

Abbey, Edward, 36, 65, 151
Abell, Sam, 174
Adams, Ansel, 20, 25, 28, 29, 32, *32, 33,* 35, 36, 40, 46, 87
Adams, Robert, 8
Allard, William Albert, 81
American Photographers and the National Parks (Cahn & Ketchum), 10, 27
The American Wilderness series (TIME-LIFE), 39, 98
Angel's Gate, *78*
Angel's Window, *79*
Arizona Highways, 1, 2, 21, 27, 28, 29, 50, 64, 67, 68, 70, 74, 87, 105, 139, 155, 157, 177, 178
Arizona Strip, 12
Avey, George, 21, 27

Babbitt, Bruce, 89
Basalt Canyon, *94*
Bass, W.W., 16
Beaman, E.O. 11, 12, 13, 21
Bean, Tom, 59, 114, *114-119*
Belknap, Bill, 64
Bell, William, 21
Bennett, Sue, 59, 66, *66,* 81, 110, *110-113,* 170, 177
Bighorn sheep, *101*
Blaustein, John, 39, 59, 67, 98, *98-103, 206*
Blessed by Light (Trimble), 3, 134
Bohn, Dave, 98
Brady, Matthew, 8
Brahma Temple, *29, 75, 76, 202, 203*
Braun, Ernest, 34-35, 114
Bremner, Dugald, 59, 170, *170-175,* 177
Bright Angel Lodge, 3
Bright Angel Trail, 3, 18, *18,* 20, 61
Brower, David, 32, 34-36, 40, 46, 62, 65
Brown, Frank, 13, 15
Brownold, Tom, 59, 160, *160-163*
Buchheit, Mike, 179, *196-197*
Buck Farm Point, 65
Buddha Temple, *122*

Cahn, Robert, 10
Cameras: *56-57;* Arca-Swiss, 36, *61,* 87, 144, 164; Blair stereo Hawkeye, *7;* Brownie, 17, *17,* 18, 40; Calumet, 36, *61;* Conley 4x5 folding, *7;* Deardorff, 28, 36, 48, 50; Digital, 7, *61,* 68, 69, 81, 139, 160; Graflex, *7,* 20, *20;* Graphic press, *27,* 36; hand-held, 17; Hasselblad, *27,* 70, 71, 72, 98; Kodak, 17, *17;* large-format, 7-8, 10-13, 17, 18, 20, 28, 29, 36, 48, 50, 74, 79, 85, 87, 105, 132, 139, 155, 160; Leica, *27,* 37; Linhof, 36, 70, 72; Mamiya RB67, 162; medium format, 144, 162; Nikon, *27,* 37, *61,* 69, 74, 98, 144, 145, 178; panoramic, 93, 126; Pentax 645, *61;* Polaroid Land, *1;* Reflex, *7;* Rolleiflex, *27;* Scovill and Adams camera, 15; Seneca 8x10, *7;* 35 mm, 35, 36, 70, 81, 98, 110, 160; Toyo, 36
Cañonita, 12
Canyon (Winter), 3
Cape Royal, *33, 54,* 87, *109, 156, 194*
Carlson, Raymond, 21, 27
Cataract Canyon, *153*
Cathedral Wash, *108*
Cavagnaro, David, 114
Cheops Pyramid, *158*
Clemenz, Bob, *24-25, 25,* 28, *28*
Clifton, Carr, 119
Cogswell, Raymond, 19
Collier, Michael, 59, 144, *144-149*
Collodion, 8, 10
Comanche Point, *80, 204*
Communication Arts, 112
Conde, Alfredo, 3, 59, *120-125,* 121
Confucius Temple, *97*
Conquistador Aisle, *181*
Cove Canyon, 105
Cowlin, James, 59, *92-97,* 93
The Creation (Haas), 39, 65, 98
Crystal Palace Exhibition, London, 7
Crystal Rapid, 39, 132, 134
Cunningham, Imogen, 46
Curtis, Sherri, 3, 59, *120-125,* 121

Daguerrotype, 7
Datura, 127, 146
Deer Creek, *41, 43, 48, 71, 102, 128, 133, 188*
Desert Solitaire (Abbey), 65
Desert View Watchtower, *183*
Deva Temple, *202, 203*
Diamond Creek, 8, 10, *10,* 16
Dietrich, Dick, 25, 28, 50, *50-55*
Dimmock, Brad, 177
Dinosaur National Monument, UT/CO, 32

Disney, Walt, 28
Doing the Grand Canyon (McCutcheon), 13
Down the Colorado (Porter & Powell), 40
Drylands (Hyde), 46, 48
Dusard, Jay, 160, 164
Dykinga, Jack, 59, 68, *69,* 74, *86-91,* 87, 155
Dutton, Clarence, 13, 35

Eastman, George, 15, 17, 20
Edwards, David, *v,* 64, 66, 67, *67,* 170, 174, 177, 179, *180-181*
Eiseley, Loren, 35
El Tovar Hotel, 13, 20, 121
Elmer, Carlos, 27
Elves Chasm, 35, 46, *128*
Emerson, Ralph Waldo, 46
Eminence Beach, *182*
The Enchanted Light (Thomson), 67
Ensenberger, Peter, 157
Esplanade, *105, 148*
The Eternal Moment (Jussim), i
The Exploration of the Colorado River and its Canyons (Powell), 11
Explore Grand Canyon (Cowlin), 93

Fennemore, James, 5, 11, *11,* 12, 21
Fern Glen, 35
Film: American paper-backed, 15; celluloid, 15; color, 20-21; Ektachrome, 35, 37; Kodachrome, 21, 35, 40, 98, 151; Kodacolor, 37; large-format, 68; roll, 15, 16, 18; sepia Polaroid, 66, 80, 82-85; Velvia, 139.
Flagstaff, AZ, 2, 3, 16, 66, 74, 81, 110, 114, 144, 150, 170, 177
Ford, Gerald, 39
Forest Service, US, 19
Foster, Dave, 106
Fox, William, 63-64
FPG Agency, 50
Frazier, Pamela, 2
Freya Castle, *156, 159*

Geological Survey, United States, 11, 13
George, Kyle, 179, *194-195*
Glen Canyon, 15, 32, 35, 36, 40, 105
Goldwater, Barry, 27, 70
Gourley, Geoff, 179, *188-191*
Grand Canyon (Disney), 28

The Grand Canyon (Haas & Wallace), 39, 98
Grand Canyon, a Century of Change: Rephotography of the 1889-1890 Stanton Expedition (Webb), 16
Grand Canyon Association, 2, 67, 164
Grand Canyon National Park, enlargement, 34-35, 39
Grand Canyon of the Living Colorado (Braun and Nash), 34-35
Grand Canyon Suite (Grofé), 28
Grand Junction, CO, 13
Grand Wash Cliffs, 35
Grandview Trail, 195
Granite Falls, 3, *104,* 174, *175, 178*
Green River, UT, 13
Green River, WY, 10
Greenland Lake, *165*
Grofé, Ferde, 28

Haas, Ernst, 25, 28, 37, *37, 38,* 39, 65, 67, 98
Hance Partners (see Richard Jackson)
Hance Rapid, *49, 96*
Harvey Company, Fred, 13, 19
Havasu Canyon, *16,* 18, 50, *140, 141,* 151, 153, 157, *162, 172, 206*
Havasupai Indians, 3
Hayden, Mount, *28*
Henderson, Esther, 27
Hermit Rapids, *95*
Hermit Road, 68, 95
The Hidden Canyon (Blaustein), 67, 98
Hillers, John F. (Jack), 5, 11-13, *11, 12,* 21, *61,* 63, 64
Hilltop Ruin, *134*
Holmes, W.H., 13
Honor Dance (Running), 81
Hopi Point, *73*
Horseshoe Mesa, *95*
Houk, Rose, 144
House Rock Rapid, *44, 45, 92,* 93
How the Canyon Became Grand (Pyne), 13
Hualapai Indians, 3
Huey, George H.H., 32, 59, 164, *164-169*
Hummingbird Trail, 20
Hyde, Philip, 25, 28, 32, 34, 36, 46, *46-49,* 65, 87, 139; David (son), 46
Hymans, Liz, *ii-iii,* 59, 126, *126-131*

Iceberg Canyon, *9*

In Wildness is the Preservation of the World (Porter), 32, 40

Indian Garden, 18

Isis Temple, *96, 158*

Iwai, Keiji, 110

Jack Dykinga's Arizona, 87

Jacka, Jerry, 59, 70, *70-73*; Cindy (daughter), 70; Lois (wife), 70

Jackson, Richard, 2

Jackson, William Henry, 17

James, George Wharton, 17

Jenney, David, 2

Jenshel, Len, 63

Jussim Estelle, i

Kaibab Plateau, 150, *165*

Kaibab Trail, 87, 89

Kanab, UT, 12

Kanab Canyon, 12, 13, 105

Kauffman, Richard, 139

Keith, Christine, 179, *184-185*

Ketchum, Robert Glenn, 27

Klett, Mark, 59, *62-63, 63-64*, 67

Kings Canyon National Park, CA, 20, 36

Kingsnake, California, 81, *83*

Kittredge, William, 8

Knighton, Jose, 62

Knights of the Light Table, 67

Kodak Corporation, 17, 20-21

Kolb, Ellsworth & Emery, *i, 4-5, 5, 6,* 7, 18-20, *18, 19, 20, 21, 22, 23,* 39, 64

Kolb Studio, 2, 18, 20, *21,* 179; Blanche (wife), *21*

Krutch, Joseph Wood, 35

Ladd, Gary, *58-59,* 59, 61, *104-109,* 105

Lamb, Susan, 114

Lange, Dorothea, 46

Lava Chuar, *193*

Lava Falls, 2, 12, 46, 105, *173*

Leatherbury, Paul, 179, *198-201*

Leis, Dianne Dietrich, 28, 50

Lees Ferry, 10, 12, 15, 35, 105, 127, *145*

Leydet, François, 34

LIFE magazine, 37

Lindahl, Larry, 179, *182-183*

Lipan Point, *3, 24-25, 133*

Little Colorado River, *90*

Litton, Martin, 34, 98, 105

Living Water (Cavagnaro & Braun), 114

Loper, Bert, 19

Lummis, Charles, 20

Magnum Photo Agency, 37

Mahaffey, Merrill, 93

Maisel, Jay, 170

Manley, Ray, 27

Marble Canyon, 12, 15, *44, 45, 47,* 65, 92, 93, 152, 161, 171, *187, 203*

Maricopa Point, *138*

Mather Point, *ii-iii,* 1, 74, 75, 79, *119, 130-131, 136, 137, 142,* 158, *163, 169*

Matkatamiba Canyon, *58-59,* 66, 67, *68, 69,* 129

McDonald, Robert, 59, 74, *74-79*

Mesa, Cañon, and Pueblo (Lummis), 20

Moab, UT, 132

Mohave Point, *143*

Mojave Indians, 8

Moran, Thomas, 15

Muench, David, 25, 27, *28-29, 29, 30, 31,* 36, *65-66,* 139

Muench, Josef, 25, *26,* 27, 74

Muench, Marc, 27, 179, *179, 186-187*

Muir, John, 18, 61

Museum of Northern Arizona, 3, 67, 81

Nankoweap, *103, 187, 190, 195*

National Canyon, 174, *186*

National Geographic, 18, 20, 37, 64-65, 87, 118, 170, 174

National Park Service, 19, 105, 139

Navajo Point, 79, *200*

Needles, CA, 16

Negatives: dry-plate, 17; glass-plate, 7, 8, 10, 16, 17, 18; paper, 7

New Hance Trail, 95

"The New Topographics," 62

New York Times, 34

Newhall, Nancy, 29, 32, 164

Nichols, Michael "Nick," 59, *64-65, 64-65,* 174

Nichols, Tad, 64

Niépce, Nicéphore, 7

Nikon World, 110

Nims, Franklin, 13, 15

North Bass Trail, 164

North Rim, 12, 89, 132, 164

Northland Publishing, 2, 74

O'Neill Butte, *196*

O'Sullivan, Timothy, 5, 8, *8, 9,* 10, *10,* 21, 61

Outside Magazine, 170

Page, AZ, 105

Parashant Canyon, *191*

Paria River, *8, 145, 147*

Peach Springs, AZ, 16

Phantom Ranch, 121, 164

Picture, 8, 10

The Place No One Knew: Glen Canyon on the Colorado (Porter & Brower), 32, 35, 40

Plateau magazine, 3, 67

Point Imperial, 28, *52, 115, 117*

Point Sublime, *64, 97*

Porter, Eliot, 25, 28, 32, 34, *34,* 36, 40, *40-45,* 65, 66, 139; Fairfield (brother), 40

Powell, Clem, 12-13

Powell, John Wesley, 10-13, 18, 27; Powell Survey, 21

Powell, Lake, 32, 105

Powell Memorial, 118

Prentice, Randy, 59, *154-159, 155, 204*

Prescott College, 160, 164, 170

Priehs, T.J., 67

Print the Legend: Photography and the American West (Sandwiss), 7

Printing, color, 21, 27; halftone, 20

Prints, albumen, 7; contact, 17; dye-transfer, 40

Pyne, Stephen, 13

Purcell family, *vi*

Reclamation, U.S. Bureau of, 32, 34

Red Canyon, *49*

Remington, Frederick, 18

Ribbon Falls, *203*

Rider Canyon, *82*

Roosevelt, Theodore, 18, *18*

Rothman, Hal, 17

Running, John, 39, 59, 66, *66, 80-85,* 81, 110, 112, 170, 177

Running, Raechel, 81, *81,* 179, *191-192*

Russell, Charles, 19

Saddle Canyon, 105, *154*

Salt Lake City, UT, 11, 12

Sandwiss, Martha, 7

Santa Fe Railway, 16, 17, 18

SB Point, 65

Sierra Club, 20, 32, *34-35,* 40, 46, 62; exhibit format books, 32, *34-35,* 36, 40, 46, 65, 139

Sinyala Canyon, 106

Shinumo Creek, 164

Shiva Temple, 78

Shivwits Paiute Indians, 13

Showers, Jay, 179, *202-203*

Sinking Ship, *197*

Siskind, Aaron, 160

Slickrock (Hyde & Abbey), 36

SOA, see Alfredo Conde, Sherri Curtis

Sockdolager Rapid, *22*

Solomon Temple, *78*

Sommer, Frederick, 160, 164

The Sound of Mountain Water (Stegner), 1

South Canyon, 15

Stanton, Robert Brewster, 5, 13, *14,* 15-16, 18

Steck, George, 105

Steep Trails (Muir), 61

Stegner, Wallace, 1, 2, 32, 35, 151

Stereographs, 7, 10, 12

Stetter, Rick, 67

Stieglitz, Alfred, 40

Stone, Julius, 19

Stone Creek Falls, 174

Supai Formation, 105

Swamp Ridge, *184*

Szarkowski, John, 8, 66

Tertiary History of the Grand Canyon (Dutton), 13

This is Dinosaur (Stegner), 32, 46

This is the American Earth (Adams & Newhall), 32, 164

This Living Earth (Cavagnaro), 114

Thompson, Kate, 59, *67-68, 68,* 170, 172, 174, *176-178,* 177

Thomson, Barry, 67

Thoreau, Henry David, 32, 40

Three Springs, *84*

Through the Grand Canyon from Wyoming to Mexico (Kolb), 18

Thunder River, *42, 128*

Till, Tom, 3, 59, *65-66,* 132, *132-136*

Time and the River Flowing: Grand Canyon (Leydet), 34-35

Timeline, 56-57

Tiyo Point, 88

Toroweap Point, 2, *11,* 12, 30, 60, *62-63, 64,* 74, *86, 91,* 93, 150, 155, *168*

The Transept, 164

Trimble, Stephen, 59, 150, *150-153*

Twentyfive Mile Rapid, 15

205 Mile Canyon, *149*

Ulrich, Larry, 59, *60,* 68, 69, 119, *138-143,* 139, 164; Donna (wife), 139

Uncle Jim Point, 76

Unkar Rapids, *201*

van Campen, Darwin, 27

Vermilion Cliffs, *152*

Vishnu Schist, 93, *129*

Vishnu Temple, *109, 159*

Walhalla Plateau, 105

Watkins, Christina, 164

Webb, Robert, 16, 126

Weston, Edward, 20, 46

Wheeler, George, 8; Wheeler Survey, 8, 10, 21

White, Minor, 46, 160

Williams, AZ, 18, 144

Winter, Paul, 3

Wittick, Ben, *5,* 16, *16*

Yaki Point, *55,* 116, *166, 167*

Yavapai Point, *51,* 74, 77, *158*

Yuma, AZ, 13

Zoroaster Temple, *29, 75, 76, 78, 202, 203*

Zuni Pueblo Indians, 13